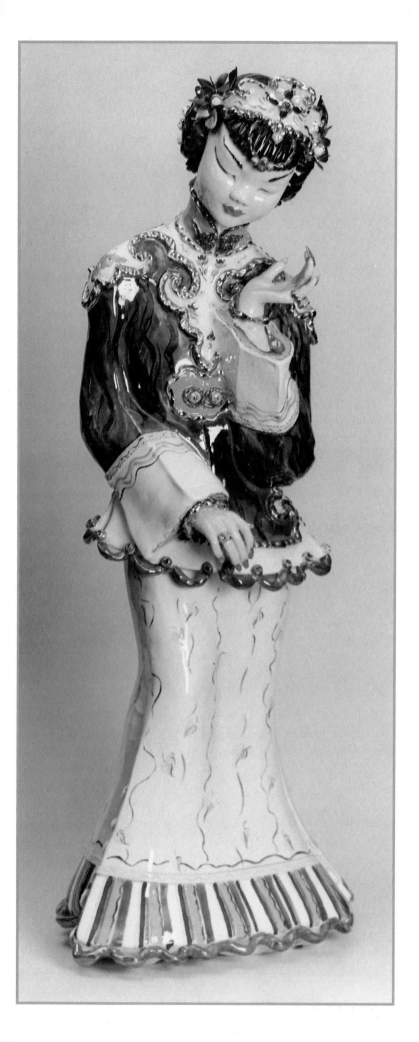

KAY FINCH CERAMICS:

Her Enchanted World

Mike Nickel & Cindy Horvath

77 Lower Valley Road, Atglen, PA 19310

This book is dedicated:

To *Frances Finch Webb*, whose knowledge and love of her Mother's work have made this book possible.

To *Ralph Hickman*, of Inland Empire Antiques, who showed us our first real collection of Kay Finch pottery, and allowed us to imagine the possibilities.

To *Elizabeth Roe Schlappi*, who generously shared her extensive collection with us, most of which had been purchased from Kay's studio in Corona del Mar, California.

And to our good friends *David and Kaye Porter,* who would like us to believe that their passion and enthusiasm for Kay Finch may well exceed our own.

Library of Congress Cataloging-in-Publication Data

Nickel, Mike.
 Kay Finch Ceramics: her enchanted world / Mike Nickel & Cindy Horvath.
 p. cm.
 Includes bibliographical references and index.
 ISBN 0-7643-0008-3 (hard)
 1. Finch, Kay, 1903-1994 --Catalogs. 2. Pottery figures--Collectors and collecting--United States--Catalogs.
3. Pottery figures--United States--History--20th century--Catalogs. I. Finch, Kay, 1903-1994 II. Horvath, Cindy.
NK4210.F49A4 1996
738'.092--dc20 96-17706
 CIP

Printed in Hong Kong
ISBN: 0-7643-0008-3

About the Authors

Michael (Mike) Nickel discovered his first piece of American Art Pottery in 1970, and has been chasing it ever since. He is an authority on Roseville Pottery, produced in Zanesville, Ohio, from near the turn of the century until 1954. He is Life Member Number One, and a former officer, in the American Art Pottery Association. A retired advertising creative director, he is now a full-time antiques dealer specializing in American Art Pottery.

Cynthia (Cindy) Horvath, his wife, travels with Mike on the antique show circuit. She is a relative newcomer to the Ceramics world, but what she lacks in years of experience, she makes up for in enthusiasm. Especially in the Kay Finch arena. Once bitten by the Kay Finch bug, she cajoled, pleaded, and with Mike's blessing and assistance, set out to capture every piece of Finch ceramics known to man. She's not there yet, but still trying. Her collection has a special place of honor in a bedroom in their home that's aptly named "The Finch Room." No furniture, just Kay Finch.

When they're not exhibiting at antique shows, the couple reside in Portland, Michigan, with their two Pomeranian dogs, Tillie and Zoe, and their cat, BC. If you have any questions at all about Kay Finch Ceramics, they would love to hear from you at: P.O. Box 456, Portland, MI 48875. 517-647-7646.

Published by Schiffer Publishing Ltd.
77 Lower Valley Road
Atglen, PA 19310
Please write for a free catalog.
This book may be purchased from the publisher
or the authors.
Please include $2.95 for shipping.
Try your bookstore first.

Contents

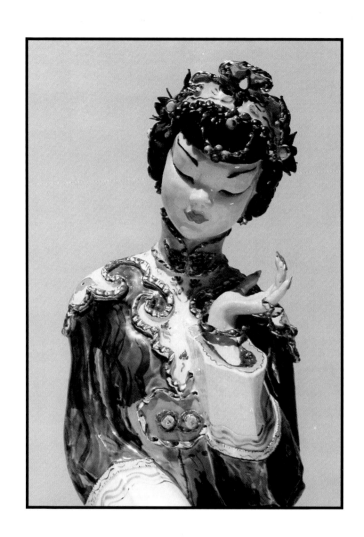

My Mother Was Kay Finch...

I suppose that I was nearing my teens before I began to consciously realize that there was so much more to her than just being my Mother, and Mom to my two Brothers as well. As far back as I can remember, she bore a unique attitude toward animals and nature and freely expressed it, since we always had dogs and puppies around and later acquired Smoky, a California Mustang, that became the model for one of her early horse sculptures.

Kay had forever been dedicated to sculpting and trained for it early on. As a youngster, it seemed to me that she was constantly enrolled in one art school or another. She was always similarly immersed in some clay project around our house. Fortunately, we had some household help to tend many of the needs of a growing family. So that did leave Mother free to pursue her development of art, which she really attacked more than pursued.

Since arriving in Southern California we had lived in eight different houses over a period of eight years, and my Mother and Dad had made an around-the-world trip, all before the purchase and installation of the first ceramics kiln in the old milk shed of our ninth home, in Santa Ana, California. But that purchase was only the beginning.

After establishing Kay Finch Ceramics, she proceeded to expand her particular interest in dogs by founding Crown Crest Kennels, and becoming a breeder. Eventually a world-class dog show judge, Kay developed another entirely new world of friends and fans. Sometimes when she was judging abroad she would telephone. One of her favorite fans, my husband, Jack, would usually hand me the phone with, "It's our 'Auntie Mame' calling, dear—from Tokyo this time."

Somehow my Mother never seemed to stop growing in her interest in people, art, learning, and the curiosity of life. She was honest and sincere, with an unaffected personality. While she knew of the reservoir of her admirers in the dog world, Mother did not live quite long enough to have realized the breadth and extent of her friends in the world of collecting. I truly believe her response to that knowledge might have been something like "Oh, Gee! Isn't that nice?"

Frances Finch Webb
January 1996

Katherine Seamon Finch, 1903-1994.

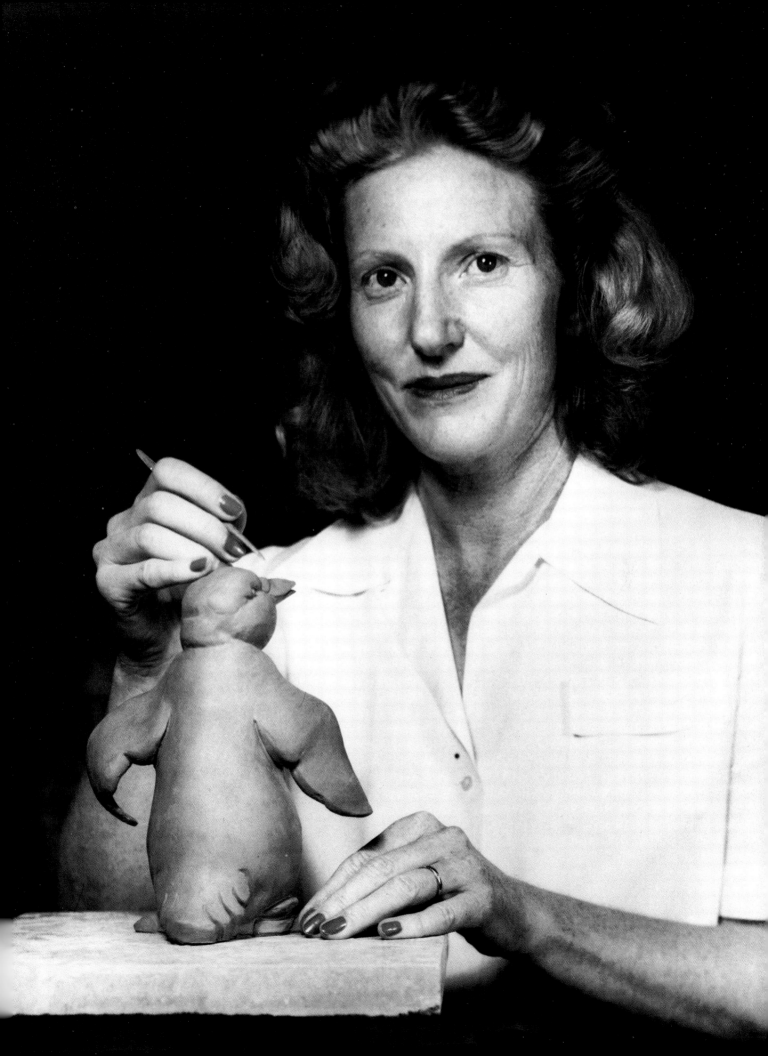

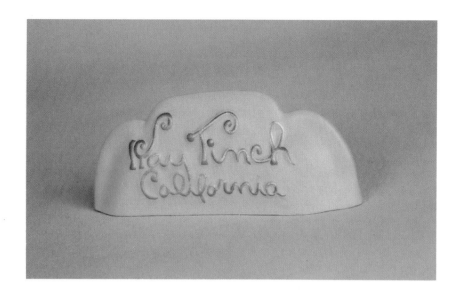

Dealer sign, 2¼" x 5¼" ($600-750). *Kaye & David Porter Collection.*

Acknowledgments

If it were not for the diligence, generosity, hospitality, good-will, and encouragement of the following people, this book (and the ceramics in it) would still be an idea instead of a reality.

Jim & Jolene Andrus
Tom Bainbridge
Sharlene Beckwith
Ted Birbilis
Len Boucher & Debby Clarke
Jack Chipman
Dane Cloutier
Penny Cloutier
Janet Codair
Joe Devine
Gordon's Antiques
Ralph Hickman, *Inland Empire Antiques*
Jane Knapp
Joan Letterly
Dorothy Lombard
Lisa Louis
Richard & Ruthann Murdock
Ron & Juvelyn Nickel
David & Kaye Porter
Esther Phillips, *Lucky Find Antiques*
Sandy Raulston

Elizabeth Roe Schlappi
Steve Schoneck
Patti Shedlow
David Shupp
Don R. Smith
Bill Snelson
Mary Spolarich
Roberta Tripoli
Dan & Diane Veirs
Jack & Frances Finch Webb
Frank Weldi & Mary Weldi-Skinner
Bill Wise

Most of the photographs in this book were taken by the authors. But there were four photographers who, because of the demands of time or bonds of distance, were instrumental in assisting us with the completion. The archival photos, located primarily in the chapter entitled "Her Scrapbook," came from public and private donors where photographic sources are unknown, and are the property of the Finch Estate.

Charles De Vries, *Grand Rapids, Michigan*
Richard Murdock, *San Bernadino, California*
John Nelson, *Prescott, Arizona*
Richard Rud, *Bloomington, Minnesota*

Discovery

American Art Pottery has been a passion of mine for over twenty years. But I confess that most of my attention, up until the fall of 1989, had been devoted to pottery produced in Ohio: Roseville, Weller, and Rookwood. Like most collectors, my collection had been built from shows, auctions, trading with other collectors, and mail order from publications like the *Antique Trader*. And, once in a while I'd get an unsolicited list in the mail from someone I'd done business with in the past. In October 1989, one such list arrived with the usual offering of Ohio potteries. But at the bottom of the list the seller offered a grouping of Kay Finch animals and birds. All were "whimsically sculpted and decorated" in the "Kay Finch style." Included were: a pair of large pigs, a pair of small pigs (one was a bank), a set of three owls, and a pair of small cats. All were done in a pink glaze with accents of lavender, green, white, and blue. They were priced as a group at $200.

Since my soon-to-be wife, Cindy, had a cat collection, my primary interest was feline. Christmas was not far away, and I thought the cats would be a nice addition to my already burgeoning holiday stash.

So I called the dealer to attempt to pry the pair of cats loose from the group. I also wanted to find out the what, when, and where of Kay Finch pottery just to satisfy my unceasing curiosity, since Lois Lerner's *Encyclopedia of U.S. Marks* had only a brief paragraph on the subject. The dealer couldn't tell me much more than I had gleaned from Lerner's book. But he did say that Kay's work was wonderful; the decoration and style were almost beyond description. ("You have to see it to appreciate it…") He also convinced me to buy all nine pieces with the understanding that I had a return privilege if I wasn't completely satisfied.

The package arrived about a week later. Needless to say, nothing was returned. I called immediately to tell him: More! More! More! Cindy got to see the new arrivals well before Santa made his annual visit. And the race was on.

We told everyone we knew (and many we didn't) to start hunting Kay Finch for us. We even ran a 'Wanted to Buy' advertisement in the *Antique Trader*, which is how we came to meet Kay's daughter, Frances, and her husband, Jack. We thank them again publicly for giving us the opportunity to acquire many spectacular examples of Kay's work. And, for their warmth, hospitality, and patience during a marathon interview/photography session in June of 1995.

To the best of our knowledge, the facts and information contained in this book are as complete as we could make them. Our quest for a complete collection of Kay's work continues. And we gratefully acknowledge the contribution of each and every individual who helped to fill in the gaps when examples from our collection were not yet a reality.

Mike Nickel
January 1996

Call this picture "Three Beauties." Circa 1943. *Courtesy Finch Estate.*

Her Beginning

Katherine Seamon Finch was born to create. Fortunately for us, her innate abilities, which were for the most part self-developed, translated from early childhood whims to eventually become one of this country's most successful mid-century ceramic enterprises. Who could imagine that a little innocent "horsing around with Texas mud" would metamorphose into a creative force in the development of Southern California's ceramics industry.

Kay entered the world in El Paso, Texas on August 19, 1903. As a small child you didn't need a crystal ball to see she was destined for greater glory in another world—that of artistic endeavor. While most girls her age were playing with dolls and stuffed animals, Kay had better ideas. You can see them emerging by reading some of these prophetic anecdotes taken from a 1939 article about Kay in *The Western Woman*, a California-based publication:

"One sunny morning anxious parents found little Kay and the family dictionary had disappeared. A search disclosed them at an adobe brickyard several blocks away. Daughter was sitting in the mud modelling a horse from a picture in the volume. Another time, as a five-year-old, she returned from Sunday school with the announcement that she didn't want to go to Heaven. She said, 'Teacher says that horses and dogs don't go to Heaven, so I don't want to go there either,' when asked to explain."

More insights about Kay from a retrospective written by her mother, Mrs. Frank H. Seamon, in 1959:

"What a child she was—crazy about dogs and modelling them in mud from the back yard. Later, we bought her some real clay and she won a prize for the animals she modelled and exhibited at a county fair in El Paso."

"Her Daddy bought her a burro to ride, and she called us to come and watch her make him talk. She asked, 'Do you want to take me for a ride?' The burro shook his head, the answer being 'No.' We discovered later that she had put a pebble in his ear and that he was merely shaking it out."

"The children in the neighborhood decided to have a circus in our back yard. They put up a tent and charged three cents admission to see the animals. Kay painted a white cat with black stripes as a tiger, and Nora, a St. Bernard dog, was made into a fierce-looking lion. They had a parade around the block

and Kay, owning a pony now, rode him standing up on his back. She sat down only when passing by her home."

"When Kay went for a walk, she often returned with several dogs following her. Not content with dogs, her Father found her in our back yard milking a cow which she had persuaded to come home with her. She had gotten nearly a quart of milk, too."

"Another day, she came home with fifty cents that she had been given by a neighbor for bringing home a horse that had strayed down by the river. Finally, she confessed she had let him out and had ridden him home bareback. Her explanation was the poor thing needed some exercise."

"One summer before buying a cottage, we rented one in Cloudcroft (New Mexico). It had a ceiling painted blue. Kay and a friend went up ahead of me, and later, when I came up, I found the ceiling was painted with huge white clouds, and peering through them was an angel with spreading wings."

And again, from a 1939 issue of the *El Paso Times:*

"Throughout her later school life in El Paso and Nashville, Tennessee, Kay was seldom without either a bin of clay or a horse. Her parents saw to it that she had both whenever practical."

"After her marriage in 1922 to Braden L. Finch of Memphis, Tennessee, the result of a college romance, Mrs. Finch continued to ride and model horses. In fact, Mrs. Finch still loves them as she did when she rode in the Cloudcroft rodeos, or over Cloudcroft trails on a livery stable nag with a dog or two at the nag's heels."

Kay's artistic side continued to get all the nurturing it needed at the Memphis Academy of Fine Arts, interrupted only by the births of her daughter Frances and son George. Then, in 1929, the plot thickened. Kay and Braden, a career newspaper man for the Memphis Commercial Appeal, decided to move to California—a place that Kay had fallen in love with, when just a child, on family vacation visits.

At this point, rather than have us document the events that followed, you're in for a rare treat. Kay's daughter, Frances Finch Webb, has agreed to let us publish relevant excerpts from Kay's private diary. Get ready for an exciting ten-year trip into history with Kay as your personal guide.

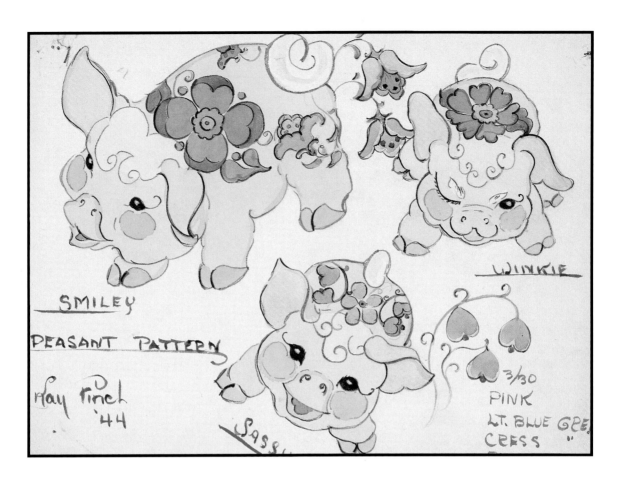

Smiley, Winkie, and Sassy, Yellow Daisy Pattern.

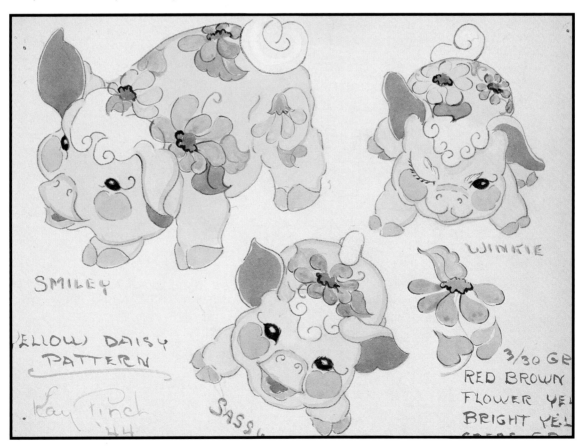

Smiley, Winkie, and Sassy, Peasant Pattern.

Her Diary

We begin in 1929 in Ventura, California, where Kay and Braden have taken up residence with their family. Braden worked at the Ventura Star as a reporter and advertising man from 1929 to 1932.

1929

July 19... (Visit to San Francisco) We visited the Park and the Art Gallery and Aquarium there. Enjoyed the huge exhibition of American Sculptors. It is all scattered out over the gardens in the Legion of Honor building. It is wonderful and very inspiring.

August 18... (Santa Monica) We drove Mother to the station stopping at the Art Gallery (Los Angeles) first.

1930

February 5... (Ventura) Feel tired. Wish I were studying sculpture or doing something of interest.

November 5... Entered Mr. Andrew Simon's sculpturing class (Santa Barbara) for 3 lessons a week for 5 weeks. $15.

November 10... Got up early. Took Peggy (Wirehair Terrier) and drove to Santa Barbara. The trip didn't seem so long as I traveled 45 and 55 per hour. Enjoyed the class a lot. Have a man posing nude in rather dumb pose.

November 12... Another day at school. Accomplished quite a lot. Mr. Simon said I worked fast.

November 16... Drove to Huntington galleries (San Marino) and enjoyed the exhibits immensely.

December 15... Enjoyed working so much and think the figure my best work, as we have carried it much farther than I'm accustomed to.

1931

January 2... (Written in Ventura about a visit to Memphis) Called by the Art school and told Miss MacIntyre of our western schools!

February 9... Went to art class at night school, but it's the bunk.

February 12... Braden made a cast of my face. It was plenty good after all the labor. Pouring wet plaster over one's face isn't so hot, but you can get used to it. Jake and Ella came and he made Ella's.

February 25... Went to Santa Barbara. Got clay and casts to work with. Came home and cleaned garage and made boards.[1]

February 26... Got Ella and rode out for more clay. Made a long table and fixed up garage for my class.

February 28... Made more boards. Inquired at St. Catherine's school for pupils. They said they would announce it.[2]

February 29... The class came along fine. The Roberts boys didn't show up but I had enough to keep me busy. The Staunton child has talent. Also H. Dunshee.

March 4... The sister at St. Catherine's school phoned that she had eight pupils for a class in clay modelling. I taught this afternoon and about 18 showed up. Some will drop out tho' they are very enthusiastic.

March 5... Mr. Simons loaned me his Caproni catalogue for plaster casts. Got clay.

March 6... I ordered six dollars of casts.

March 7... I'm making a cat in blocked style for my kids to copy. The Roberts boys didn't show up for class. I'll leave them alone.

March 9... My tools arrived from Santa Barbara.

March 11... Am very tired after a busy morning mixing 50 or 60 lbs. of clay. Braden helped me carry the box and clay to St. Catherine's. I will leave in an hour to teach my class.

March 23... Checks seemed to pour in for my teaching. I deposited $16 in bank after paying Braden back $15.

March 26... Finished the lion which I started for the class to copy. Pretty good class today, but am dead tired.

March 28... Class again today. I ended it a little early so I could get lunch and take the Sisters from St. Catherine's to Santa Barbara. They enjoyed it so much and I was glad to get them out.

April 6... It was great to be back at school in Santa Barbara. We have a young girl model in a sitting pose. Drove up there in 40 minutes and returned in 35.

April 7... Another day at school. I get pretty tired after 3 hours standing and the drive to and from Santa Barbara.

April 10... School again. Took George—he was good but pestered me to a frenzy. Braden came out to see me about 3:00 p.m.

April 13... Modelling class today. It's a hard pose to fool with.

April 14... Went to Santa Barbara. Will be glad when pose is over.

April 15... Tired after my class at St. Catherine's. Kids were bad.

April 16... Managed to get up and rush off to Santa Barbara. Finished the pose. Will take pictures of it next lesson.

April 17... Tried soap carving but it's too hard for me.

April 20... I decided to quit school at Santa Barbara. Too much work for me.

April 25... I managed to get in my class this morning before it rained.

April 27... Got my smock and resigned from class in sculpture. Mr. Simons nice about it.

April 29... Had class today at St. Catherine's.

May 2... Class is over.

May 6... Had modelling class after lunch.

May 9... Had class this a.m. in the garage as usual. Dorothy Staunton shows much talent.

May 13... Had a class at St. Catherine's.

May 16... A punk class. Just two students! They wanted to play all of the time.

May 20... Class today. They are making tiles and I'll have them fired.

May 23... I almost thought the girls weren't coming for class, but they were late.

June 11... Fixed exhibit in clay modelling class.

October 15... Have been so rushed this past month—My job keeps me busy (athletic supervisor at St. Catherine's)

1933

January 11... (Santa Paula) Moved to Santa Paula.[3]

February 10... Cabell born.[4]

March 10... Had a terrible earthquake last evening which killed 100 people in Long Beach.

1934

June 17... (Santa Paula) We are looking for property to build on. Fern Oak. We got our house plans from Roy Wilson. It is lovely and will be nice...anxious to have it started.

September 21... (Visiting in Memphis) Called at the Art School.

October 6... (Visiting in Chicago) Toured Marshall Fields, Art Institute and Fair.

October 8... (Memphis) At the Art School. Florence MacIntyre persuaded me to model in the afternoon. I got a good start and enjoyed it.

October 9... Art School for one hour. Frances started in Still Life class.

October 18... (Santa Paula) Modelled Perrito (Chihuahua) in p.m. He wiggles and is hard to "catch."

November 11... Met with the (Everett) Jacksons - he an artist, she society editor for the San Diego Union.

November 16... Am making vari-colored cocktail napkins for Xmas presents. Will block print them.

November 18... Finished ravelling the napkins and Braden stamped them. 32.

November 20... Modelled the dog. Papers all signed on our property.

November 30... Rode Smoky over here since I am modelling his head.

December 2... Modelled all p.m. Santa Barbara...got my horses. 7 for $4.

December 18... Finished up the book ends.[5]

December 19... Worked on our Xmas card and Braden printed them. Very cute. A family of Finch birds.

December 25... Braden gave me a lovely Douglas Shively picture. Surprised.

1935

January 15... (Santa Paula) Worked all morning on Cabell's life size statue.

January 19... Modelled all morning.

January 22... Worked steadily this morning on the fountain. It is getting along. Cabell doesn't pose much but goes around naked which helps some.

February 4... Modelled awhile but Cabby is so wiggly it is nerve-wracking.

February 12... I tried to model but everything seemed wrong and Cabell never kept still so gave it up.

February 16... Have done a lot on the fountain and seemed inspired more than ever.

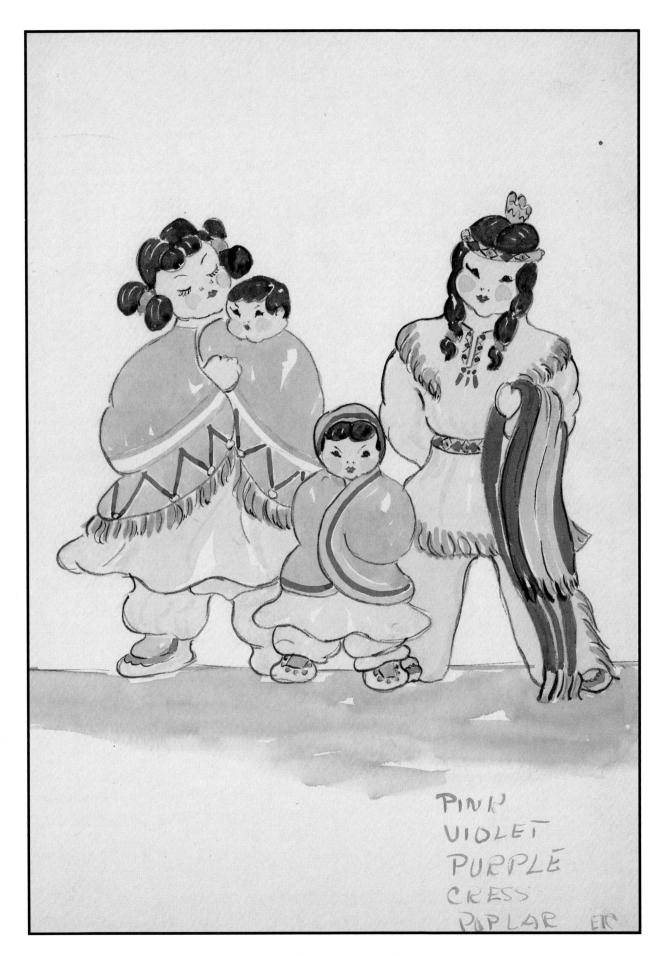

The American Indian Family.

February 25... Am not used to the steady work of cooking and washing dishes. Also modeling.

March 1... Modelled some.

March 2... Modelled all morning.

March 4... Worked all day long on my modelling. Accomplished lots.

March 7... I tried to model some but not in the mood.

March 11... Am getting along fine today with (Cabell's) expression.

March 15... Modelled all a.m. Seems I could work the rest of my life on it, but will try to finish it up as soon as possible.

March 20... Worked all day on the model. Was very tired but feel I am accomplishing a good piece. The turtle is finished and it adds lots to the whole.

March 23... Am finishing my statue. Have had several friends come see it. Mrs. Reddick's lending us her truck to carry it up in.

March 24... Got to Santa Barbara OK. May be able to sell my work. Mr. Von is delighted with it.

March 25... My work will cost $30 to cast for 2 of them.

April 4... To Santa Barbara to see the fountain. Not much work done on the casts. Think Mr. Von is full of bull! Glad I went though.

April 6... Spent all day in Santa Barbara. To Flower Show of Garden Club at Court House. My fountain was exhibited. Of course I didn't like the setting.

May 2... Have papers to read, modelling to do and writing.

May 4... Finished Skeezix's (Chihuahua) head and took it to Mr. Von. Will cast it for $3. Paid him $25 for the "baby" (Cabell statue).

May 20... Stopped in to see R. Reddick's art class at work.

August 21... Moved into new house

October 9... Heard Mrs. Botke's lecture.[6]

November 1... Planned to go to Santa Barbara for lunch and to see Botke's exhibit but brake on new car stuck so went to Ojai and Ventura.

November 17... Braden fixed up the clothes line and put out the fountain of Cabell.

November 19... Did a lot of modelling.

December 5... Just back from Santa Barbara... saw the Botke's exhibit.

1936

January 9... (Santa Paula) Art class at night. Enjoy that.

January 10... Will go to high school and see if the slip is dry in my mold.

January 12... Made a small horse.

January 13... Worked at high school pouring another mold.

January 15... Braden made Editor of the Santa Ana Journal.[7]

January 23... Enjoyed art class and am tickled over the glazing results of my modelling. Gave Sue a small horse. Starting a cocker spaniel pup.

February 5... C. Claberg came over and I modelled her pup.

February 9... Am modelling Wesley's colt.

February 13... I am modelling a lot.

February 25... Art class at night.

February 26... After a late start I left Santa Ana for Santa Paula. Took model along and travelled slowly so it wouldn't crack. Disappointed that I couldn't find man to cast it so left it at Chouinard Art School (Los Angeles) with a student.

March 10... Attended class and started a butter plate and cover.

March 12... Went to class.

March 27... Located a house to rent in Panorama Heights in Tustin near Santa Ana.

March 31... Went to art class.

April 11... Moved.

May 19... Frances went to Memphis.

August 20... Visited the Bird Farm, Pottery, and had a grand swim (Catalina).

August 30... To Pomona to visit Kellogg Ranch.

October 7... Modelling class tonight.

October 15... Spent afternoon and evening at art class. Modelling a tile and colt. Started a plaque for a portrait relief of George.

October 18... Modelled on some bells for Xmas presents.

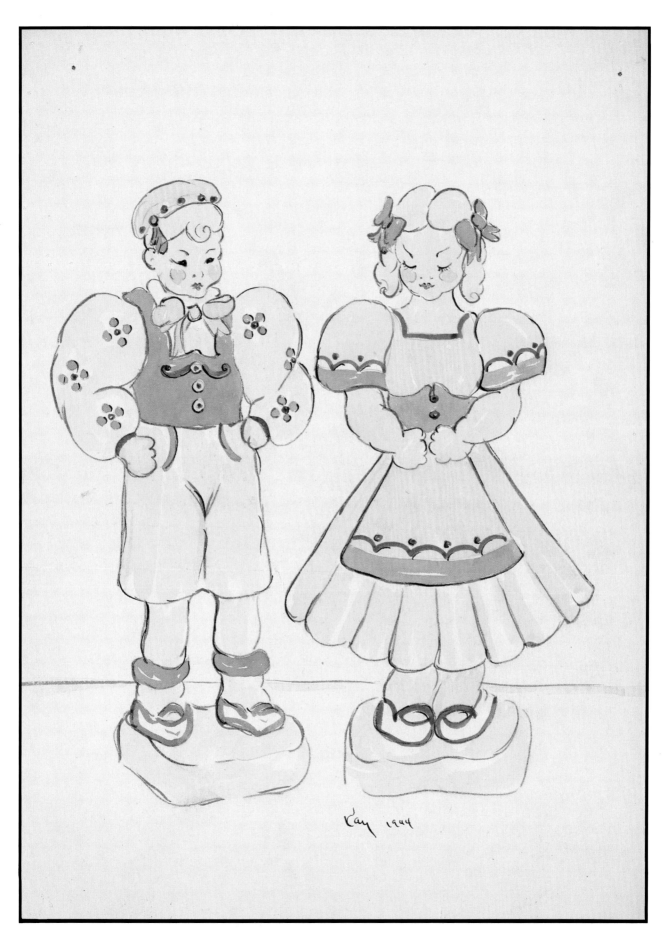

The Peasant Boy and Girl.

October 22... Registered for Junior College art course. Meets Monday, Wednesday, Friday. Think I'll enjoy it more than night school.

October 23... Going to class today—enjoyed the class. Am making a letter holder for Braden's desk...suggesting a dream he told me.

October 28... I made fine casting of the relief this p.m. So proud of it. Teacher was too.[8]

November 4... Art class.

November 6... Visited the high school art and pottery class. They have grand equipment. Class in p.m. Modelled after supper.

November 9... Spent all day modelling. Turned out terra cotta and clay casts of George's mold. High school has grand place to work.

November 16... Cast my "Peke." Very interesting work. Am anxious to see how well the mold is. Surely tired at night after a day of standing on my feet.

November 17... Was anxious to get to school and cast my cocker spaniel, which I did. Lots of work, tho'.

November 18... Hurried down to high school to see and glaze my pieces. Only one was broken. Ear came off. Worked hard at junior college art class too. Have 3 dogs to fire now.

November 23... (Santa Ana) Am spending 3 good days a week at art. Trying to get things ready for Christmas.

November 24... Am modelling a tile of 3 horses heads. Went to Laguna for a lecture. Dry.

November 25... Spent all p.m. at art. Accomplishing a lot.

November 26... Modelled all day.

December 1... Was successful in selling my dogs to Brayton Studio, Laguna, for $5 each, but got pinched for not stopping at stop sign.

December 3... Collected my first $10 ever earned! Poodle dogs not accepted.

December 7... Cast a dog and doll today. Plenty of work.

December 9... Paid a $6 fine this a.m. to Judge Mitchell. Cast the last dog. Things are easier now. Brought home all my animals.

1937

January 11... (Santa Ana) Stayed home. Modelled some and read.

January 13... Went to art class and cast a plaque of horses heads. Reading "Heads and Tails" by Malvina Hoffman.

January 20... Delivered some figures to be fired at high school.

January 31... Modelling a Clydesdale horse. Ran out of clay but have a good start.

February 1... Worked at high school on glazing. Took ages to register for 2nd term junior college course. Visited the Stinson Horse Farm. Will model over there tomorrow. Gorgeous animals. Belgians.[9]

February 2... Mr. & Mrs. Stinson were very nice to offer any of the horses I wanted to pose. He has his champion trained to do tricks. He weighs only 2300 lbs. or so! Surely got tired after working so steadily.

February 3... The year-old horse is a dandy to hold still. Hope I have good luck with him.

February 4... After going to high school and finding the kiln wasn't fired account of gas leakage, I drove to Stinson's and modelled. Feel like I'm getting somewhere now.

February 5... Had to change a tire today before I could go to school. Am sending a relief of the horses heads to L.A. to be electroplated for fun. Made slip and poured a mold. Cindy Griffith sent home my doll. It turned out very well.[10]

February 8... Worked all day at my art...Some of my dogs turned out pretty well. Brought several home.

February 9... Too windy to work and Braden took my car with modelling tools in it anyway.

February 10... Expect to go to Stinson's and finish my horse. Will take Betty her dogs I promised her.

February 12... Worked all morning on the horse. Brought him home. Everyone seems to think it is OK. Have more work on it, tho'. I like it.

February 15... No sale on my horse. In fact, my trip to Laguna was discouraging. Costs too much to have things fired at Rembrandt's Pottery, too. So will be content to practice along at the high school kiln. Learn more anyway.

February 16... Got some of my things from high school. The gun metal dog is perfect.

March 8... Worked at high school glazing. Have an idea my things will be all cracked, etc. next time I see them.

March 21... We drove through Santiago Canyon to Capistrano where we visited the Mission... Returned via Laguna... have an order to make a "burro."

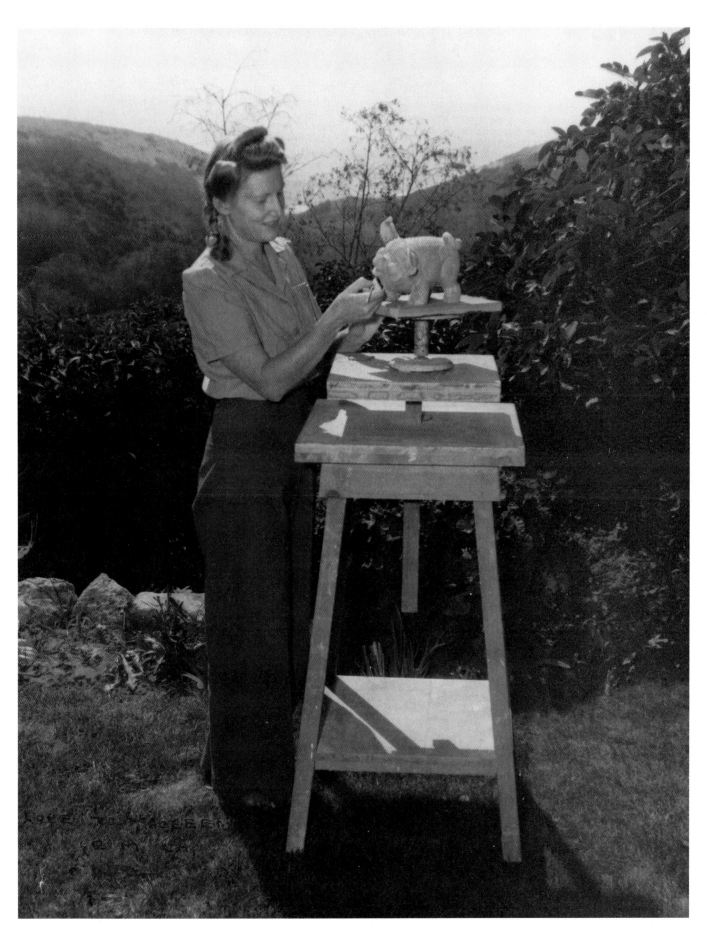

Here's Kay making the clay model of *Smiley* outside her studio. Circa 1941. *Courtesy Finch Estate.*

March 30... Finished two donkeys for Rembrandt's studio and took them down to Laguna. He liked the big one and I'm glad as I like the little one! Will cast it. Busy as a bee.

April 4... Stayed home all day modelling.

April 5... Using new slip to make the French poodles. Much better and stronger. Went to high school and class.

April 6... Took clay things to Laguna. Will work up a little business and learn things at the pottery.

April 7... Will exhibit a few of my things at P.T.A. Parents' Day.

April 8... Dashed to school to cast the horse. Had an accident which keeps it from being a perfect job and am anxious to see just how the casting turns out.

April 9... Padua tonight. Taking Frances. Have a donkey for Donald Button who is interested in ceramics and runs an art column for Journal.

April 10... Made a good approach at selling my modelling. The Shop of the Open Window (Laguna) will handle them.

April 11... Will cast another horse.

April 12... After getting home from class and music lessons, had a nice surprise and invitation to lunch and talk with Mr. Manker and D. Button at Padua Hills next Monday. They may want some of my work![11]

April 13... Turned out another horse. Not as good as last week's.

April 17... Will turn out another horse and take some things to Dudley studio to fire.

April 19... Lunched at Padua Hills with William Manker, ceramist. He liked my work but suggests more modern treatment. Offers 1/3 profit!

April 20... Starting new models. Hope they suit. Library for Roy Harris' exhibit. Will get one of his drawings as present.

April 21... To Laguna. Glazed some of my donkeys at Rembrandt's. Like the man in charge. He's fair enough to let me putter around.

April 23... Did a little glazing at high school. Hope my animals are successful in firing. School until 3:30. Will model figures in Mr. Manker's style.

April 24... Bright idea. Braden and I and children are going to write a story titled "Petey the Donkey." Cute beginning and should be fine if Harris illustrates it.

April 25... Laguna...Got my things from kiln. Look darling. Am so proud.

April 26... Stayed home and made a mold for new style donkey. Will need more molds if we sell as many as I have hopes of doing along with Petey story.

April 29... Got my donkeys and came home.

May 2... I modelled. Sent two donkeys to Barker Brothers. Hoping for orders! We'll see—

May 5... Worked all day modelling. Have about finished the horse. Hope Manker likes it. Braden thinks it's great.

May 6... Grand day in City (Los Angeles). Elsie Revill drove me and two high school girls up to see Ceramic exhibit, also Pacific Pottery. Very fascinating and interesting.

May 10... Letter from D. Button saying to plan on entering something at Laguna Beach Art Gallery for June 1st. Worked at high school and Laguna. Haven't gotten a large horse yet.

May 11... High school to glaze. Helped unload kiln. Learning every day. Can't keep track of all the donkeys! Made red slip which should be interesting to do with. Called Manker.

May 12... Expect to take new style horse to Claremont to show Manker. Wonder if he will like it...Am I delighted! He likes the horse and says it's swell! Must finish it now. My Chinese blue and purple horse came out fine.

May 13... Worked fast and accomplished gobs! Modelled all day and here it's 9 p.m. Just stopped.

May 14... Glazed 42 burros. Got home almost 4:30. Tired out.

May 15... Barker Brothers wrote saying they wanted the two donkeys but didn't order any more. Cast a small colt.

May 16... Am through working on Mr. Manker's horse. Looks pretty good and should be swell glazed. Went to Laguna with family and got two of my horses and they look keen. One I'll keep for exhibition. Am so happy over it. Worked on doll too.

May 18... Donald Button and I had grand luck on our venture to Barker Brothers. Sold 2 pair large horses and 12 donkeys! So thrilled. $24.40. We visited 12 galleries and improved our Art appreciation considerable.

May 19... Am trying to get horses done before I leave for Santa Paula. Brought home 42 donkeys. Swell luck in firing.

May 21... Taking the Chinese blue horse to Santa Paula.

May 26... School in a.m. Drew the kiln and helped stack it for bisque.

May 30... We all slept half a day. Two nights in a row up till 2 a.m. tells on you when my age. Started a dog and horse for Rembrandt's.

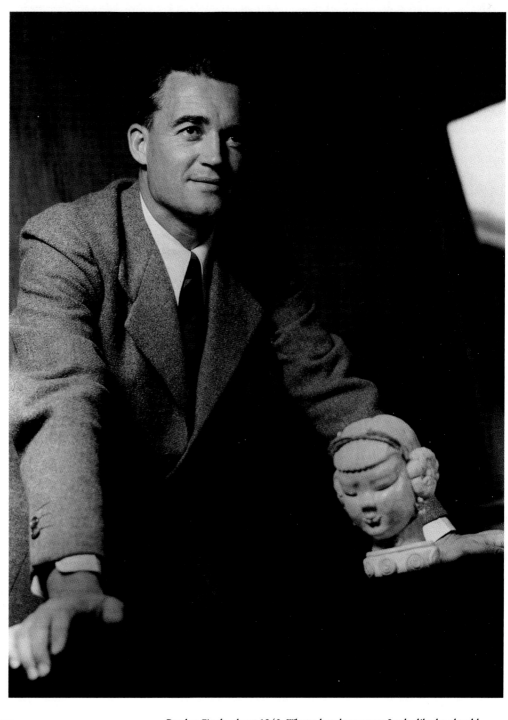

Braden Finch, about 1940. What a handsome guy. Looks like he should have been in the movies with Bogart and Flynn. Note the *Chinese Princess* head that was always on his desk. *Courtesy Finch Estate.*

Kay named this horse *Equus*. It was in her personal collection and might well be the one referred to in this diary entry. *Courtesy Finch Estate.*

June 1... Horses not ready for Barker's order. Potters can certainly delay one. Will take children to school and start in early at high school.

June 2... Modelled.

June 3... Must go to Claremont again to change a few things on horse for Manker. Hope he finally gets satisfied! Glad I went and made the changes on the horse.

June 6... Caught up on my modelling.

June 7... Worked at high school all a.m. glazing. Have learned lots this semester.

June 9... Worked at high school all a.m.

June 16... Mailed horses to Barker's.

June 17... Got the things from high school's last fire. Large horse is lovely. White transparent. Put my things in window at Smith's. Had a swell sign made for the exhibit.

June 19... Stopped by Barker's and saw my things. Priced 50% higher.

June 20... Spent last night at Maude's. Lovely time. Botkes were dinner guests. All raved over my work.

June 21... Starting U.S.C. summer course with Glenn Lukens. Should be very promising.[12]

June 23... Had breakfast in bed as I have to leave for school. I don't want to work too hard. Swell class. Should learn lots.

June 25... Got back from U.S.C. about 1/2 hour before guests arrived.

June 26... Am anxious to start another piece for my class work—started a cute model of donkeys playing. After Ray Harris' drawing.

June 28... Took Frances and George to L.A. Museum while I went to school. Lukens liked my donkey study and laughed. Learning a lot. Check from Barker's came. Must move by July 15. (From Panorama Heights, Tustin to Santa Ana.)

June 29... Lecture with Mary King at U.S.C., Eddie Minnis of Vanderbilt.

June 30... Got to U.S.C. in time to work a little. Met Jean Goodwin who teaches there and I will offer her transportation. Nice girl and talented.[13]

July 3... Padua Hills. Met the Botkes and Hinckleys on time and had a lovely evening. Dropped in to see Mr. Manker. He never mentioned my horse.

July 9... School today. Long old trip.

July 25... Haven't had the energy to write in this book after a week of moving, painting, etc.

July 26... Went to school. Good day in class.

July 28... We had fine time in Santa Paula at Sue's. Left about 10 a.m. Stopped in L.A. to shop a few minutes then Dad took me to school. Brought home my work which pleased the folks.

July 30... ...then to school. Mr. Lukens wound up the class nicely.

July 31... Feel rather shaky this a.m. to know there's no more class at U.S.C. Is a nice feeling as I've been doing too much lately for my own good.

September 23... Worked on my modelling and started to cast the model of Tony (Wirehaired Fox Terrier). Hard work.

September 24... Cast the dog I modelled from Tony.

October 15... Had Ray Harris to supper...doing so cleverly with the story.

November 3... Worked at high school glazing for first time this term. Heard from Manker. He has horses cast.

November 6... Drove to Padua Hills and worked on four horses which Manker finally cast. Met Merrell Gage.

November 24... Sold some things at the junior college art tea. Mrs. Moulton bought a blue horse.

November 25... Modelled a little.

December 13... Worked at high school glazing.

December 17... Am constantly modelling. Sent some things to Laguna for last firing.

1938

January 10... (Santa Ana) Mixed two batches of new clay bodies.

January 11... Am mailing a colt, donkey, and bulldog to Mrs. Clint Hall, 225 Fifth Avenue, NY (agent) as samples to see if she can sell any.

February 18... Did some glazing at school.

February 22... The firing was terrible this time. Not hot enough. One dog which I needed for an entry is OK after being crackled.

February 23... Braden and I took models to L.A. Museum for Exhibition.

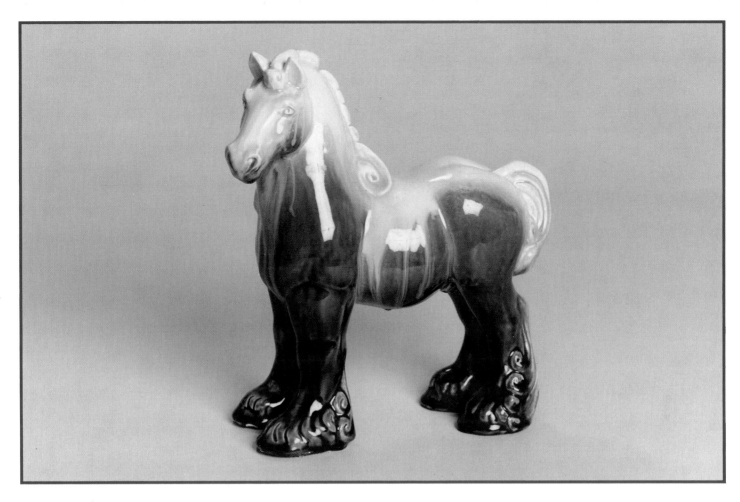

Authors' Note: This "Equus" is signed "Kay Finch '37" inside of one foot. Another foot is signed with his provenance… "Equus No.1". He—or a twin brother— was selected for the prestigious "First California Ceramic Exhibition" at the Los Angeles Museum in March, 1938. Equus was on the cover of the program along with two other pieces—a bowl by Laura Andreson and a vase by Beatrice Wood. Other ceramists of note in this show were Sorca Boru, Jean Goodwin, Roger Hollenbeck, Glen Lukens, William Manker, and Myrton Purkiss. Impressed? We were. *Authors' Collection.*

February 24… Modelled in a.m.

April 4… Modelled and went to school. Received El Paso paper with account and pictures of my work.

April 16… Just about a year ago Mr. Manker seemed interested in my work. Today he sent me 6 little rabbits which he bought from me and had copyrighted.

April 17… Had swell time last night at Stevens'. Was lucky in cards and sold them 6 dogs for table prizes. Glad they appreciate my models.

April 22… Drove up to Mankers—modelled all day. He wants the dog I'm doing. Gave criticism on the colt. Must finish it soon.

April 23… Didn't do anything except fix up my pottery notes in order.

May 4… Received another order from San Diego Museum for "Equus" (no.19). Lucky number at $12.50 each! May be another order this week too.

May 5… Completed mold of new colt yesterday.

May 10… Spent day at Padua modelling. Think I could earn a living at that job if necessary.

Mid-May—
mid-November… Around-the-world trip.

Authors' Note: This was the basic turning point in Kay's career. While in Santa Ana, Kay and Braden had converted an old milking shed into a studio where they installed a small, second-hand, hand-fired kiln purchased for thirty-eight dollars. We return, again, to the *El Paso Times* to quote the 1942 article:

"Mrs. Finch was soon producing a variety of hand-decorated ceramics that won praise from all who saw them. A buyer from Bullock's Wilshire store in Los Angeles contracted for her entire output, with the result that she was in business almost before she realized it. Braden Finch then decided to resign from

the Santa Ana Journal and go into the ceramics business. Knowing little of production methods, he and Mrs. Finch stopped everything to take a six-month world tour studying and inspecting the ancient centers of ceramic art in Japan, China, India, France, and other European countries."

November 18… I accepted a position with Ferne Irwin in her new decorator's shop. Not too confining and a chance to sell my work—also model in shop.[13]

November 19… Braden went to Manker's and brought some bowls and my horses which created some admiration. Will try to make up the angels with Braden's help so we can have some in the shop for Xmas.

November 21… Braden is helping me turn out enough angels for Mr. Manker to fire in small kiln. I worked at the shop in the afternoon.

November 25… Phoned Mr. Manker who says he'll glaze the angels for 20 or 25 cents. Very good.

December 17… Have sold so many angels! Only have a few of Manker's left! Will have more Tuesday. The shop is doing good business.

December 19… Will work this p.m. at shop.

1939

February 9… (Santa Ana) Am so busy with working in the shop. Modelling on the Chinese garden piece (a commission) and small figurines.

Although Kay's diary ends here, what came next is basically the dawn of a new era in creativity and productivity.

1. Boards for modelling clay.
2. Private parochial school (attended by Frances) where Kay wanted to teach classes in clay modelling.
3. City where Braden became editor of the *Santa Paula Chronicle* (1933-35. A Scripps-Howard paper).
4. Cabell Braden Finch, third child.
5. "Head," horses," "bookends"—all cast figurines gave as Christmas presents.
6. Jesse Arms Botke, famous painter.
7. Organized as competition for the *Santa Ana Register* (now *Orange County Register*) by Scripps-Howard.
8. A bas-relief of son George's head profile.
9. Models for Kay's Work Horses/Percherons.
10. Cindy (Lucinda) Griffin was the ceramics teacher at Santa Ana High School. Her father was famous Laguna Beach landscape painter William Griffith.
11. William Manker, celebrated ceramist and instructor at Scripps College. Also had a gallery.
12. Glen Lukens, nationally known ceramist who established a full-time department of ceramics at the University of Southern California in 1933. Lukens espoused creation and modelling through press-molding rather than through the use of the potter's wheel.
13. Ferne Irwin's gift boutique in Santa Ana also carried ceramic vessels produced by William Manker, as well as Orrefors Glass, and Andersen Pewter.

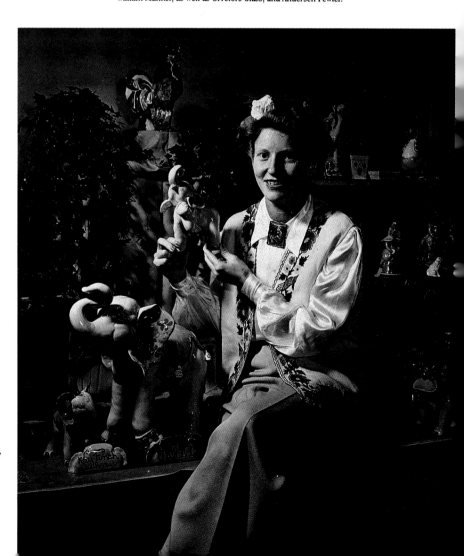

Kay in a rare shot with her elephant family. We'd pay dearly to get that "Violet" sign in front of her largest pachyderm. Circa 1942. *Courtesy Finch Estate.*

Her Productive Years
(1939-1962)

It didn't take long to outgrow the thirty-eight dollar, second-hand kiln that Kay bought to eliminate those long drives to the high-school and to Laguna Beach to fire her creations. It was time to move onward—and upward.

Kay and Braden had the wherewithal in 1939 to acquire a two-lot parcel and build a small studio on a bluff overlooking the Pacific Ocean in a suburb of Newport Beach, California—Corona del Mar. And Kay Finch Ceramics was born at 344 Hazel Drive on the lot next to their home.

Braden assumed the lion's share of administrative duties, which left Kay free to pursue her creative endeavors while working with the decorators. They even found their first agent, a Los Angeles man by the name of Dick Knox, who also represented William Manker, the brothers Climes (known as Will-George), and La Mirada Pottery. They were off and running. Of course their modest beginnings were not without close scrutiny from their peers. Braden, who did most of the leg work in the door-to-door merchant sales arena, once said: "Our newspaper friends came around to tease us about our cow-shed factory. It was a laugh for all of us for a time, but as my work progressed, I realized that Kay, with her artistic genius, and I, as the fortunate husband who was willing to wear my shoes out, *had* something. It's the dream of two ambitious workers come true."

Well, when you're hot, you're hot. Orders came in so rapidly that a large kiln was ordered to replace the first one. Just one year later, in 1941, an even larger one had to be built. The handful of employees were working at a frenetic pace. World War II had begun. Imports were cut off. Demand for American ceramics skyrocketed. Kay of course would never consider sacrificing her quality or reducing the amount of hand decoration on her wares to meet the demand. So she and Braden went first class, expanding the existing facility to the status of a major production studio and showroom, locating to the 3901 Pacific Coast Highway address. It was dubbed the first modern ceramics studio on the West Coast.

The aforementioned 1942 article in the *El Paso Times* described it this way:

"Located on the high bluffs overlooking the Pacific, glass enclosed on three sides and surrounded by well-kept flower gardens and velvet lawns, it is one of the show places of that area."

"The late Alfred Schultz, Braden Finch's brother-in-law and graduate engineer of Purdue University, then joined the firm and designed a 100-foot tunnel kiln in which cold pieces are placed at one end of a conveyor belt, emerging some 12 hours later after being heated to hundreds of degrees. This and other modern methods increased production to the point where some 65 employees are required to operate the plant which supplies dealers in all parts of the United States and 19 foreign countries. Mrs. Finch herself continues to mold the original models of the ceramic figures, and from these originals, molds are made into which the clay is poured by assistants. After the clay is dried and painted the figures are run through the kiln, taking from 12 to 24 hours passing through extreme heat. After this first kiln treatment, the figures are dipped in glaze and run through the kiln again."

"Her chemist father, Franklin H. Seamon, also assisted in the development of some of the pastel glazes which distinguish all Kay Finch ceramics. Kay Finch's work combines fine modeling and originality with a sure knowledge of glaze and color. Every piece is freehand painted, many enchantingly decorated with flowers and all featuring somehow, somewhere, that distinctive, whimsical touch apparent in every Kay Finch ceramic."

"Among the hundreds of fascinating ceramic personalities created by Kay Finch, there is not one note of somberness or of the grotesque. Her lovable creations delight at first glance. Kittens, dogs, chickens, animals of every kind—Chinese maidens, Godey figures, vases and even luncheon ware, each with infinite charm and attraction, are included in several hundred items regularly carried in stock. Kay Finch Ceramics, in a few short years has become a national fad. Many of her pieces are seen in movie sets, and form backgrounds and decorative accents in national fashion and home decorating magazines. One chubby, winsome piggy bank may be seen in the current issue of Vogue."

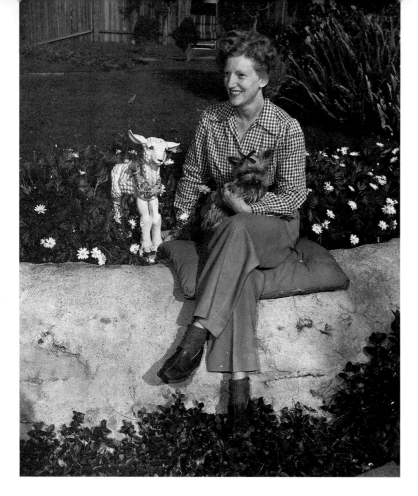

Another great shot of Kay with two of her favorites: Petit Point (her Yorky) and her 20" *Life Size Lamb*. Circa 1943. *Courtesy Finch Estate.*

You can tell from a review of the faces and attitudes in old company photographs that Kay Finch Ceramics was a great place to work. Many of her decorators were the wives of servicemen overseas. The location just oozed creativity. In fact, an eager journalist from the *Balboa Bay Blade*, after an interview with Braden once reported, and we quote:

"The Great American Novel could be written in Braden Finch's factory office. Glass-enclosed on three sides, with a view of the vast Pacific Ocean, surrounded by flower gardens and well-kept lawns, a person would have to be a complete moron if he couldn't get inspiration there. The same may be said of the whole plant, from the room where the molds are made...through the various factory departments, to the handsomely appointed display room, where samples of the finest ceramics the world knows are displayed for buyers from the four points of the compass."

Now is as good a time as any to address Kay and Braden's design, production, marketing, and distribution standards, as they played an ever increasing role in the continuing success of the company.

Number 1: Kay Finch Ceramics were labor-intensive. Multiple firings, hand modeling, hand painting/decorating, hand trimming (Kay's daughter Frances worked for the firm as a trimmer and remembers the meticulous process), careful handling and shipping in post production—all factors that affect the eventual cost and retail price of the product. They also affect the quality and desirability of the product. However, Kay's people were paid by the hour, not by the piece, so the integrity of those standards was never challenged.

Number 2: Kay Finch Ceramics were therefore...expensive. Many of Kay's popular pieces like Biddy (the hen) and Butch (the rooster) were retailing for $6.25 a pair. Grumpy and Smiley Pig were $4.00 each. Grandpa Pig and Violet Elephant were $22.50 each. Harriet, the 21 inch rabbit was $75.00. And the limited edition Chinese Princess was $750.00. Serious money in those days, when the average weekly income was about $50.

Number 3: Kay and Braden quickly outgrew their original West Coast representation, aligning themselves with a broader base of regional/national (New York, Chicago, Dallas, Atlanta, Los Angeles, Miami) ceramic sales organizations. These agents came equipped with high-tech showrooms and the clientele to move Kay Finch Ceramics into fine quality gift shops, and the gift departments of the most exclusive stores—Marshall Field & Company, Neiman Marcus, Saks Fifth Avenue, and the Biltmore Galleries.

By 1947, Kay Finch Ceramics employed nearly seventy people and Kay's creations could be found in over 2,000 such establishments in nineteen countries worldwide. Not bad for a devoted mother of three who, less than a decade before, had said to an interviewer from *The Western Woman*:

"...As my children grew older, I found more free time, and the old urge to work in clay came back with new strength. I began to model and glaze, with my saddle horse Smoky and my dogs as models, just for fun. Then friends began to ask for duplicates. Soon people even wanted to buy them. Then sales agents offered to take over my work and almost before I knew it I was in business for myself."

Number 4: Kay trained and supervised all of her artisans. She obviously couldn't decorate each piece herself. But each piece was a reflection of her high standards, so if the decorating didn't pass her critical inspection, it never reached the kiln for firing. Plus, all of the formulas—clays, pigments, paints, and glazes—were not only designed to her specifications, but also mixed and tested on-premise before application.

Number 5: Her clays came from Tennessee and Kentucky and were blended with a West Coast product called California Talc. The result was a durable, lightweight mixture that would move easily into every mold crevice, capturing the most minute details.

Number 6: Nearly all of her pieces were decorated and finished with a product called slip. Slip is a mixture of clay and pigment which, when fired, adds relief and dimension to the areas where it is applied. Slip is difficult to apply because it's thick, but it adds a look and feel to the end-product that is without peer. Another unusual characteristic of slip is that it changes color during the firing process. Which means the artists had to learn to paint in abstract colors to achieve the desired post-firing result.

Authors' Note: Like Majolica, Dresden, or Cut Glass, Kay's ceramics were contact sensitive. They required delicate handling during cleaning, moving, or examination. The slightest bump or 'clink' against another hard surface caused glaze flaking or worse yet, breakage. The more complicated the piece, the more likely the imperfection. So if you're going to collect Kay's work, plan on having examples that are imperfect. We have several, and love them for their artistic merit, not for their condition.

Number 7: To appreciate the philosophy that propelled the good ship Finch, you need to hear some direct quotes from the principals:

From Kay...

"Everyone should develop his own particular style and individuality. Then try and reach as high a standard as possible."

"The art of the future will not be one of extremisms. Instead it will be a simplified and decorative treatment of the objects we like to have about us."

From Braden...

"Our people are right for this kind of work—they are creative people, and the atmosphere is happy."

"The ingredients for success are a sound product, a sound technical process, a sound sales and distribution policy, and hard, hard work."

Simple but eloquent concepts like these are the main reason Kay Finch Ceramics survived and prospered. Especially at the end of World War II when the flood gates opened and inexpensive Japanese and European imports poured back into the United States.

This excerpt from a 1946 article in *Giftwares* Magazine told it like it was:

"...The increasing demand for California ceramics is tribute to native artists like Mrs. Finch, whose talent and progressive ideas have given new artistic significance to one of the most ancient arts."

"...During the war, when retailers had to have something to fill their shelves, the demand for ceramic products hit an all-time high. Many amateurs, who never would have done so under normal circumstances, went into the business. Everyone who had an idea, an inclination, and the backing to buy a kiln started a ceramics factory and cashed in. Clay skunks, clay replicas of baby bottles with flowers planted in them, tiny clay reproductions of furniture, and a thousand other gimcracks sold fast and high."

"Of course, there was a day of reckoning. The giftware market fell apart early this year and it was probably a beneficial calamity for the whole industry. A few manufacturers had maintained quality, but many had taken advantage of the boom market by making junk. Now they're back in their backyards with a hobby instead of a business."

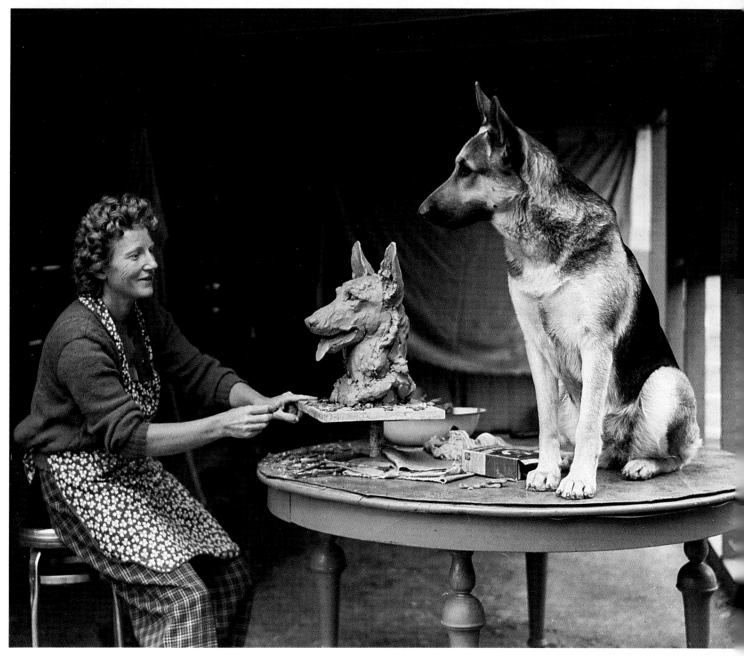

Kay is modelling a bust of a German Shepard bitch named "Grail", who belonged to her friend, Joan Ludwig. Circa 1949. This was later cast in bronze. *Courtesy Finch Estate*.

Her Canine World

Kay's experience as a nationally known breeder and dog show judge, and her obvious love for all breeds of canines, became the catalyst for a spectacular series of sculptures aptly named *The Dog Show*. Unlike most of her other works which seem to reflect a recurring whimsical style, Kay's dogs adopt a more realistic character. But she did exhibit a few flights of fancy with some of her glazes on the large Cocker, *Vicki*, the Pomeranian, *Mitzi,* and the Pekinese.

Dealers in dog collectibles have known about the desirability of her work for years. The demand for Kay Finch dogs has been equal to or greater than the demand for porcelain pieces produced by Edward Marshall Boehm or limited editions by Royal Doulton.

This may well account for the scarcity factor in finding dogs available for sale. We had been collecting Kay's work for over a year before we uncovered our first example, an eight-inch Cocker. Admittedly, we have been fortunate enough to acquire a number of superb pieces. But there are still more dog figurines on our "Want List" than any other animal, bird, sea creature, or person.

For the record, Kay was an Afghan hound breeder of renown. She established Crown Crest Kennels, registered with the American Kennel Club, in 1945. By 1957, she had produced *three* of the all-time Top Ten winners. Her dogs won over sixty-nine Best In Show awards for Crown Crest. Many of her breedings went on to become champions in other countries, having been placed with families world-wide.

After Braden's death, she became a licensed American Kennel Club judge, always in demand, not only in the United States, but in many capitols throughout the world. But Kay's creative genius was not content to lie fallow, as she continued to design and produce canine bronzes for friends and clients.

When Kay's dog, TaeJon, won three consecutive Best of Breed awards at the prestigious Westminster Kennel Club Dog Show, she created this sculpture, complete with medallion (opposite page), the back of which reads "Born May 12, 1950." TaeJon measures 17½", and graced Kay's home for decades after his creation (Unique). *Authors' Collection.*

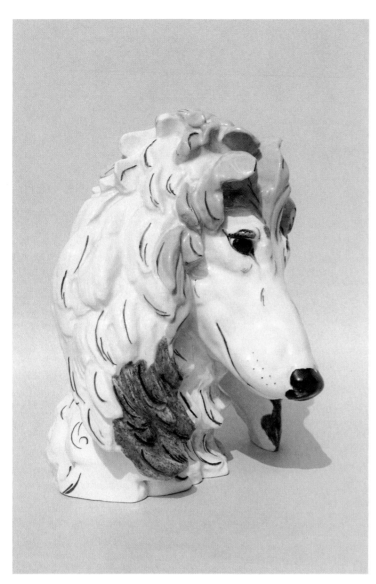

This Afghan, whose name is *Banu* (#476), is quite rare. He measures 12" tall, and judging from the catalog photos, also came with an optional ceramic base that resembled a dog collar with a heart-shaped design ($1500-1750). *Sharlene Beckwith Collection.*

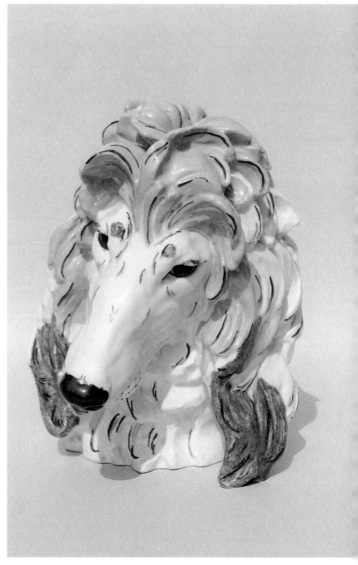

Below: *Windblown Afghan* (#5757) in a pewter-like glaze, 6" x 6" ($350-450). *Joan Letterly Collection.*

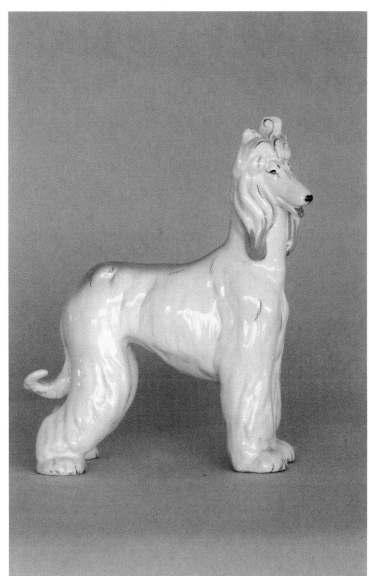

This *Standing Afghan* (#5016) was made by Kay to match the colors of friend Joan Letterly's dog, Nefertiti. 6" x 5". *Joan Letterly Collection.*

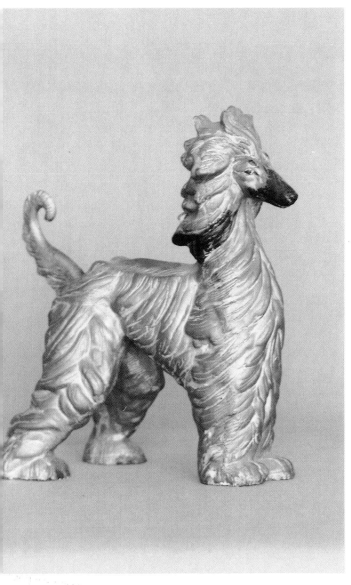

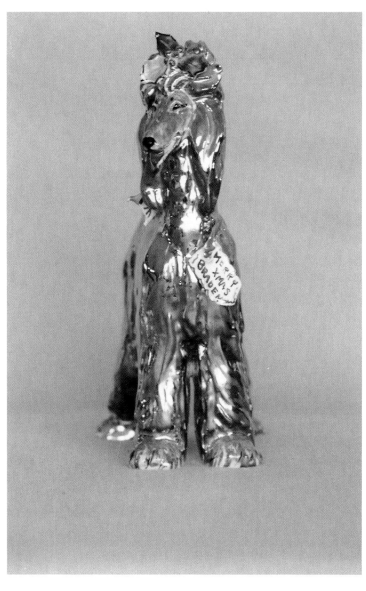

This silver example of the *Standing Afghan* (#5016) was made by Kay as a Christmas gift for her husband Braden in 1949. 6" x 5". (Unique). *Joan Letterly Collection.*

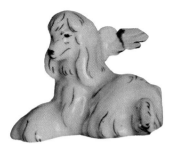

The reclining *Angel Afghan* (#4964) seems to be the most elusive of the three shapes ($400-450). *Joan Letterly Collection.*

Three Afghans: *Romping* (#5554), 5" x 6", *Standing* (#5016), 7", and *Afghan Stein*, 7" (#5458). $400-500 each. *Authors' Collection.*

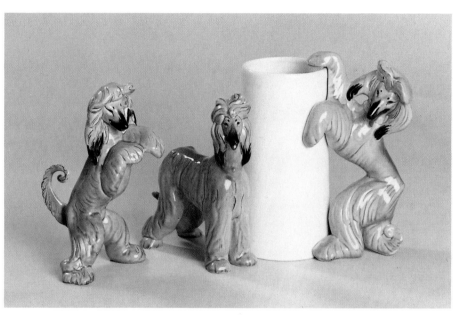

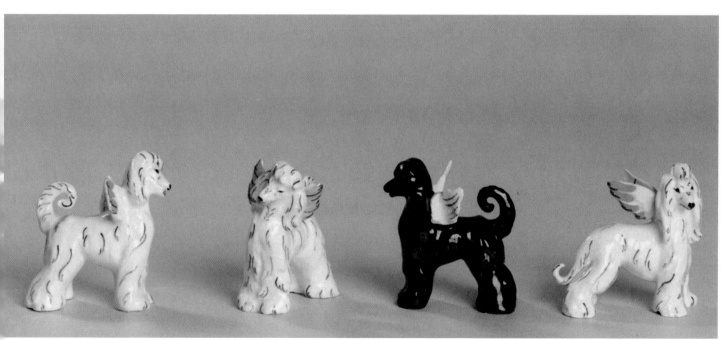

Kay created the miniature 2½" x 2½" *Afghan Angels* as an extension of her philosophy: "If dogs can't go to heaven, I don't want to be there either!" Shown are different views of shape numbers 4911 and 4963. The black one is extremely rare. $350-400 each. *Authors' Collection.*

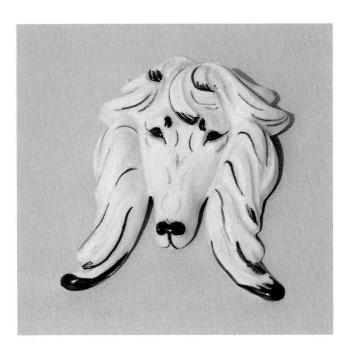

Ceramic Kay Finch jewelry is extremely rare. She made both a Cocker Spaniel and an Afghan head into a pin or tie-slide. The white Afghan (*Sharlene Beckwith Collection*) and the tan Afghan (*Kaye & David Porter Collection*) were made as pins, measure 2" x 3", and are catalog number 5081 ($300-350).

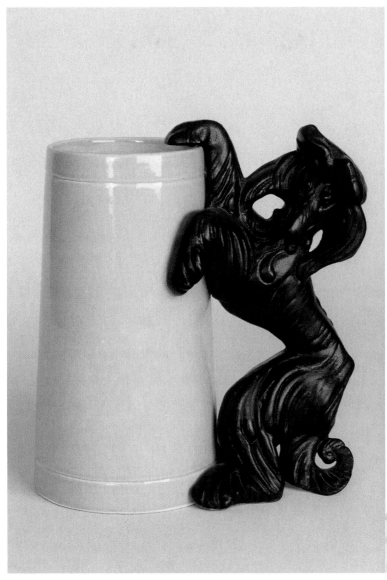

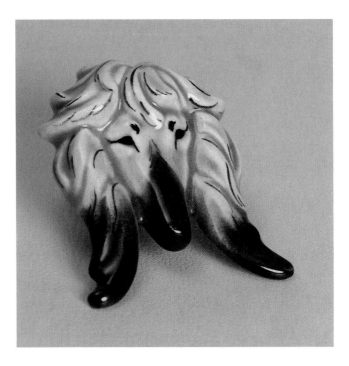

Another *Afghan Stein* (#5458), 7", with a rare matte black glaze on the dog ($400-500). *Kaye & David Porter Collection.*

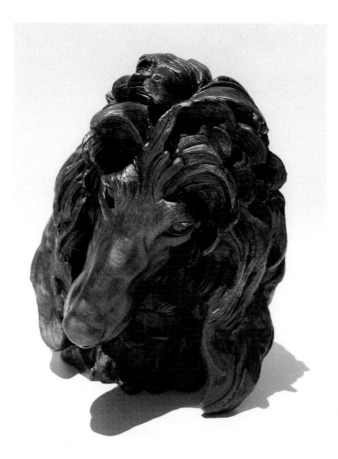

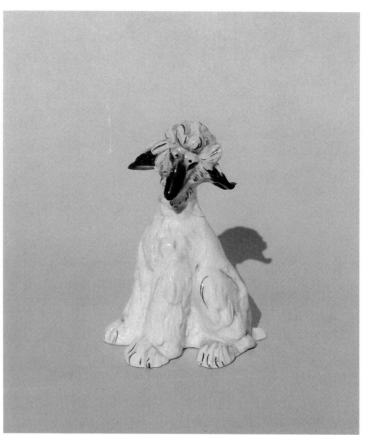

The 12" *Banu* Afghan head was also cast in bronze. The detail is startlingly realistic ($2000-2500). *Courtesy Finch Estate.*

A *Sitting Afghan* (#5553), measuring 5¼", is another example from Kay's elusive *Playful Pups* series ($400-475). *Dorothy Lombard Collection.*

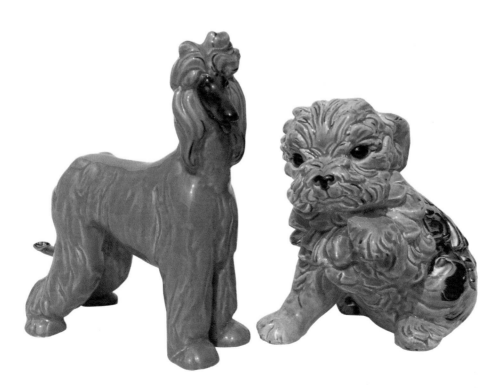

This *Afghan* (#5016) has a unique caramel color with a black face. It stands next to a *Yorky Pup* (#171) in a rare caramel and silver/black glaze. $350-400 each. *Sharlene Beckwith Collection.*

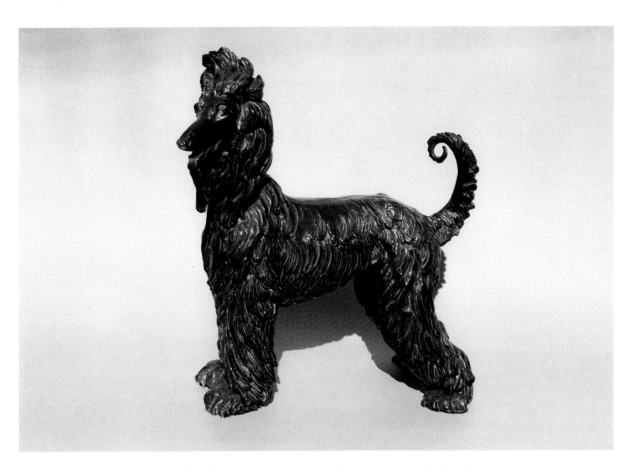

Rudiki (#5082) is the name of this Afghan. He stands 13" tall and was produced in a variety of glossy gold, silver, and hand-decorated colors. Shown here are a forest green finish ($500-600) and the identical dog cast in bronze ($2000-2500). *Courtesy Finch Estate.*

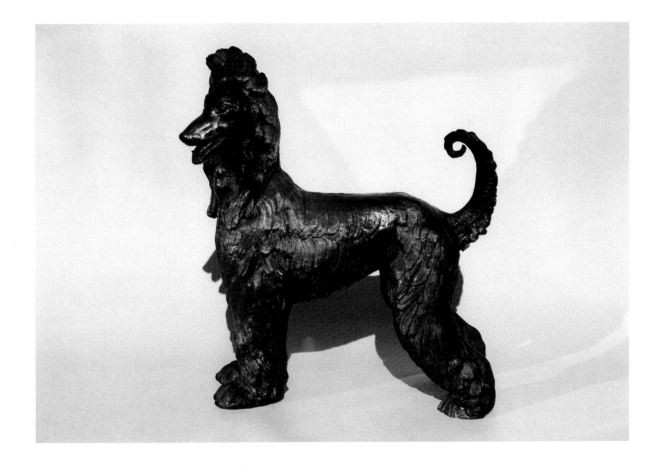

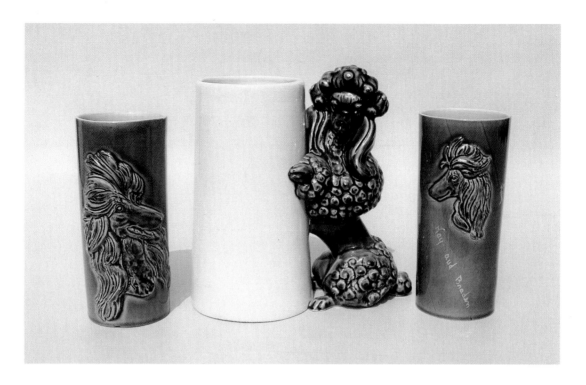

These six-inch tumblers with an embossed Afghan design are marked "Kay and Braden" ($200-250). They surround another *Stein* (#5458) with attached Poodle ($350-450). These steins were also available with Dachshunds and Scotties. *Sharlene Beckwith Collection.*

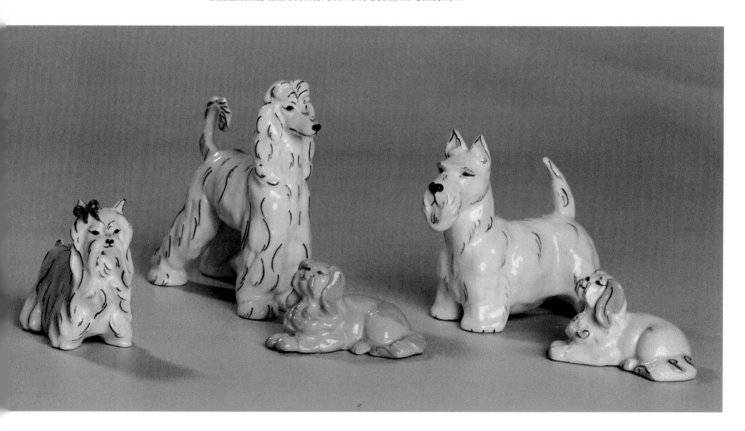

In this grouping of canines we have the *Dog Show Yorkshire* (#4851, $100-125), 2½" x 3"; the *Afghan* (#4830, $250-300), 4" x 4½"; a miniature *Pekinese* (#156, $100-125), 1½" x 3"; the *Dog Show Westie* (#4833, $200-250); and another *Peke* in a different glaze. *Authors' Collection.*

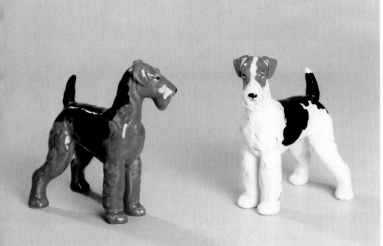

This handsome *Dog Show Boxer* (#5025) stands 5" tall and 5" long ($350-400). *Sharlene Beckwith Collection.*

The *Dog Show Airedale* (#4832) traditionally comes in a caramel and black glaze. But when you change his colors, he also looks like a Wire-haired Terrier. 5" x 5" ($300-350). *Authors' Collection.*

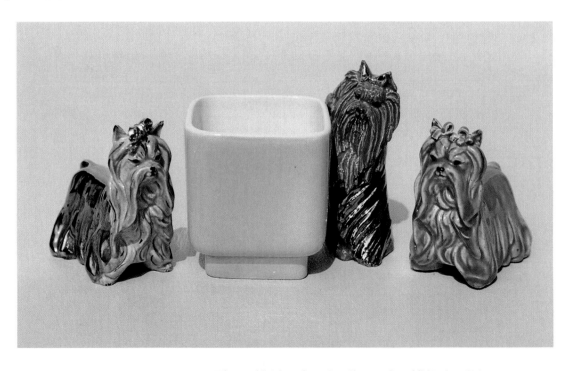

Who wouldn't love these *Dog Show Yorkies* (#4851) with their unique caramel and silver/black accent. The rare standing Yorky planter is 3½" tall. $300-400 each. *Sharlene Beckwith Collection.*

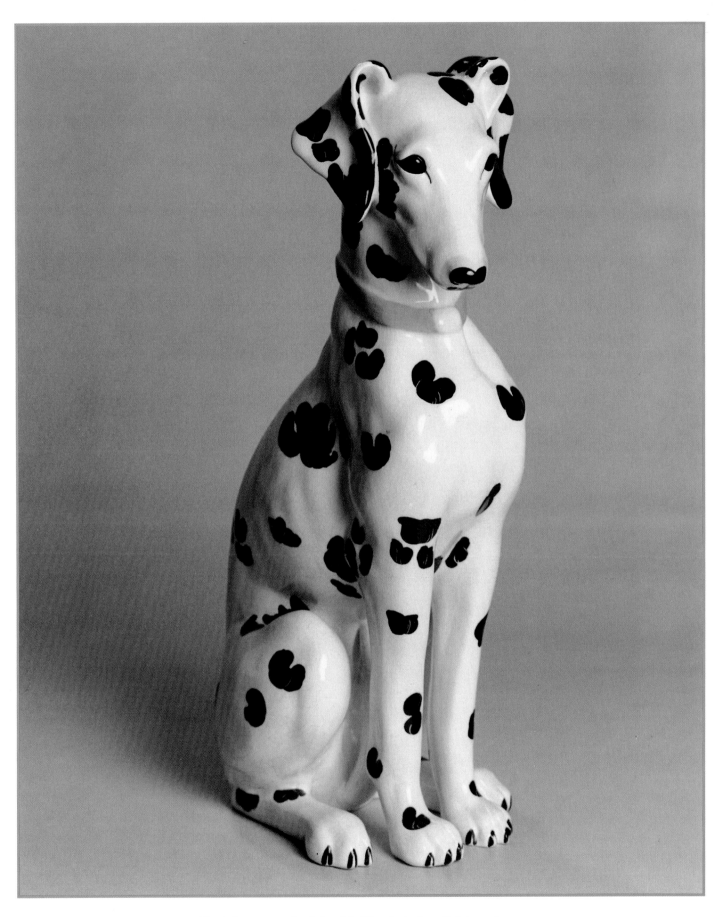

The *Dalmatian*, or *Coach Dog* (#159) as he is also called, is another majestic tribute to Kay's skillful hands. He stands 17" tall and looks so real you can almost hear the fire engines ($2000-2500). *Authors' Collection*.

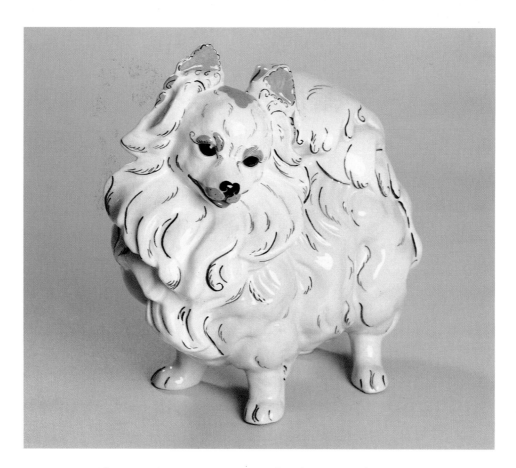

These rare *Mitzi* Pomeranians are two of our favorites. But then, we're partial because we have two real Poms ourselves. They're #465 in the catalog and measure 10" x 10". The ivory and black version had been in Kay's personal collection and wears a small ceramic crown which she designed. $1000-1200 each. *Authors' Collection.*

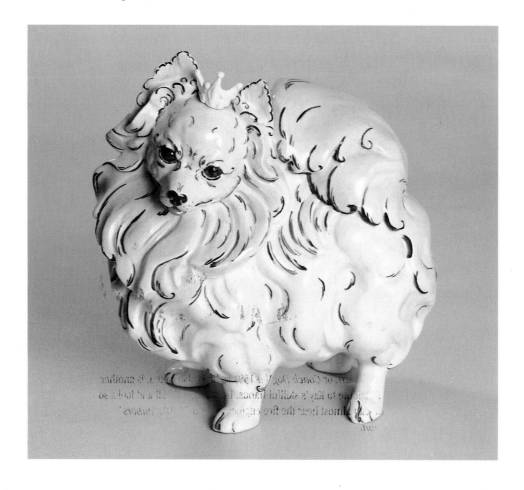

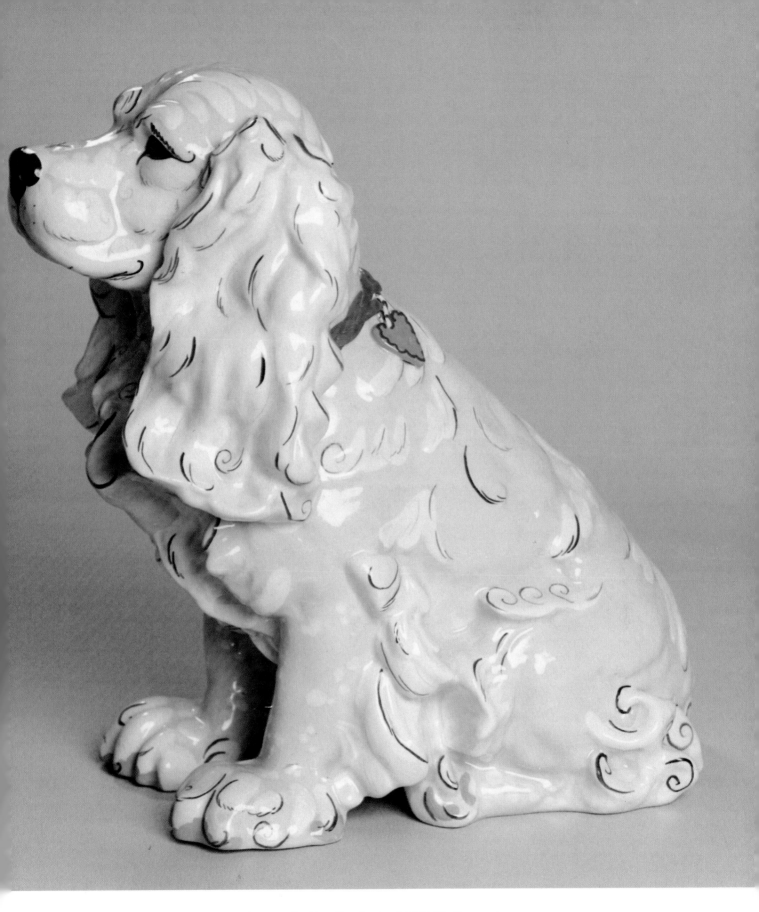

Meet *Vicki*, Kay's adorable 11" Cocker Spaniel (#455). She must have loved this dog, because we know it was produced in at least six different glaze variations. The little ceramic heart attached to the dog's collar was another nice touch. These little decorative extras are part of what makes Kay's work so desirable ($750-850). *Authors' Collection.*

Vicki in black ($850-950). *Authors' Collection.*

Vicki in pink and white with gold accents ($750-850). *Courtesy Ron & Juvelyn Nickel.*

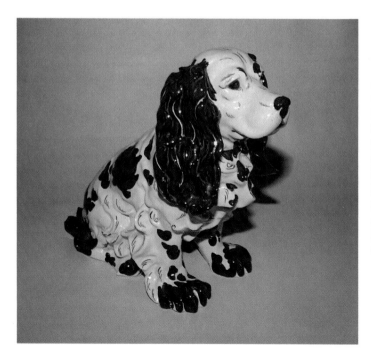

Vicki in black and white ($850-950). *Authors' Collection.*

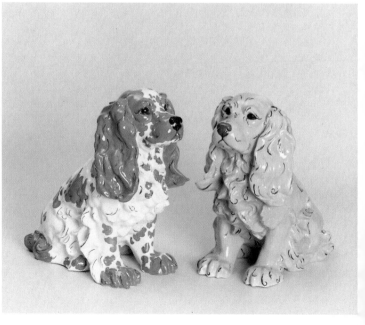

Vicki in caramel and white, and natural buff ($800-900). *Authors' Collection.*

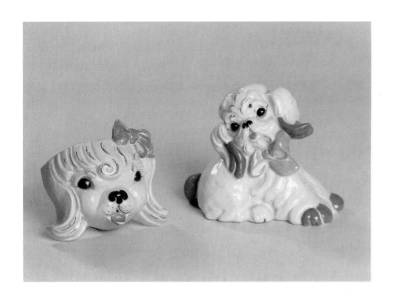

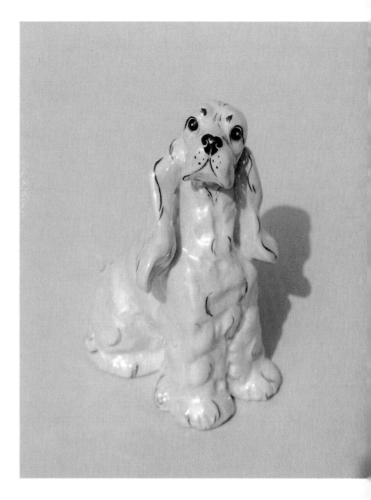

Stringholder collectors, pay attention. The dog on the left (4½" x 4") was made to hang on the wall and dispense string through its mouth. (We've not found a catalog or price list reference for him, $350-400.) And the fella on the right is named *Doggie* (#5301). He measures 4½" x 5½". Kay offered it as a figurine or a bank ($400-500 figurine, add $75 for the bank). *Authors' Collection.*

These Cockers were also well represented in Kay's canine repertoire. Here we see three glaze variations of Kay's 8" sitting *Cocker* (#5201, $350-450); two glaze variations of her standing *Dog Show Cocker* (#5003, $250-350), 3½" x 4½"; and a nice example of her 4½" sitting *Cocker* (#5260, $250-350), in black and white. *Authors' Collection.*

Another 4½" *Cocker* (#5260) in an attractive pearlized white glaze ($300-375). *Sharlene Beckwith Collection.*

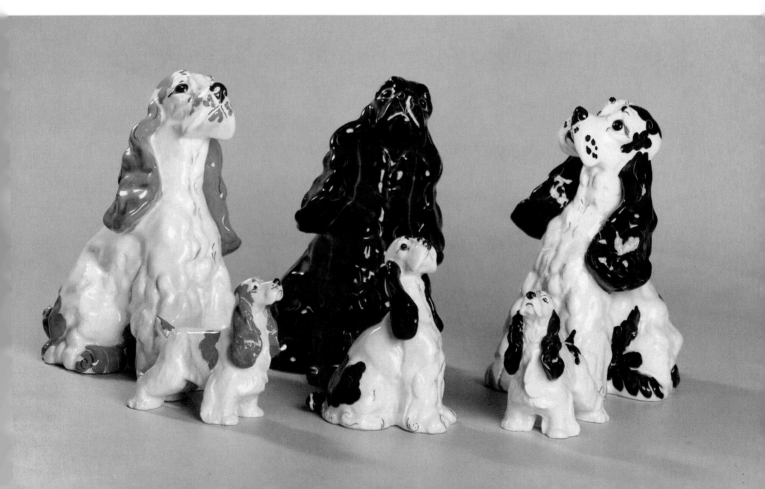

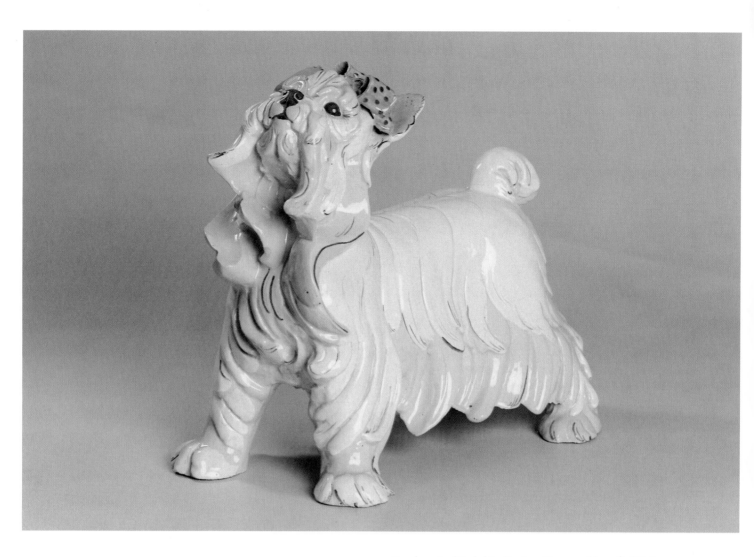

Kay also raised Yorkshire Terriers. Her superbly crafted Yorky mom, *Puddin'* (#158), is on nearly everyone's want list. She measures 11" x 12" and is very fragile ($2000-2500). *Authors' Collection.*

The gold and platinum glaze on this *Puddin'* is both rare and breathtaking ($1500-2000). *Kaye & David Porter Collection.*

This Yorky tea tile is 5½" square and has a hanging hole in back ($75-95). *Authors' Collection.*

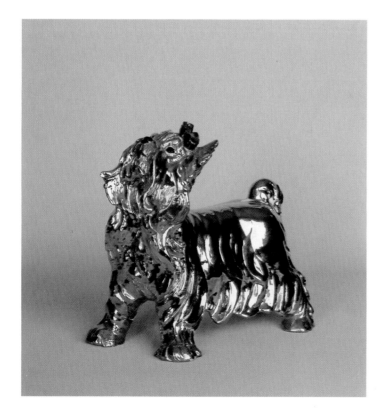

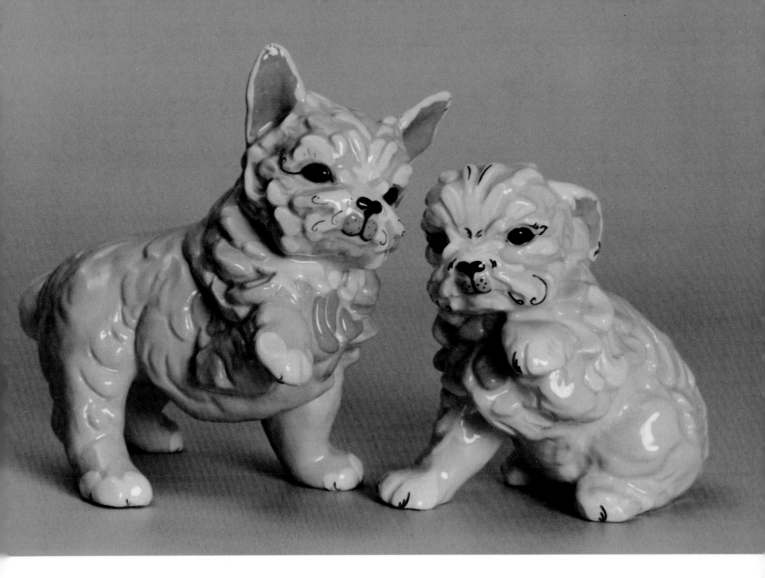

Kay's *Yorky Pups* (#170 & #171) are two of her more popular
creations. Measuring 7" and 5½" tall, they are seldom found as pairs
today. Their raised-paw stance makes them very "tipsy" and subject to
breakage. $500-600 for the pair. *Authors' Collection.*

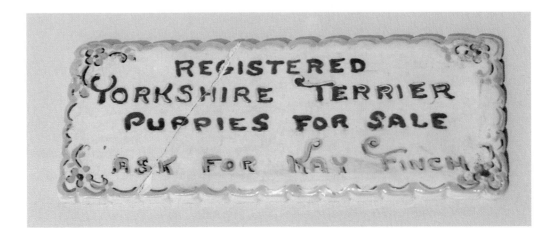

This plaque was Kay's subtle but lovely ceramic sign advertising her pups.
It measures 6¾" x 2½" and was "rescued" during an estate sale at the
studio ($700-800). *Sharlene Beckwith Collection.*

The *Pekinese* (#154) would look like the real McCoy were it not for his Kay Finch trademark colors: pink, mauve, white, and black. He's an amazing 14" long and packed with personality ($600-700). *Authors' Collection.*

Introducing the *Shaker Pup* (#4617), designed for use as a kitchen shaker. Six inches tall, he was also produced as a figurine *and* a very rare cookie jar, which, so far, we've been unable to locate but is pictured in an archival photo in the chapter "Her Scrapbook" ($350-425). *Authors' Collection.*

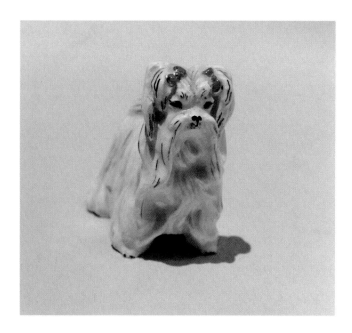

This elusive *Dog Show Maltese* (#5833) proves bigger isn't always better. She's only 2½" tall($250-300). *Courtesy Finch Estate.*

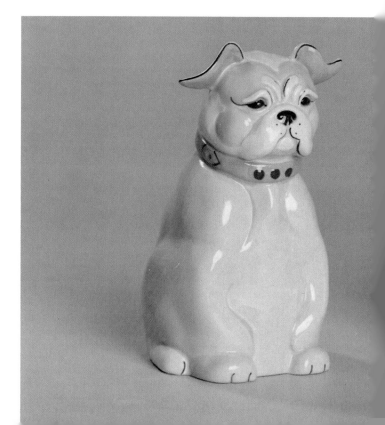

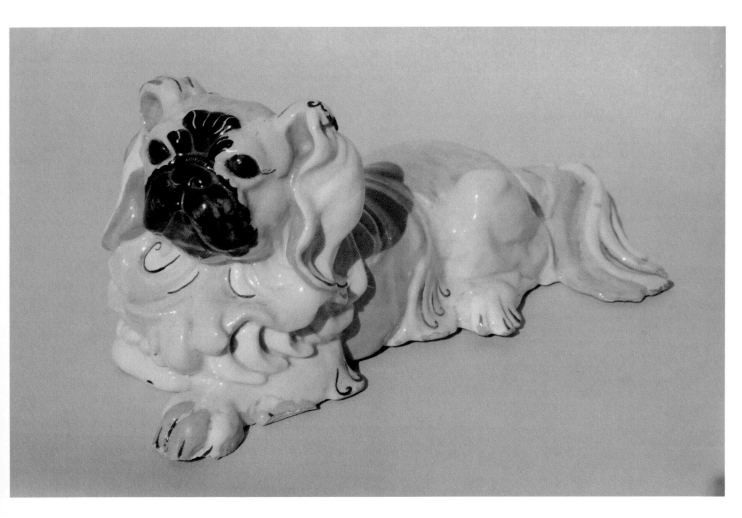

Here's *Peke* again with an interesting black treatment done at the studio by decorator Dorothy Lombard ($600-700). *Dorothy Lombard Collection.*

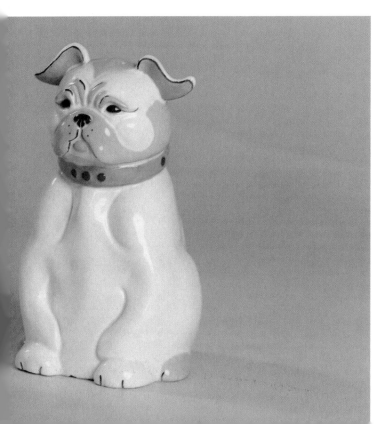

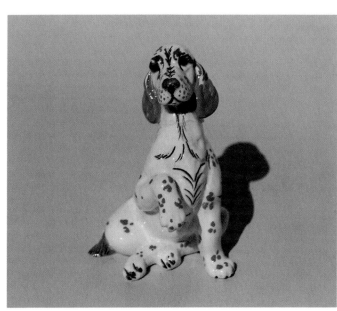

This 4" Setter pup done in 1953 has no catalog reference. ($300-375). *Courtesy Finch Estate.*

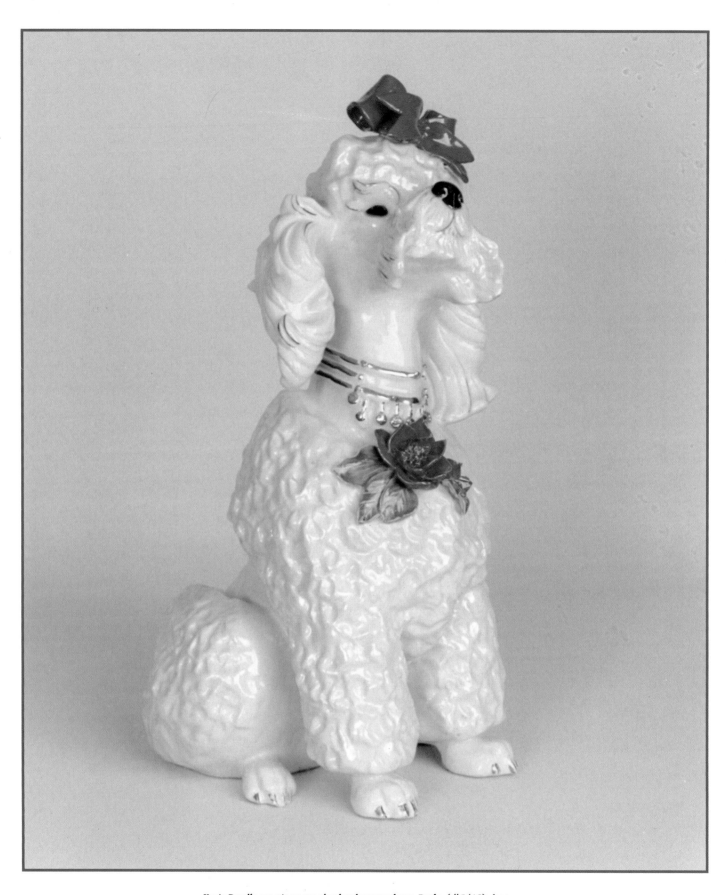

Kay's Poodle creations are absolutely marvelous. *Perky* (#5419), her largest at 16" tall, is to die for. Fragile bows and floral appliqués add a crowning touch to this ceramic beauty. Her retail price was $50 in the mid-fifties, so production had to be limited ($2000-2500). *Kaye & David Porter Collection.*

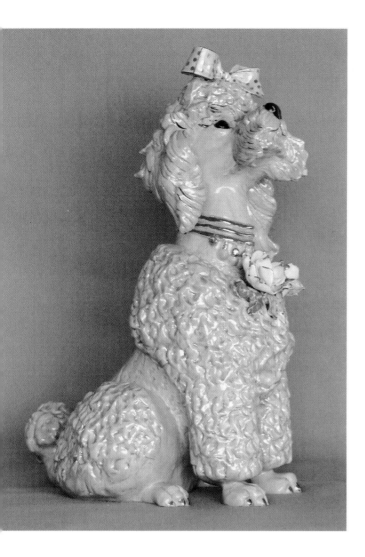

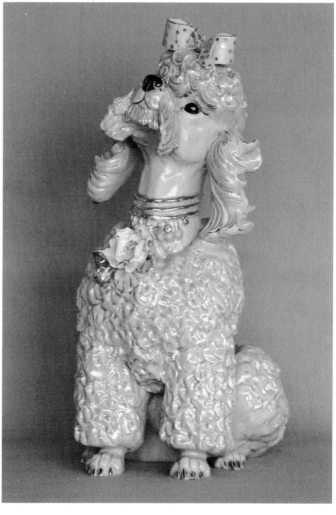

This pearlized example of *Perky* sat by Kay's bedroom door for decades.
Joan Letterly Collection.

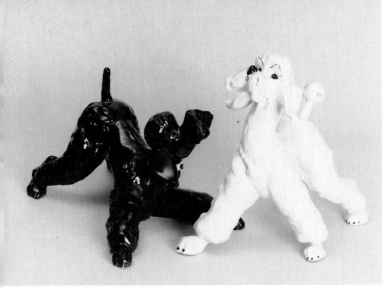

Appropriately named, these are Kay's *Playful Poodles*. The dog on the left (#5204, $400-500) is 7" x 11", and his standing companion (#5203, $500-600) is 10" x 11". The black glaze is rather rare ($550-650). These pooches usually surface in white, pearlized white, or pearlized grey. *Authors' Collection.*

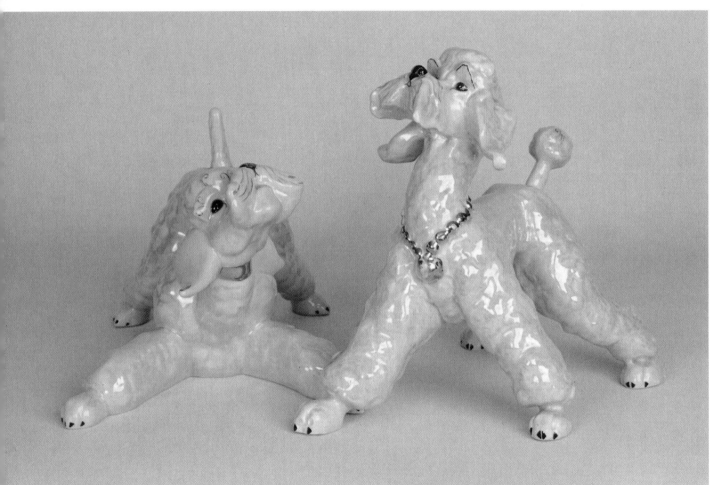

This pearlized grey pair are richly accented in gold. Also, the standing version seems particularly hard to locate in *any* glaze. *Kaye & David Porter Collection.*

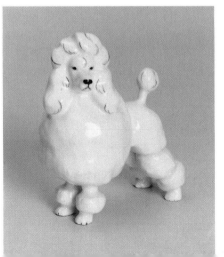

This is Kay's *Dog Show Poodle* (#5024), 5" x 4½" ($350-450). *Authors' Collection.*

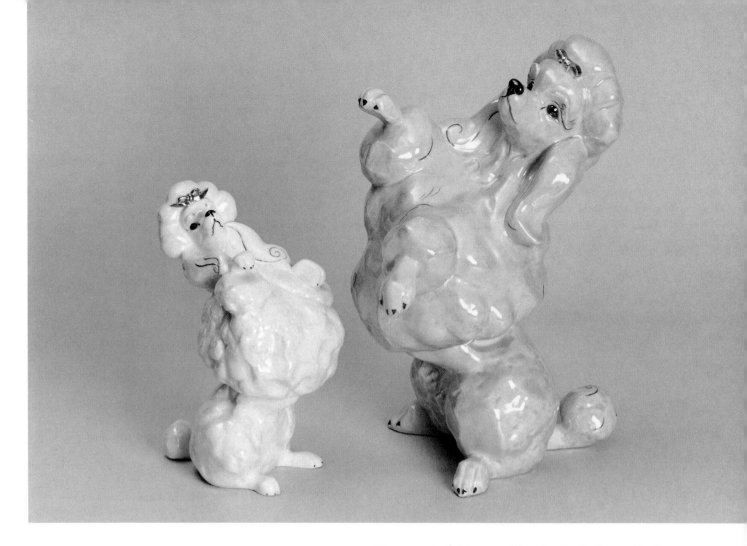

It's no surprise that Kay named these two Poodles *Beggar*. The *Beggar* on the left (#5262, $500-600) is 8" tall and his bigger brother (#5261, $1000-1200) stands 12" tall. *Authors' Collection.*

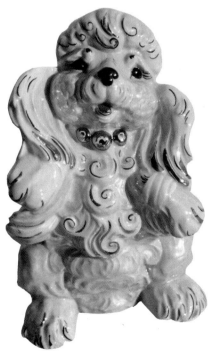

The next Poodle, called *Doggie with Silver Bell* (#5001), is 7½" tall and cute as a button. He also comes with small holes beside his ears where a real silver bell can be attached ($500-600). *Courtesy Ron & Juvelyn Nickel.*

Kay's square ashtray/plaques ($50-75 each) had a dual purpose: on the table or on the wall. The sizes are 4¾" (#4955); 7¾" (#5332); and 5¾" (#5331). *Authors' Collection.*

Kay introduced this stylized 6" tall *Long-eared Dog* (#5926) in 1959. He is done in a brown matte finish ($150-175). *Kaye & David Porter Collection.*

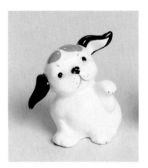

Last, but not least, is a cute little miniature mutt, *Junior,* done in three colors, measuring just 2" tall ($100-125). *Authors' Collection.*

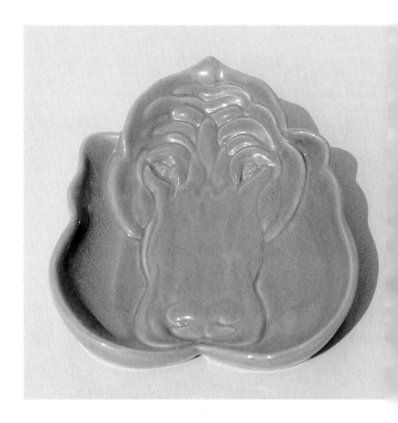

Kay produced a series of six dog-head ashtrays. This *Bloodhound* (#4773) measures 6½" x 6½" ($65-75). *Sharlene Beckwith Collection.*

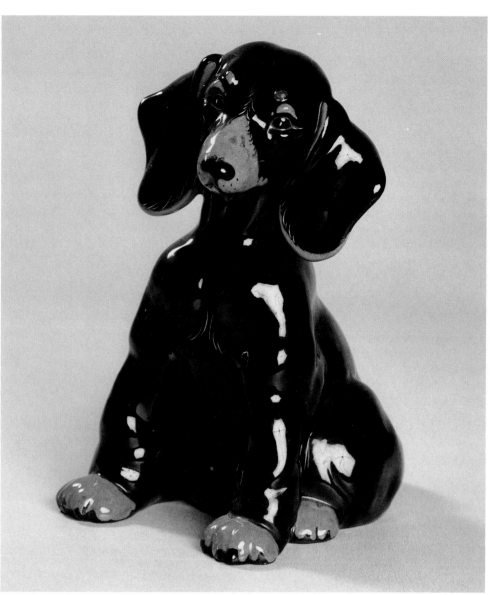

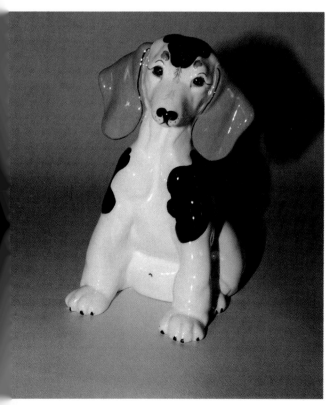

Here's a dog worth adopting. An 8" *Dachshund Pup* (#5320) whose eyes would make you melt. The one on the left is in natural colors. The one on the right in 'Heinz 57' colors. ($600-700 each.) *Authors' Collection.*

This is a publicity shot of Braden, circa 1950. *Courtesy Finch Estate.*

Her Feline World

Cat lovers…beware! This clowder of clever, creative, charming, captivating critters can cause cravings choosy cat collectors can't control. Clearly, Kay has outdone herself. From the smallest two-inch cat to the tallest eighteen-inch cat, the Kay Finch Cat Family will make you purr for more.

Her glazes here are predominantly pastels. Among the rarest is the Cookie Jar—*Cookie Puss.* In conversations with several cookie jar collectors (a few boasting several hundred jars), none of them had ever seen one for sale or in another collection.

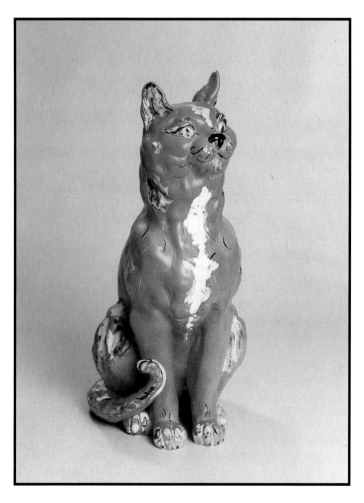

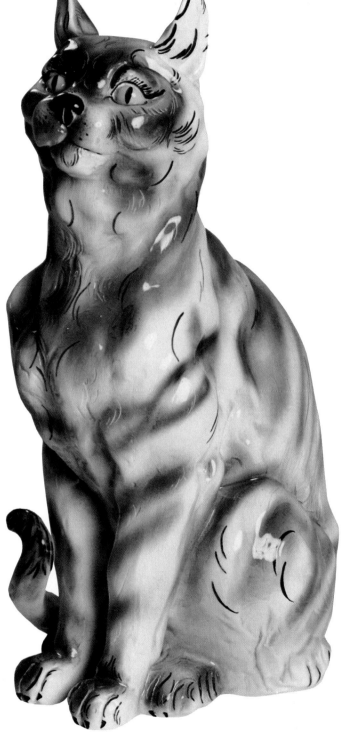

Kay's most majestic cat, *Mr. Tom*, is 18" tall and, according to Frances Finch Webb, was created and produced in *very* limited quantities in 1960. This pair has two totally different glazes. Both lived with Kay at her studio in Corona del Mar before moving to Michigan ($1500-2000). *Authors' Collection.*

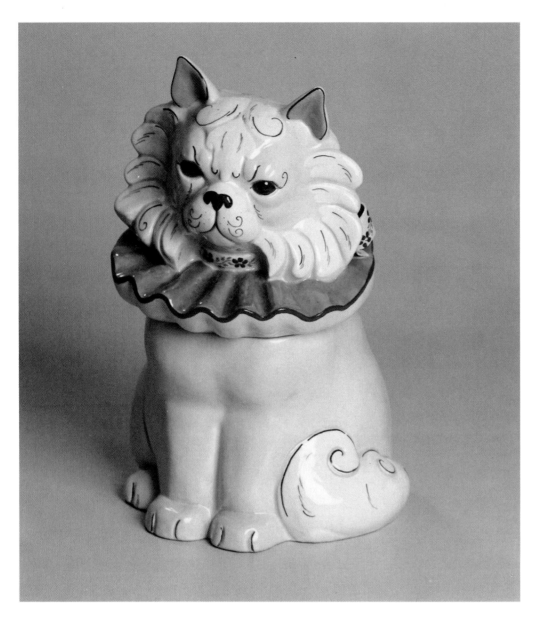

Number Two on Kay's Feline Hit Parade has to be her extremely rare 11¾" tall cookie jar...*Cookie Puss* (#4614, $2000-2500). *Authors' Collection.*

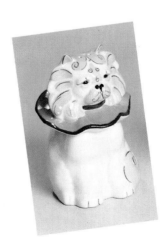 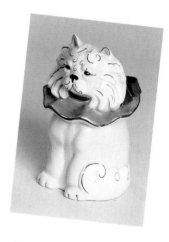

Her 6" kitchen shaker *Puss* (#4616), the homemaker's companion to the cookie jar, comes in two distinct color variations: grey/white or pink/white, with the collar color complementing the basic tones. We have also seen her without shaker holes as a decorative figurine ($350-425). *Authors' Collection.*

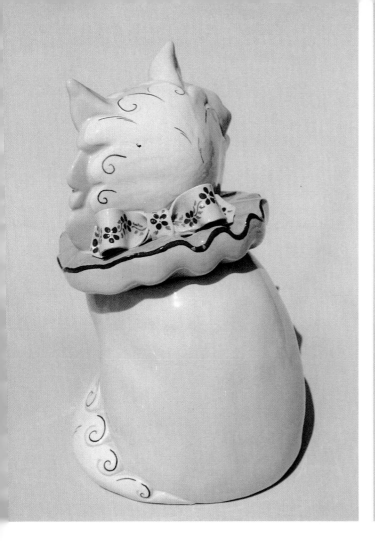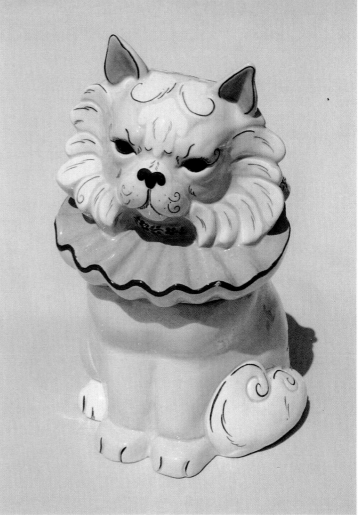

Here's another look at *Cookie Puss* with a different collar treatment, along with a reverse view so you can get a good look at her bow detail. Finally, a family portrait with both shakers. *Courtesy Ron & Juvelyn Nickel.*

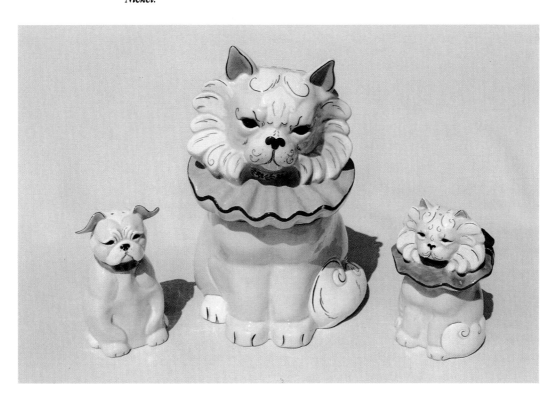

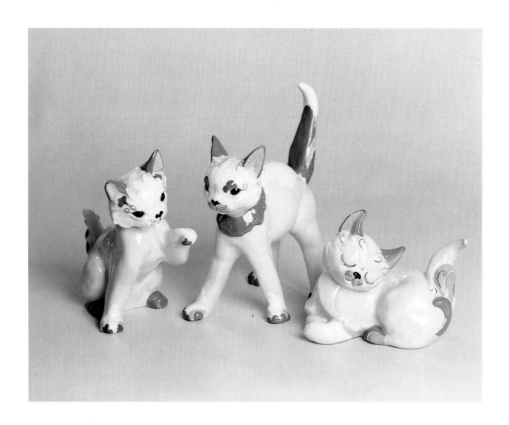

Kay created a lovable trio of rather sizable cats in bright pastels and grey/taupe. On the left is her Playful Cat *Mehitable* (#181, $400-500). She's 8½" tall, and is followed by Kay's Angry Cat *Hannibal* (#180, $600-750). The tallest, he stands nearly 10½". Finally, there's her Contented Cat *Jezebel* (#179, $275-350), 6" x 9". This trio will charm the socks off of just about anyone. *Authors' Collection.*

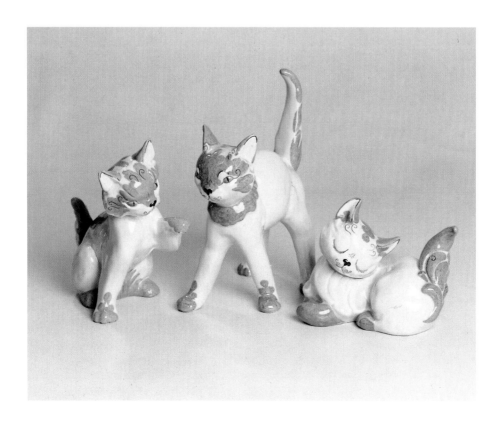

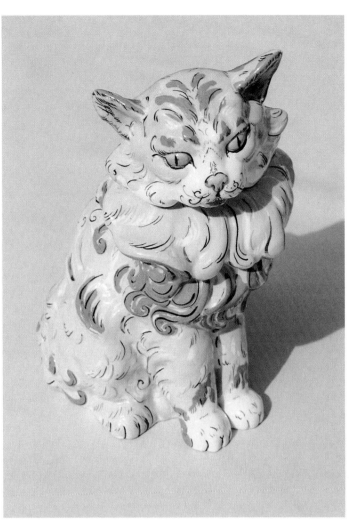

Another *Ambrosia* in more natural shades of grey and white. *Courtesy Jane Knapp & Bill Wise.*

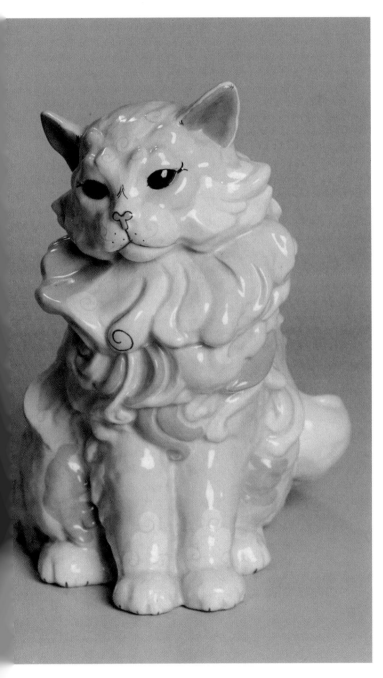

Ambrosia (#155) is one of Kay's Persian cats. Her 10¾" stature just oozes personality. She was one of our first acquisitions back in 1989, so she has a special place in our hearts ($500-600). *Authors' Collection.*

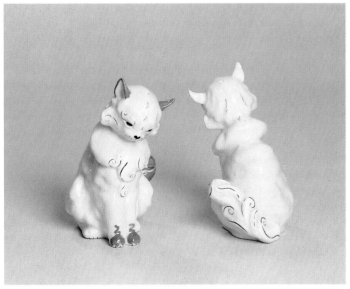

Kay also did a *Baby Ambrosia* (#5165) in pastel shades who's short in stature (5½") but tall in spirit ($150-200). *Authors' Collection.*

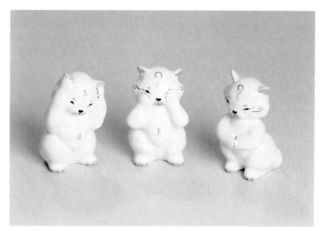

Meet a charming trio of kittens, patterned after an ancient trio of monkeys. They are named *Hear No Evil* (#4836), *See No Evil* (#4834), and *Do No Evil* (#4835). They are just 3" tall. ($100-125 each.) *Authors' Collection.*

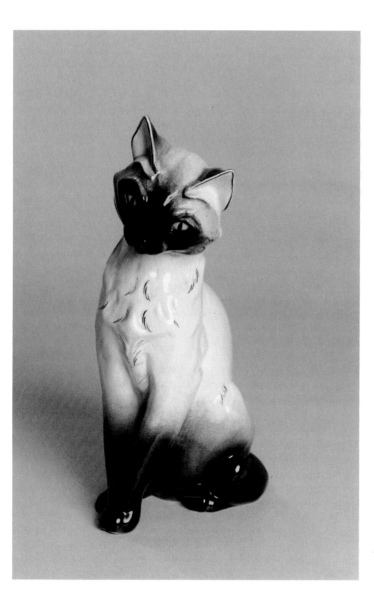

Kay's *Siamese Cat* (#5103) stands 10" tall and looks so real it's hypnotic. The detail is extraordinary ($400-500). *Authors' Collection.*

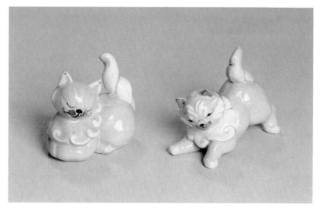

Here's a pair you'll be drawn to…Kay's 3¼" sleeping kitten *Muff* (#182) and same-size playful kitten *Puff* (#183) in pastel colors. They come in tones of grey/blue and grey/taupe, as well. ($75-85 each.) *Authors' Collection.*

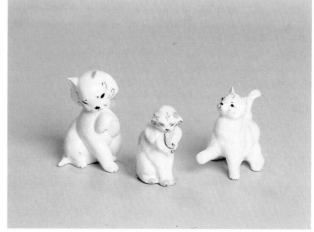

One more trio of ceramic tabbies, from left to right: 3½" *Kitten*, whom we've only seen as part of the *Kitten Globe Stand* (#B5541C), 2½" *Tiny Persian Cat* (#157), and a yet-to-be-catalogued 2¾" prancing kitten. ($100-125 each.) *Authors' Collection.*

This sleeping trio of California cuties is patterned after *Jezebel*. The larger, 4¾" tall cats (#5302, $275-350) are named *Jezzy*. The one on the left is a glaze test piece with "Pink Pearl" written on the bottom. We call the 2" tall miniature *Baby Jezzy*, but we cannot find a corresponding catalog number ($175-250). *Authors' Collection.*

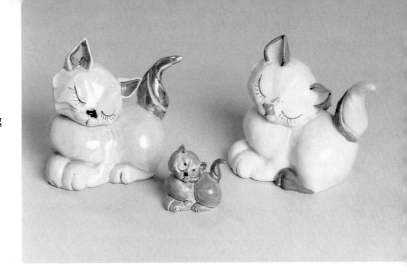

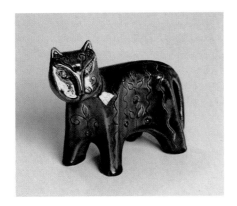

A rather unique Italian "concept cat" (5" x 6"), which Kay patterned after one that she had seen on a trip to Italy ($150-200). *Authors' Collection.*

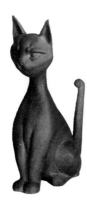

Like the dog in the previous chapter, this is Kay's 5¾" matte glaze *Long-eared Cat* (#5925, $150-175). *Kaye & David Porter Collection.*

This 4" tall feline has us fooled. A gift to Kay's hairdresser, Bill Wise, it has escaped the catalog pages for reference purposes, but it is a molded piece ($275-350). *Courtesy Jane Knapp & Bill Wise.*

Kay's whimsical style also translated to this series of bronze miniatures which are barely 3" tall. ($350-400 each.) *Courtesy Jane Knapp & Bill Wise.*

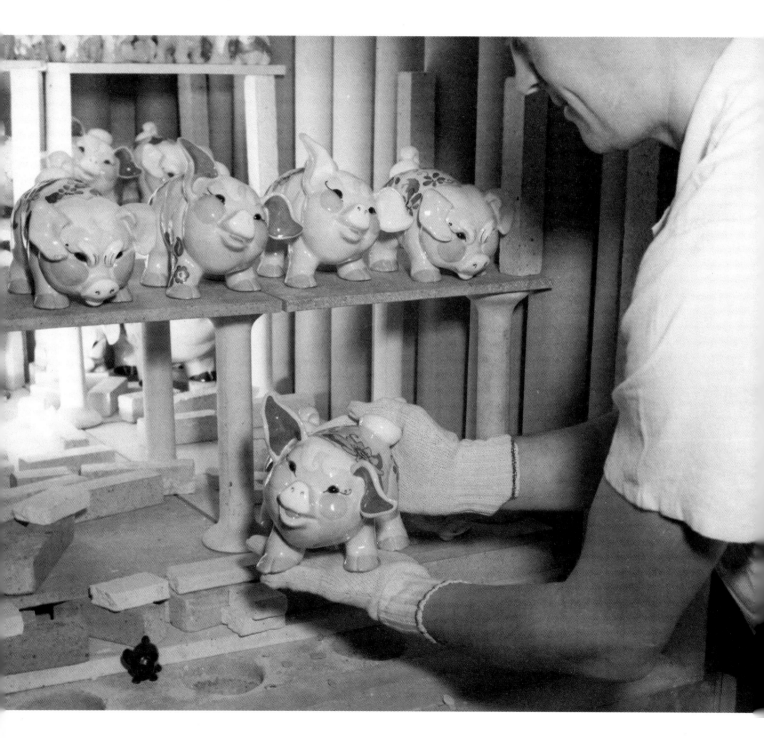

Braden unloading old kiln after final firing (circa 1940). *Courtesy Finch Estate.*

Her Pastoral World

How 'ya gonna keep 'em down on the farm, after they've seen Kay Finch? She literally tears down the fences of tradition with tattooed pigs, ducks sporting skis or fedoras, and lambs destined to pull the wool over your eyes. By the way, if imitation truly is the sincerest form of flattery, then Kay deserves a standing ovation. Her roosters, hens, and pigs have been copied by more plagiarists than you can shake a pitchfork at.

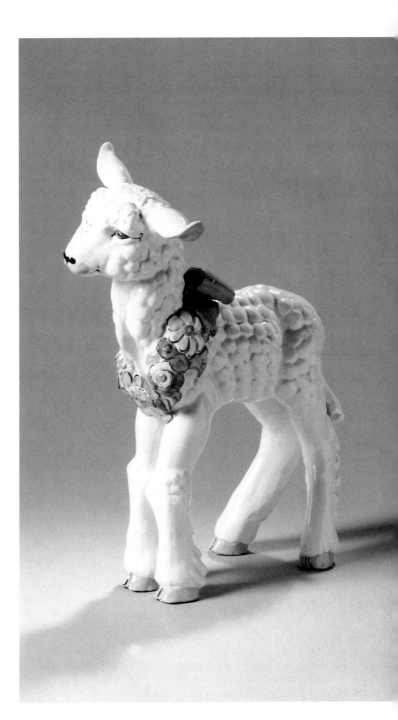

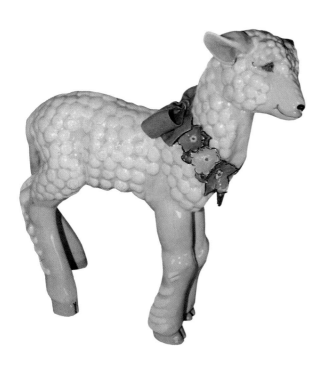

It's hard to believe that, with so many spectacular ceramic achievements to her credit, Kay had one favorite. But she did. Her rare 20" *Life-Size Lamb* (#167, $2000-2500). For the last 50 years, this fellow greeted customers from the window of Lamb's Restaurant in Salt Lake City, Utah. Then, in December of 1995, he found a new home. (Merry Christmas, Cindy.) *Authors' Collection.*

This guy appeared in an Antique Trader ad in 1993. Unfortunately, we were the second caller. He now lives with other Kay Finch critters in Minnesota ($2000-2500). *Lisa Louis Collection.*

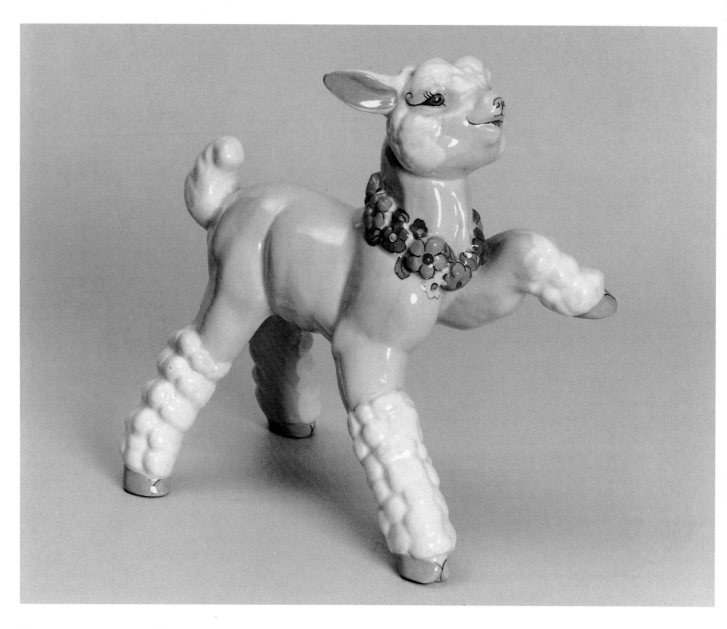

When you experience Kay's 10½" *Prancing Lamb* (#168) your first thought is . . how could any survive a California earthquake? Her balance points are very, very delicate. Like her big brother, she comes in white or pink ($500-600). *Authors' Collection.*

Here are three more lambs with charm to spare. The *Rearing Lamb* (#109, $100-125), 5½"; *Standing Lamb* (#5120, $150-175), 5¾"; and *Kneeling Lamb* (#136, $50-60), 2¼". The *Standing Lamb* with black trim and gold bow was a special piece made by Kay for collector Elizabeth Schlappi in California. *Authors' Collection.*

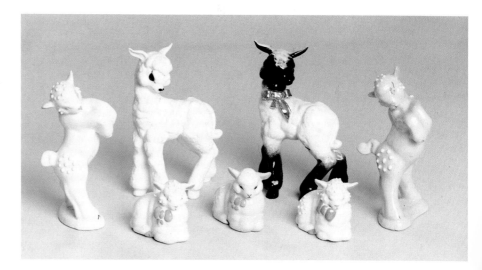

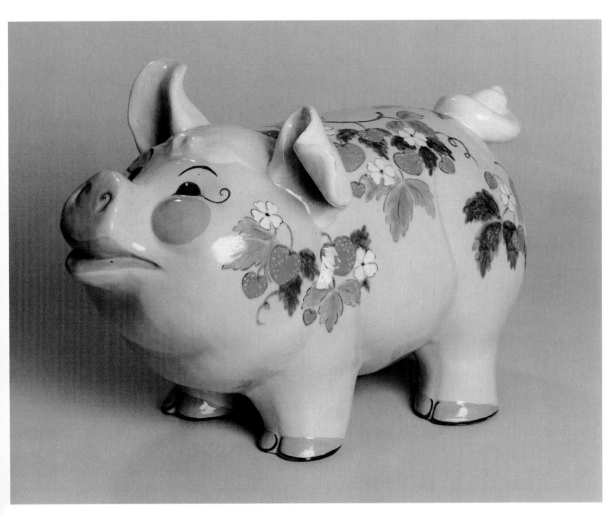

Kay made lots of pigs. In fact, they are still prize catches today. In the rarer floral decoration category are pansies, clover, and strawberries. Banks are also difficult to find. The biggest (and bestest) is a porker named *Grandpa* (#163). He's 10" x 16". Here are two examples: one with strawberries (*Authors' Collection*) and one with California flowers posed with *Grumpy* (*Kaye & David Porter Collection*) to show the size differential ($750-1000).

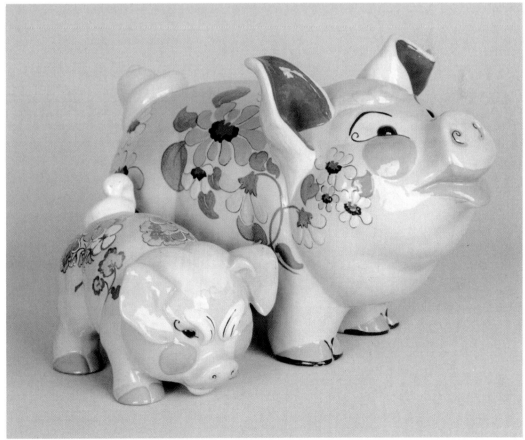

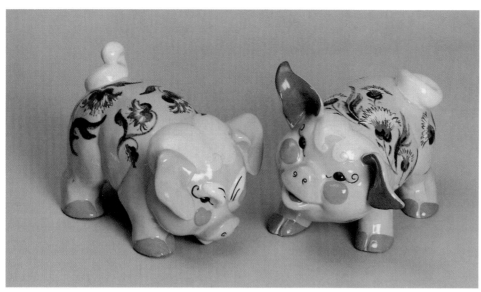

Next on the size scale of Kay's famous family of pottery pigs are *Grumpy* (#165) and *Smiley* (#164). *Grumpy* is 6" x 7½" and *Smiley* is 6¾" x 8". Both were made as banks. The clover-decorated pigs are figurines, while the California flower versions are banks. ($300-375 each, add $100 for banks, pansies, clover, or strawberries.) *Authors' Collection.*

Here's a tail-side view of *Smiley* with strawberry decoration. *Authors' Collection.*

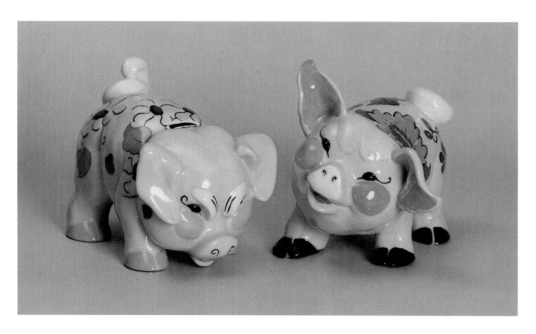

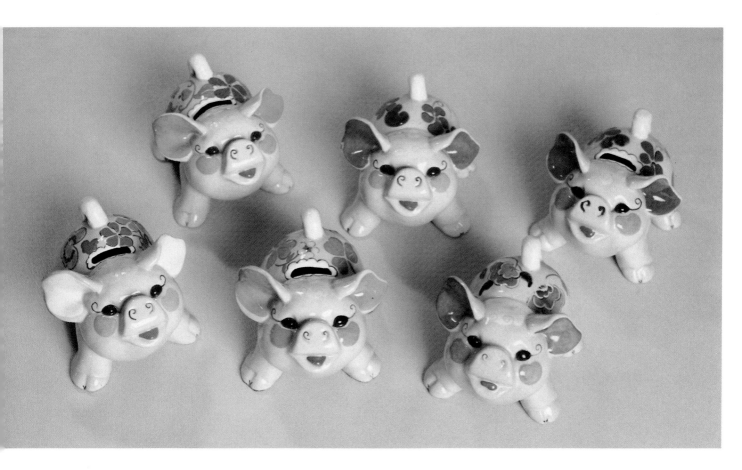

Next on the pig parade are *Winkie* (#185), 3¾" x 4", and *Sassy* (#166),
3½" x 4½". Both were made as banks, but for some reason *Winkie* is much
harder to find in that format. The following pictures show a variety of decor.
($100-125 each, add $50 for banks.) *Authors' Collection.*

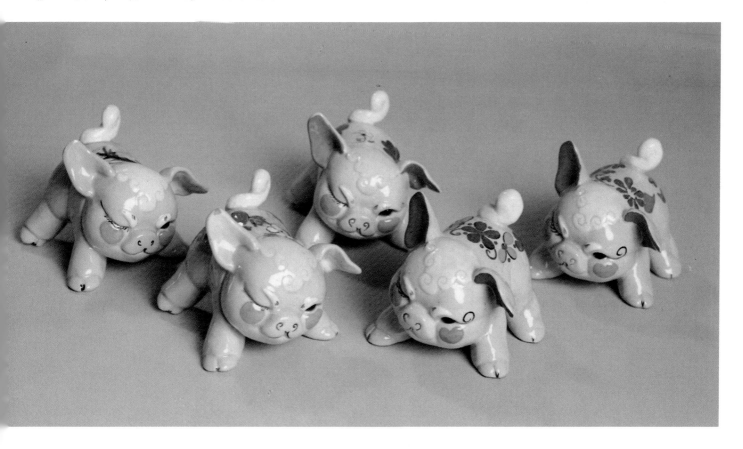

This little guy is quite scarce. Kay named him *Porky Pig* (#5055). He's only 2¾" x 3", and very desirable ($150-200). *Authors' Collection.*

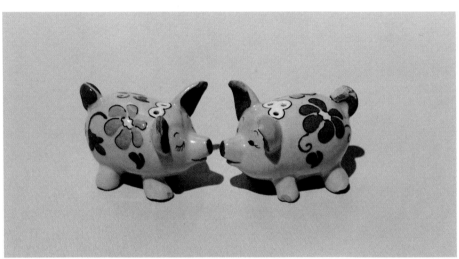

Only 1½" tall and 2¼" long, these little pigs were made as salt and pepper shakers and were always used in the Finch household. They are catalog number 131 ($250-300 pair). *Courtesy Finch Estate.*

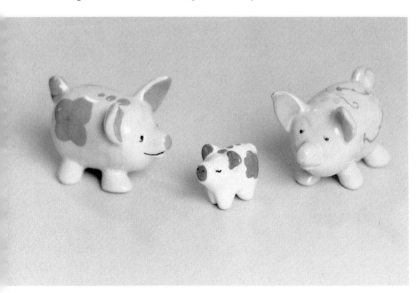

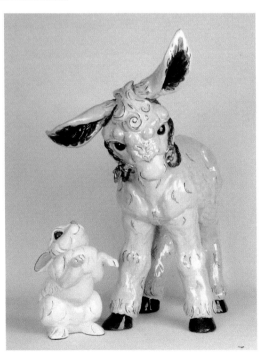

As you can see, they were also made as figurines. The demure little guy in the middle is only 1" x 1¼", and we believe he is #5408 *Piggy Wiggy* ($150-200). *Authors' Collection.*

To better appreciate his size, here he is next to *Cuddles* Rabbit, who is 10½" tall. *Kaye & David Porter Collection.*

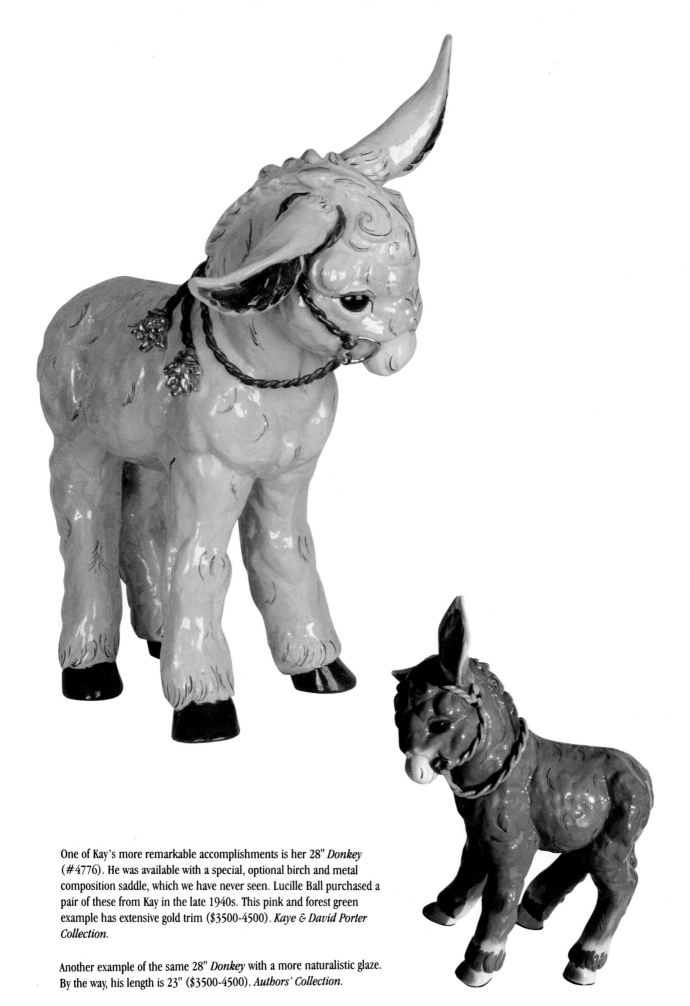

One of Kay's more remarkable accomplishments is her 28" *Donkey* (#4776). He was available with a special, optional birch and metal composition saddle, which we have never seen. Lucille Ball purchased a pair of these from Kay in the late 1940s. This pink and forest green example has extensive gold trim ($3500-4500). *Kaye & David Porter Collection.*

Another example of the same 28" *Donkey* with a more naturalistic glaze. By the way, his length is 23" ($3500-4500). *Authors' Collection.*

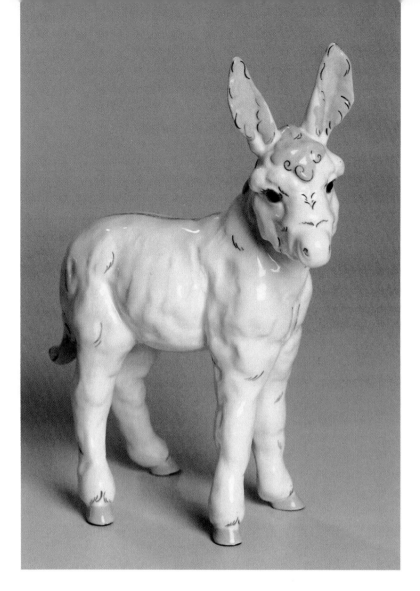

Kay called this handsome 10" fellow her *Western Prospector's Burro* (#475). He's beautifully done in white and grey with a touch of pink on his ears. But he quite likely comes in other colors like his cousin, the Donkey ($350-425). *Authors' Collection.*

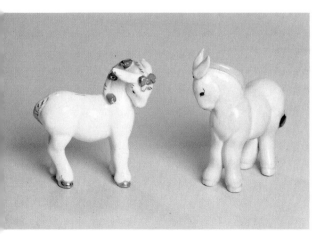

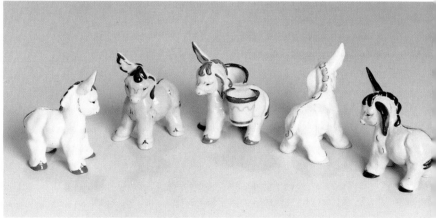

Can't find a catalog reference for these streamlined *Donkeys*. The one on the left, 4½" tall, has ceramic pieces inside (like a baby rattle) with hand-applied filigrees ($175-250). The one on the right is 5", has raised ears, and does not rattle ($150-175). Both are pretty classy. *Authors' Collection.*

These cute little 4" guys are called *Long-Eared Donkey* (#4768, $75-100). The one with the baskets is called *Long-Eared Donkey With Baskets* (#4769, $100-125). There seems to be a wide range of colors for the non-basket versions. *Authors' Collection.*

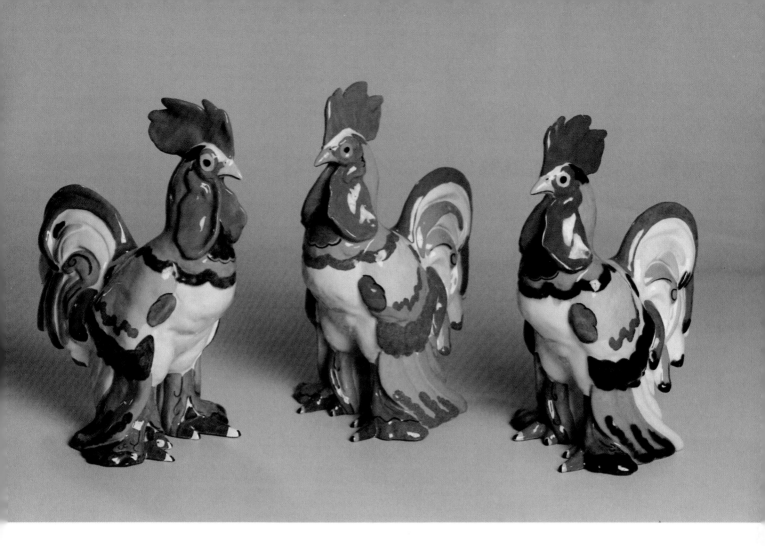

Kay's 11" *Chanticleer* (#129) rules the roost with respect to the majestic use of color and design. Pictured are the three most prevalent glazes—the one on the right with a unique iridescence ($400-500). *Authors' Collection.*

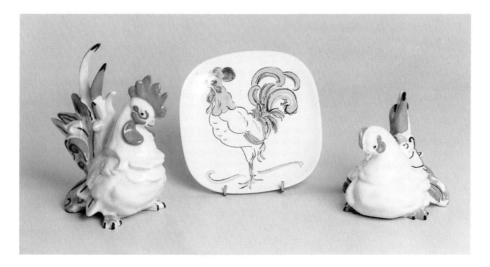

Introducing *Butch* (#177, $125-150) and *Biddy* (#176, $100-125) flanking a unique 6¾" hand-painted *Rooster Cocktail Plate* (#5409, $100-125). *Butch*, at 8½" tall, and *Biddy*, at 5" tall, have to be the most imitated/copied/plagiarized designs in ceramic history. Remember three things to avoid trouble: 1) the split tails, 2) the sizes, and 3) the finite glaze details. No ceramic copy meets all three criteria. *Authors' Collection.*

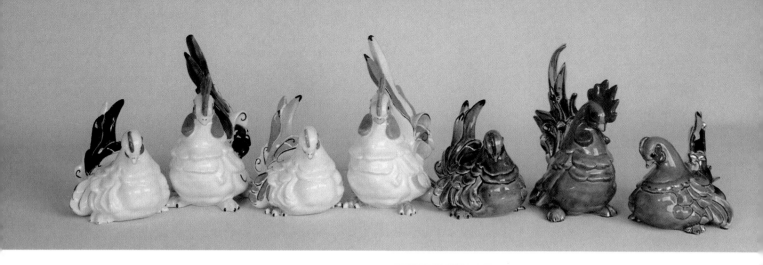

Kay gave her decorators wide latitude with colors and glazes for *Butch* and *Biddy*. Note the variety in this photo with respect to accent colors (in order): black, dark green, blue/pink/purple, rust/pink/light green, grey/ black, brown/gold. *Kaye & David Porter Collection.*

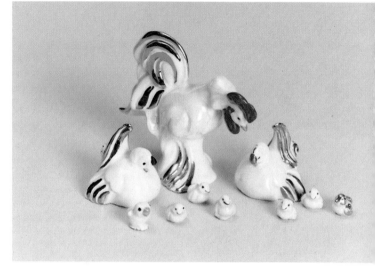

This photo shows *Butch* and *Biddy* posing with more of the Henhouse Family. A 5½" *Banty Rooster* (#4844), 3½" *Banty Hen* (#4843), and 2" *Chick* (#100). $200-250 for the set of three. *Kaye & David Porter Collection.*

Finally, we were able to assemble a rare group of miniatures. The 3¼" *Rooster* (#5354, $175-225) teams up with a 1½" *Hen* (#5355, $125-150) and a 3/8" *Chick* (#5356, $40-50 each). All in a pearlized glaze with gold accents, except for the one with gold accents hiding in the lower left corner. *Courtesy Ron & Juvelyn Nickel.*

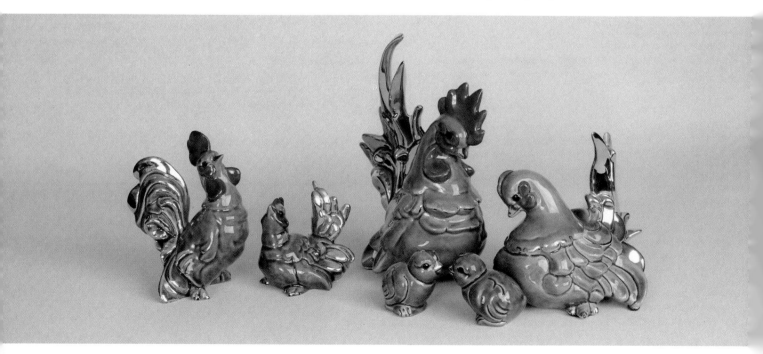

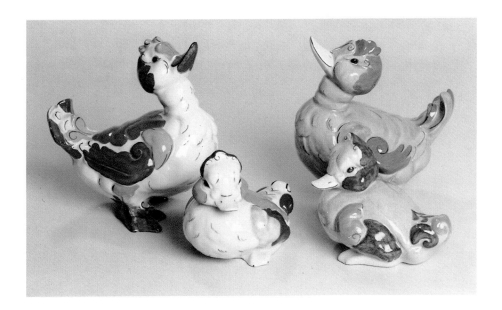

These ducks are not easy to find, but are definitely worth the hunt.
Shown here are *Papa Duck* (#471, $400-450) at 7¼" and, of course,
Mama Duck (#472, $250-300) at 4¼". Two exciting glazes are pictured
here, but we've had at least two other variations. *Authors' Collection.*

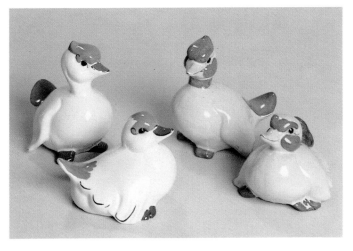

Most collectors will be able to locate these quackers—*Peep* (#178A) 4"
and *Jeep* (#178B) 3½"—in the green/white, or green/ivory tones. The
pink/brown combination presents a much greater challenge. ($50-60
each.) *Authors' Collection.*

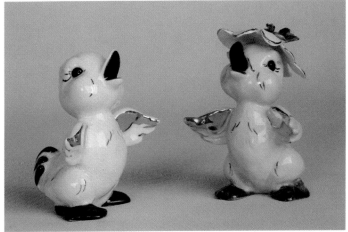

Meet *Ducky-Wucky* (#5006), 6" tall, and his friend *Ducky-Wucky With
Lustre Hat* (#5006L). They are quite scarce and had taken shelter with
Kay in Corona del Mar until they relocated to Arizona. ($450-500 for the
pair.) *Kaye & David Porter Collection.*

The *Swan Flower Bowl* (#4956, $125-150), 6½"; *Swan Ashtray*
(#4958, $60-75), 4½"; and *Swan Covered Dish* (#4957, $175-225),
6", are shown here in both available glazes. *Kaye & David Porter
Collection.*

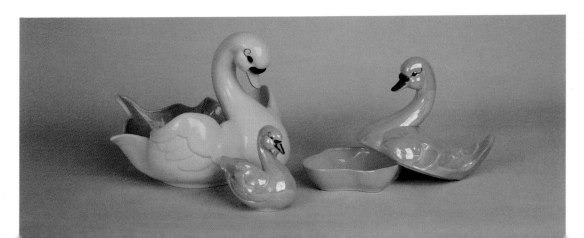

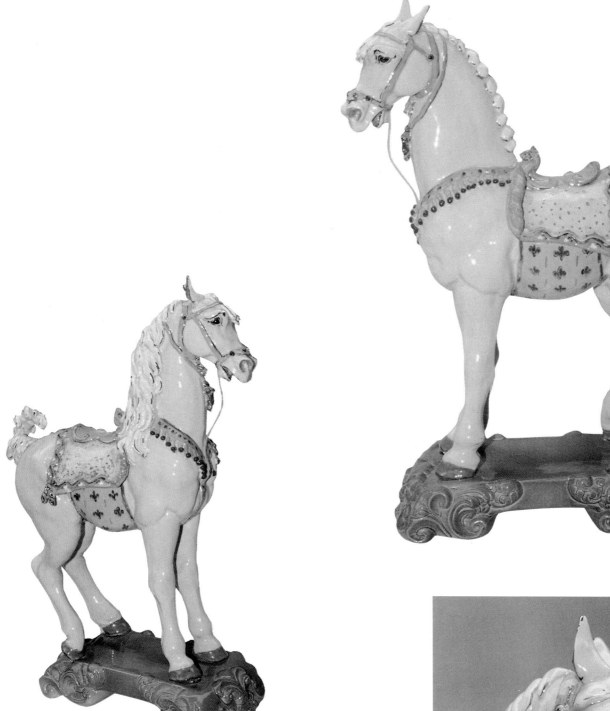

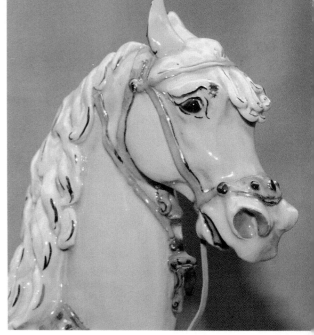

Kay's 21" *Stallion* (#213) is truly a work of art. He was decorated in the Oriental style with pink flesh tones, cream mane and tail, and green and turquoise trappings. Even the rein is ceramic. This example had been in Kay's personal collection, before it moved to another California collector's home ($2500-3000). *Roberta Tripoli Collection*.

Note the exceptional detail and hand work.

Kay's equestrian modelling expertise translated to other impressive, realistic forms. Pictured here is her 12" tall mare, named *Amour* (#474) in two inviting glaze treatments ($375-450). *Authors' Collection.*

These 5" *Stallion Head Salt & Pepper* shakers were early acquisitions for us. We've not seen or heard of another pair since ($150-200). *Authors' Collection.*

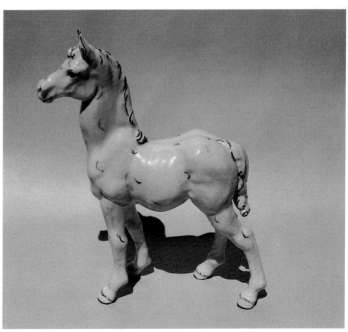

Her 11" tall *Colt* (#4806) has a name as well...*Caress.* Interestingly enough, Kay owned both of these horses prior to preserving their memory in clay ($275-350). *Courtesy Finch Estate.*

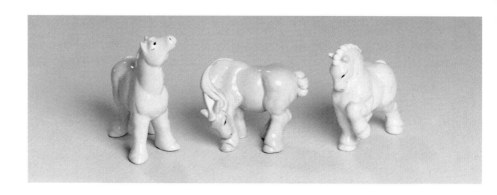

The last entries in the Kay Finch Horse Race are her three *Draft Horses* (in order #130 B, A, C)). Sizes, left to right, are 4½", 3½", 4½". Color options will range from pink to white to grey ($100-125 each). *Authors' Collection.*

This *Bull* (#6211) was one of the last figurines created at Kay's studio. This one is a sample from the studio. He's done in a matte white glaze and stands 6½" tall ($250-300). *Kaye & David Porter Collection.*

Her Woodland World

Perhaps this section should have been more appropriately titled: *The Woods According to Finch*. A perfect blend of the real...and the not-so-but-ought-to-be real. Kay employed a rainbow of glazes to spice up the environment. Mother nature never had it so good.

Kay's 21" Rabbits are nothing short of phenomenal. She used the mold (#4622) to create two versions: *Harriet*, with a hat and purse—and *Harvey*, with a bow. Pictured here is *Harvey* in two different glaze treatments ($2500-3000). *Authors' Collection.*

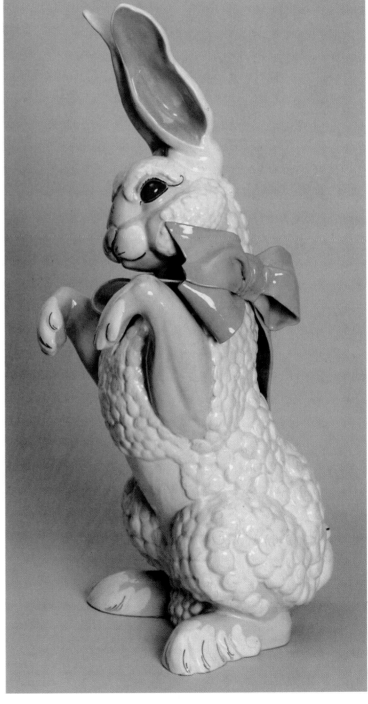

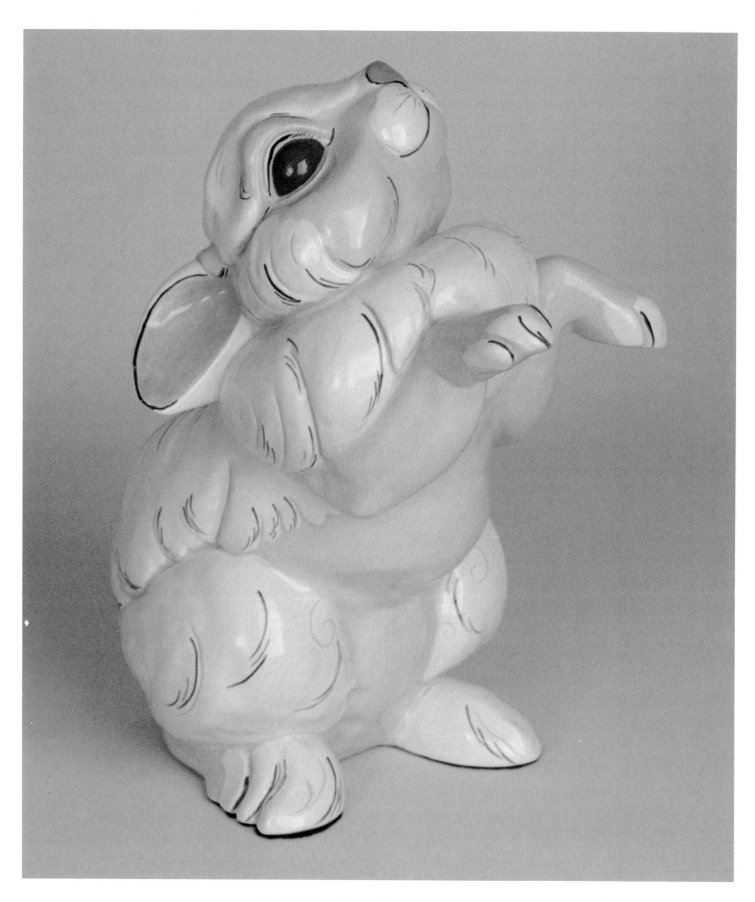

Meet *Cuddles* (#4623), Kay's second largest bunny. He stands 11" tall.
Kay must have loved Cuddles almost as much as her 20" Lamb, because
she created the two custom-designed examples (on the next page) for
herself ($500-600). *Kaye & David Porter Collection.*

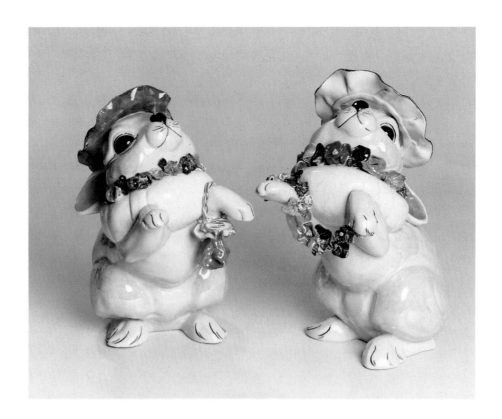

These two elaborate versions of Cuddles were made by Kay for use in her own home. The hand-made hats increase their height to 12". Each has a garland of flowers around her neck, while one carries a purse and the other carries a second garland of flowers. Note the detail in the hats on the photo below. Kay found a special place for them on her table every Easter (Unique). *Authors' Collection.*

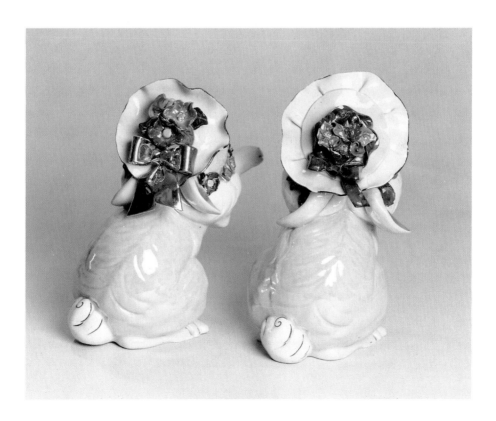

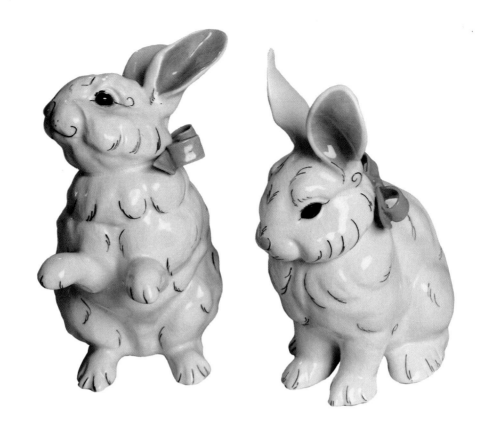

These two rabbits are also packed with personality. On the left is Kay's *Listening Bunny* (#452), on the right is *Carrots* (#473). Both stand 8¼" tall. We have not seen any colors other than white, pink/white, or brown/white. ($500-600 pair.) *Authors' Collection*.

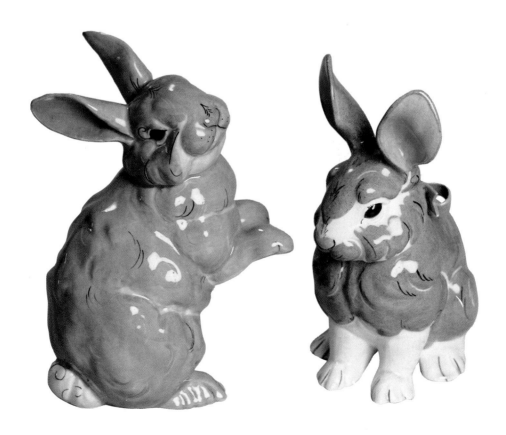

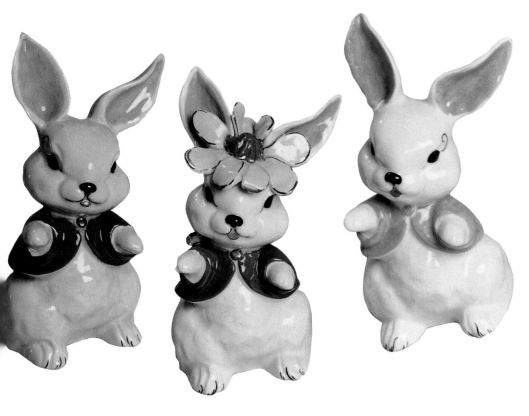

This page concludes our tour of Kay's Rabbit Warren. This group of three is called *Bunny With Jacket* (#5005, $150-175) and *Bunny With Lustre Flower Hat* (#5005L, $175-225). They stand 6" tall. *Authors' Collection.*

Here are two more bunnies, with color variations on each. On the left and right are 2½" *Baby Cottontail* (#152), in the middle is a cute pair of *Baby Bunny* rabbits (#5303), which are 3½" tall. ($100-150 each.) *Authors' Collection.*

This little 4" x 4" carrot-cruncher is an early Kay Finch creation (#120). The price list calls her *Mama Rabbit.* We call her delightful ($150-175). *Authors' Collection.*

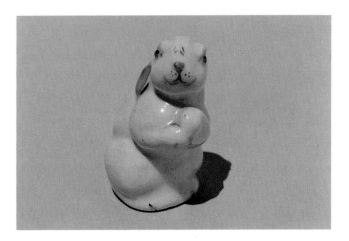

Last on the list is a sweet little 1¼" Bunny done in 1942, but it is missing from the price list or catalog references ($100-125). *Courtesy Finch Estate.*

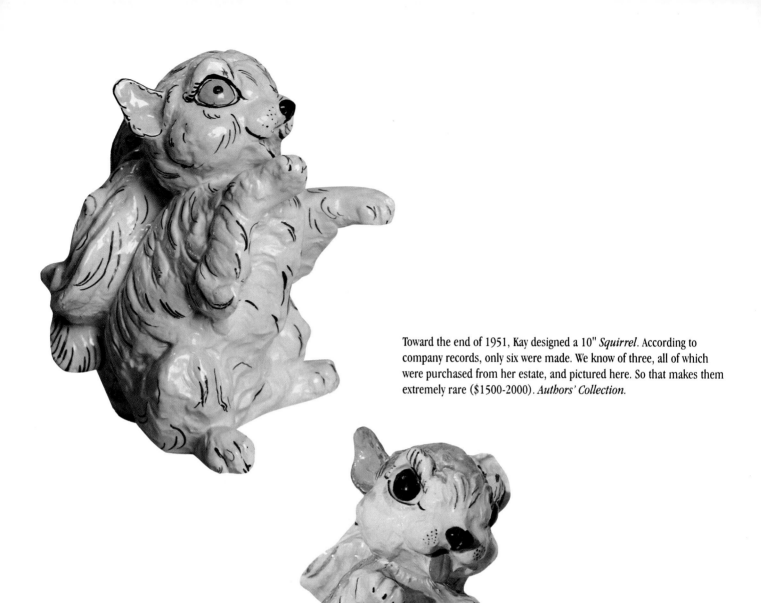

Toward the end of 1951, Kay designed a 10" *Squirrel*. According to company records, only six were made. We know of three, all of which were purchased from her estate, and pictured here. So that makes them extremely rare ($1500-2000). *Authors' Collection.*

Dorothy Lombard Collection.

This *Squirrel* has been made as a bank. *Kaye & David Porter Collection.*

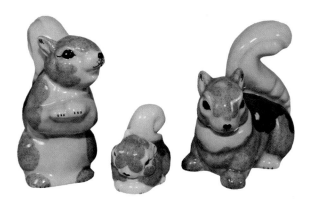

Presenting Kay's *Squirrel* Family (#108 A, B, C). Papa and Mama are 3½" tall. And Baby measures 1¾" to the top of his tail. ($200-250 for the set.) *Authors' Collection.*

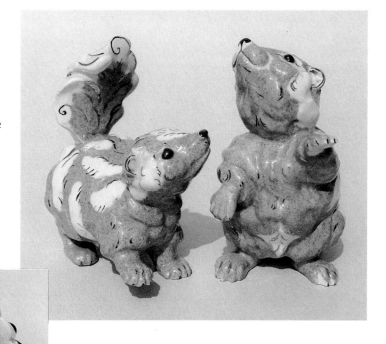

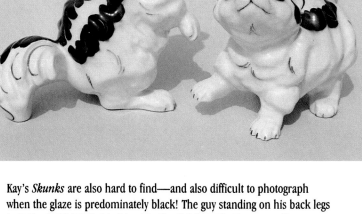

Kay's *Skunks* are also hard to find—and also difficult to photograph when the glaze is predominately black! The guy standing on his back legs is 4¼" tall (#4774), his friend is 3" tall (#4775). They're really cute, and deserve a prominent place in any Kay Finch Collection. The two glaze treatments shown here are out-of-the-ordinary. ($450-550 pair.) *Sharlene Beckwith Collection.*

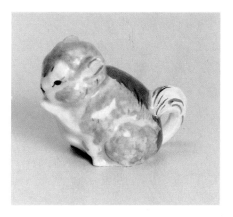

This little guy is a charmer. Problem is, we're not sure what he is—Chinchilla or Chipmunk? He's only 1¾" tall, has an impressed mark on the bottom, but no catalog or price list reference. We believe he's a fifties piece and scarce ($150-175). *Authors' Collection.*

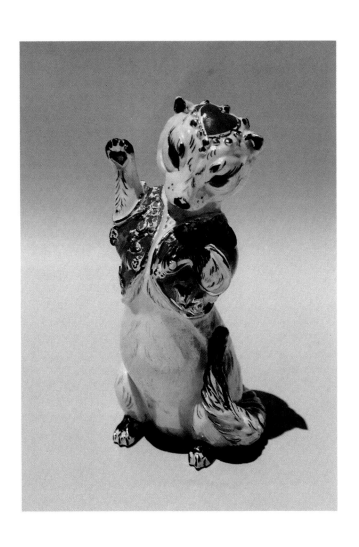

You'll want to set a trap for this little 3" life-size *Mouse*. He's molded, but again, we can't locate a name or mold number. Color him scarce ($100-125). *Courtesy Finch Estate.*

Even if you've never wanted a mink coat, we can't imagine anyone not wanting this Kay Finch *Mink* (#5924) and his coat. Although he's only 7" tall, he's an irresistible example of Kay's enchanting style ($600-750). *Courtesy Finch Estate.*

Now here's something worth hooting about. A Kay Finch 10½" *Flying Owl* (#5530). He's done in a matte white with gold accents, and has his own special ceramic perch ($450-550). *Jim & Jolene Andrus Collection.*

While we're on the subject of owls, let's introduce Kay's Owl Family: *Hoot* (#187), 8¾"; *Toot* (#188), 5¾"; and *Tootsie* (#189) 3¾". They come in a variety of pastel, grey, and brown with gold combinations. These are $375-450 for the set. *Authors' Collection*. There's even a rare *Baby Tootsie* (inset, $125-150). *Sharlene Beckwith Collection*.

In 1949 Kay created a series of tiny birds which she named *Mr. & Mrs. Dickey Bird*, 4" tall. (#4905A is Mr. and #4905B is Mrs.; the letter "S" was added when skis were added.) You can tell them apart by the hats. Mr. wears a cap or a flower hat; Mrs. wears a bonnet…or no hat at all. The little guy on the end is done in the same style, has no catalog number, and is three-quarters of an inch shorter. ($175-225 each, add $100 for skiis.) *Authors' Collection*.

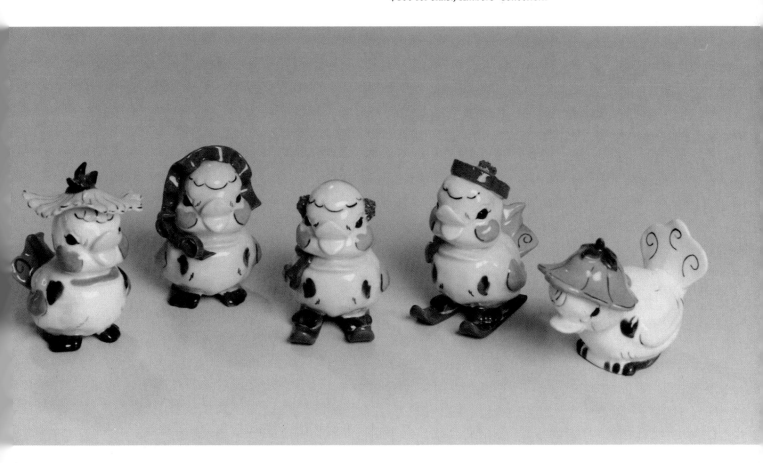

Kay created this pair of *Doves* (Tail Down #5101 and Tail Up #5102) in 1951. We have seen them in a simple white glaze with black accents for eye and feather detail. But the gold/grey/platinum combination is a knock-out. 8" x 5". $200-400 pair. *Authors' Collection.*

This matte glazed Swallow on a perch is 5" tall, and another mystery to be solved. No references anywhere. But we do have the original sculpture which is pictured in another chapter ($150-175). *Authors' Collection.*

This is Kay's 7" tall *Mama Quail* (#5984, $375-450). Her colors are stunning—her availability limited. She has a 3" baby which we have never seen. *Authors' Collection.*

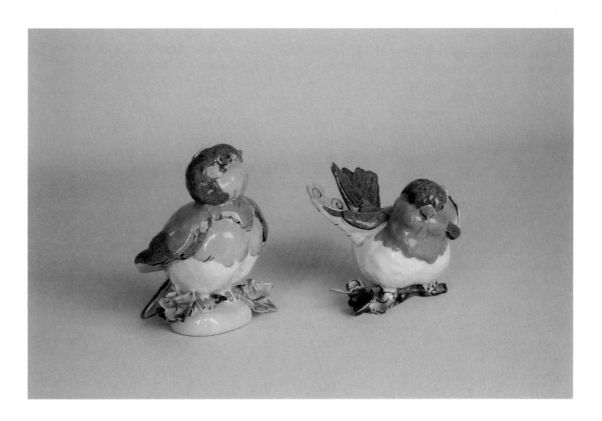

Mr. & Mrs. Bird. Produced in a symphony of colors. He (#454) is 4½"
tall and she (#453) is 3" tall. Occasionally, as in this pair, extra effort was
made during the decorating process using special colors and hand-
formed filigree-like branches and leaves. $250-300 pair. *Kaye & David
Porter Collection.*

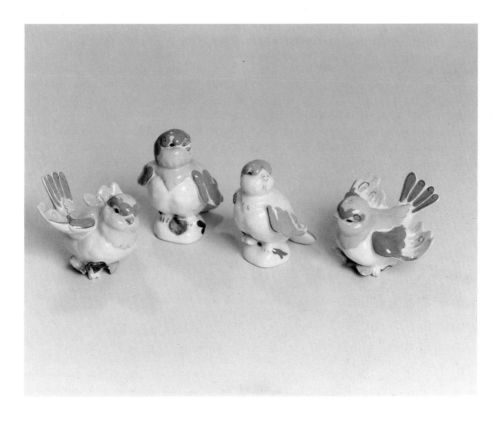

Two more matched pairs of *Mr. & Mrs. Bird* with exceptional use of color
in the decorating process ($175-250 pair). *Authors' Collection.*

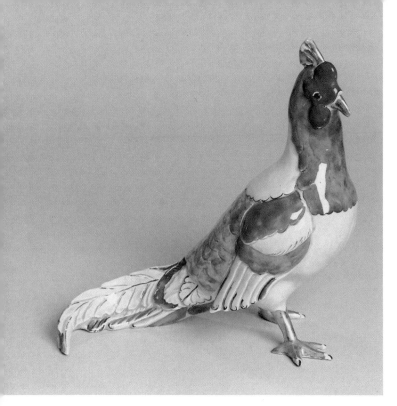

One of Kay's rarer game birds is this 10" *Pheasant* (#5300). This fellow is decked out in a trio of blue iridescent glazes ($450-550). *Authors' Collection.*

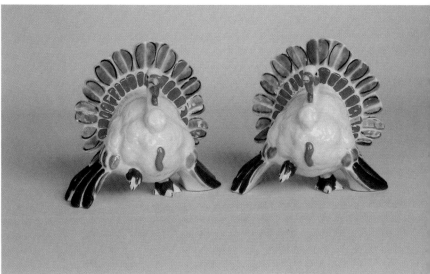

Most of Kay's *Turkeys* were designed to grace your Thanksgiving table. But these 4½" gobblers (#4853) were made to mingle with the rest of her flamboyant family of fine feathered farm friends ($175-225 each). *Kaye & David Porter Collection.*

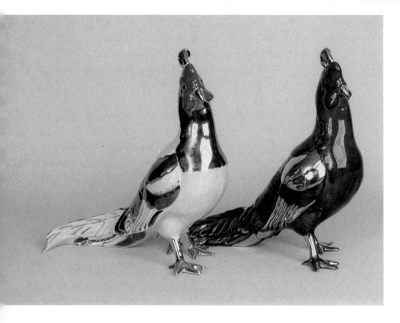

And here's another pair using grey with platinum, and brown with gold. Impressive ($450-550 each). *Kaye & David Porter Collection.*

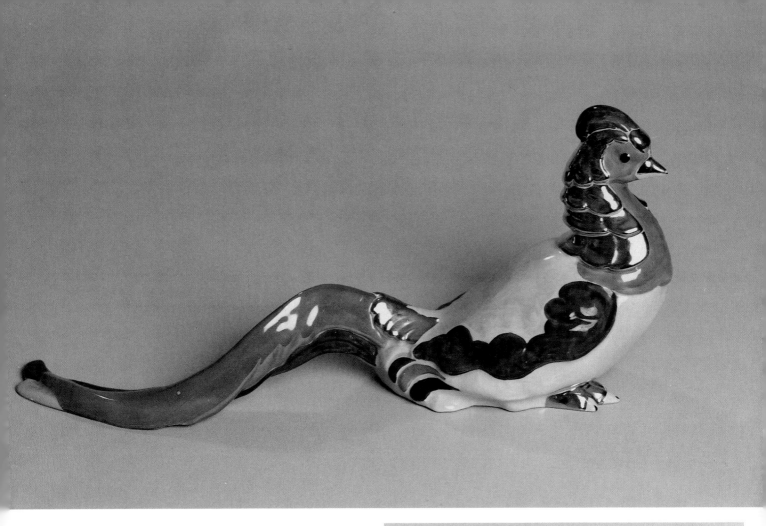

Kay's creative genius was working overtime when she conceived this 18"
long *Pheasant* (#5020). He is as much tail as he is body. And *very*
fragile. Perhaps the most beautiful specimen is this blend of pink pearl,
mauve, and lavender lustre accented with gold. ($600-750 pair.) *Authors'*

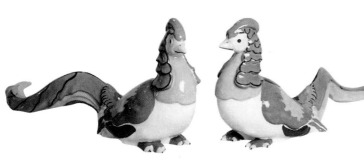

This combination of non-lustre colors gets these *Pheasants* our Second
Place Vote. And they look great as a pair. ($500-600 for both.) *Authors'
Collection.*

We took this picture to show you his back and tail decor, which is
exceptional. *Authors' Collection.*

Trust Kay to give us Goldilocks and the Three Bears. *Goldilocks* (#5366, $125-175) is 3" tall, while *Papa Bear* (#5352), *Mama Bear* (#5351), and *Baby Bear* (#5368) are respectively 2¾", 2", and 1½" ($250-350 for the set of three). Most collectors would eat porridge for these. We're glad we didn't have to. *Authors' Collection.*

In 1956, Kay designed Butterfly Wall Plaques in different size formats. This one is *Butterfly* (#5720) 14" ($175-225). *Authors' Collection.*

Her Zoological World

Once again, Kay's extraordinary sense of humor translates into a ceramic symphony that easily brings out the child in all of us. You're about to meet elephants with elegant trappings…a polka-dotted hippo that consumes tropical flora…penguins dressed to the nines. One wonders if her inspirations were triggered by childhood memories, or by frequent visits to the zoo and the 'Big Top' with her children. But whatever the catalyst, her sculptural abilities met this challenge with vigor, flair, and an air of capriciousness. Help yourself to a season pass.

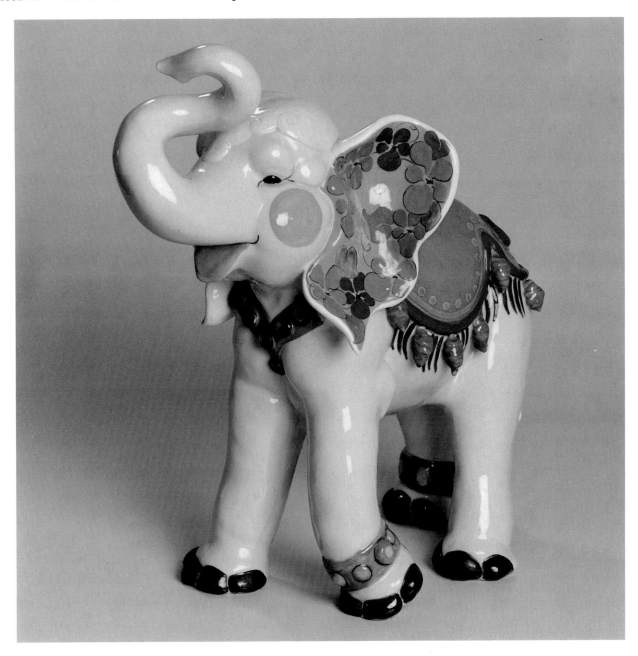

This is *Violet* (#190), Kay's magnificent Queen of the Circus. She stands 17" tall and leads the parade of prized pachyderms that follow ($2500-3000). *Authors' Collection.*

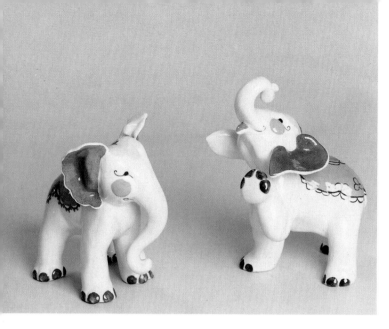

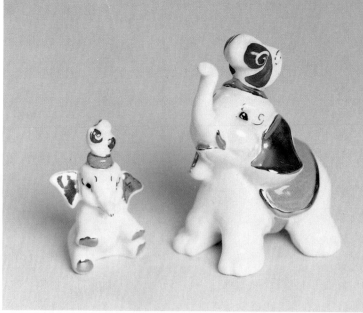

Here come *Popcorn* (#192, $250-300), who's 6¾" tall; and *Peanuts* (#191, $300-350), who's 8¾" to the top of his trunk. Their skin tones are usually pink or white. But after that, the primary accent colors can range from blue to pink to green to violet. *Authors' Collection.*

Check the hats on this pair of miniature elephants. They're real charmers. On the left is *Circus Elephant Baby* (#5365), 2¼". On the right is *Circus Elephant* (#5364), 3½". $200-250 each. *Authors' Collection.*

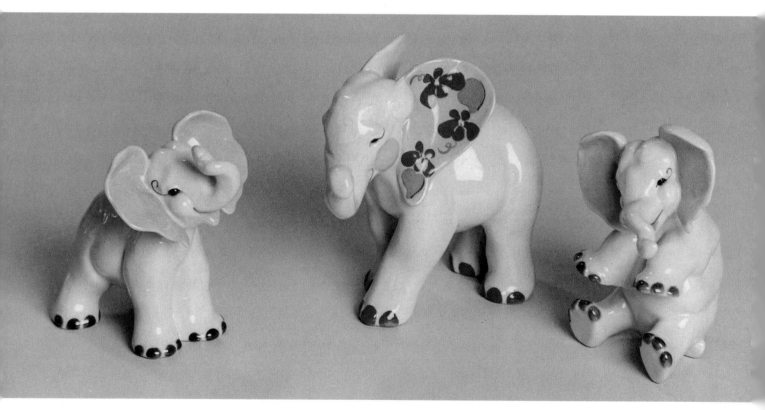

Whatever this lovable trio gives up in size, they get back in appeal. Left to right they are called *Jumbo* (#4805), 4¼"; *Elephant with Flower Ears* (#4626), 5"; and *Mumbo* (#4804) 4½". $175-225 each. *Authors' Collection.*

You'll find this cute little 4" *Sitting Elephant* attached to a planter in the "Baby's First from California" line with the number B5304, so we believe his catalog number to be 5304. Apparently, Kay liked him enough to decorate him all by himself ($225-275). *Courtesy Ron & Juvelyn Nickel.*

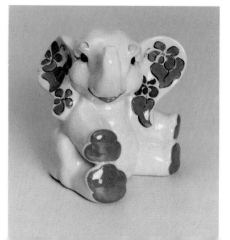

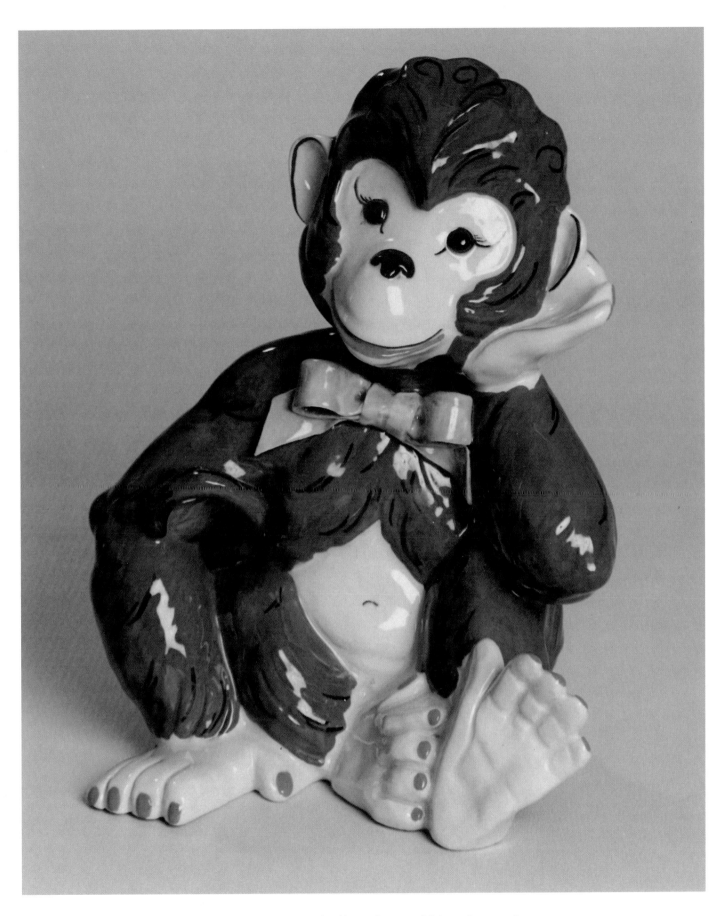

When it comes to creating lovable monkeys, Kay didn't monkey around.
This swinger is called *Happy* (#4903), and sits 11" tall ($750-850).
Authors' Collection.

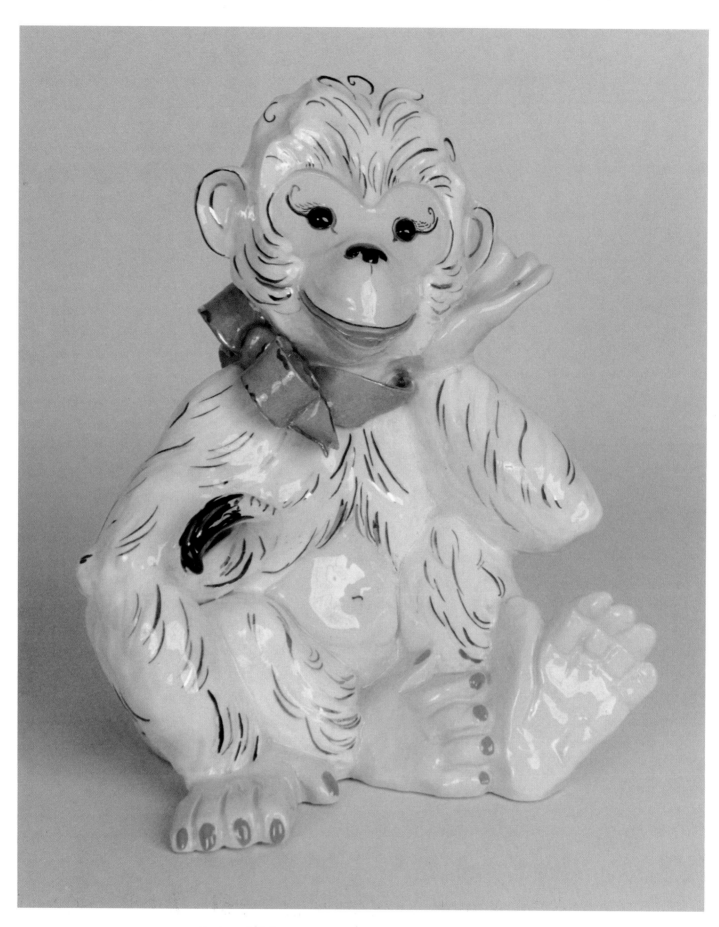

Here's another glaze treatment on *Happy*. Pretty sensational, we think
($750-850). *Kaye & David Porter Collection.*

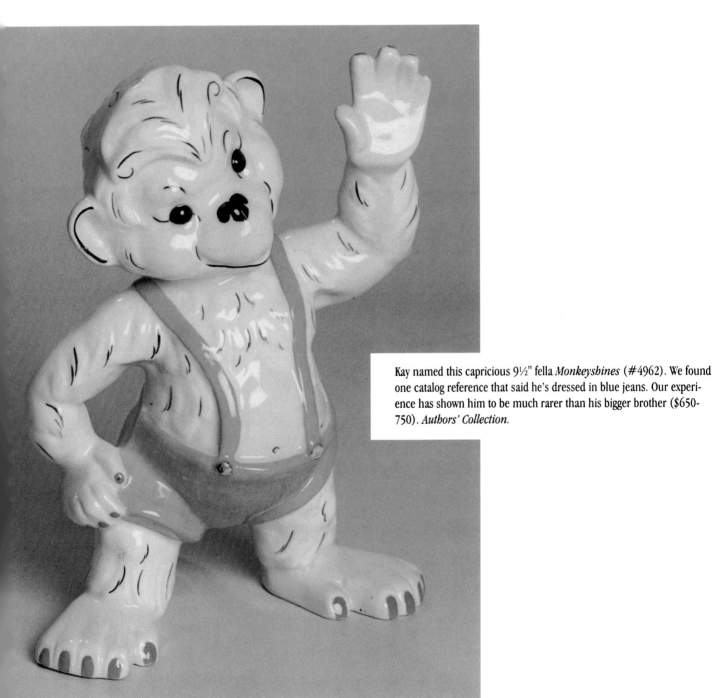

You'll go bananas for this pair. *Jocko* (#4842) is on the left. He's the rarest, probably because he tips over easily and breaks. *Socko* (#4841) is on the right. Both are 4" tall and come in a variety of decorating styles. They are almost never marked. ($200-225 each.) *Authors' Collection.*

Kay named this capricious 9½" fella *Monkeyshines* (#4962). We found one catalog reference that said he's dressed in blue jeans. Our experience has shown him to be much rarer than his bigger brother ($650-750). *Authors' Collection.*

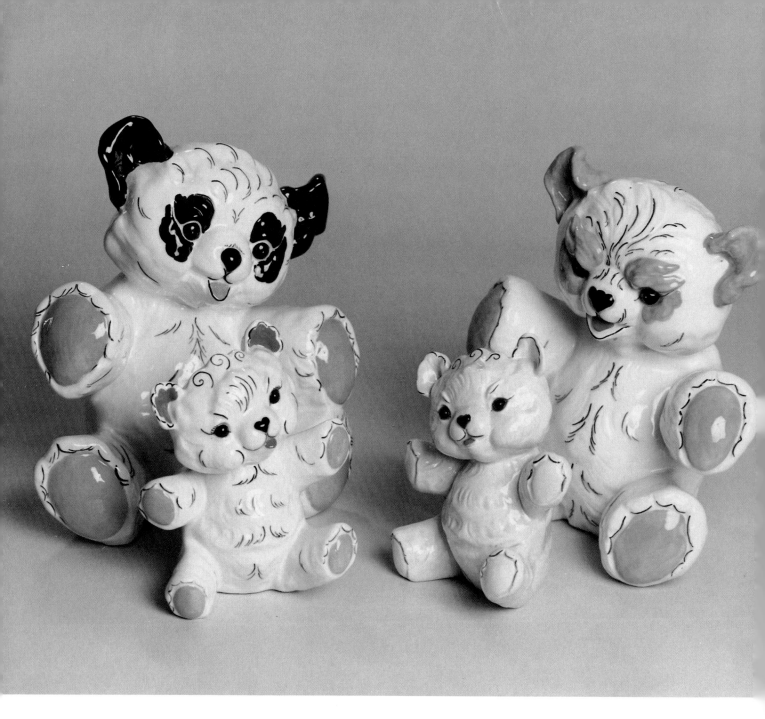

These happy Teddy Bears were made as banks, figurines, planters, and the smaller ones were attached to planters in the "Baby's First" line of nursery products. The tall one on the left (#4908, $500-600) is called *Papa Teddy Bear* and is 9" tall. He was made as a bank. *Mama Teddy Bear* is on the right (#4907, $500-600). She is 9" tall and looks identical, but look closely. There are *subtle* changes in the nose, mouth, eyes, ears, and her head sits more squarely on her shoulders. (His tilts to the right.) It's also possible that the colors were controlled here on each piece. but that's just an educated guess. The little Teddy on the left is, of course, called *Baby Teddy Bear* (#4906, $250-300). He's 5¾" tall. The one on the right looks, on the back, like he became detached from a baby vase. Also, there's a color distinction here that we will note now, and reiterate later. All Baby Line animals, birds, and baby figurines are decorated in one primary overall color: pink, blue, white, or yellow— with minimal accents of black or pink for eyes, tongues, and noses. No exceptions exist that we're aware of unless Kay perhaps made a few up as special gifts for friends or relatives. *Authors' Collection.*

There are two different Bears here, so look closely. On the left and right are *Sleepy Bear* (#5004), with one eye closed, and a small flower hat. In the middle is the same *Sleepy Bear* (#5004L), with both eyes open, and a large flower hat. They are 4½" tall. ($225-275 each.) *Authors' Collection*.

Introducing Kay's pair of 4¼" Playful Bears. On the left we have *Cubby* (#4848) in a standing pose, while his pal on the right, *Tubby* (#4847), assumes a sitting stance. ($200-250 each.) *Authors' Collection*.

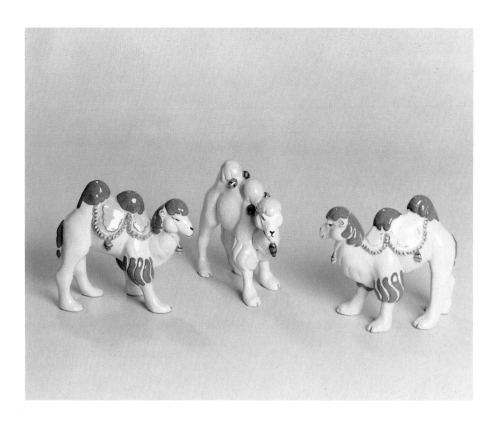

Kay's *Camels* (#464) are on just about everyone's want list. At 5" tall they're decorated with or without a "saddle" in a variety of color schemes. ($350-450 each.) *Authors' Collection*.

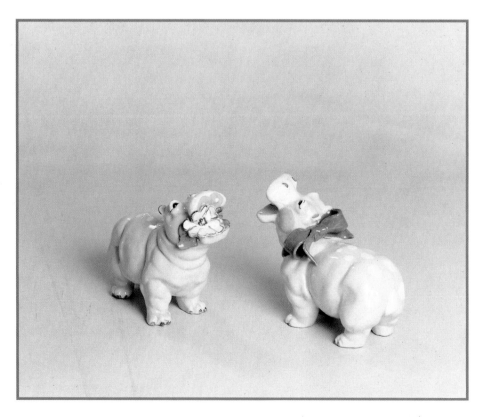

Her *Hippos* (#5019) are just as desirable. Standing 5¾" tall there are two basic decorating styles: eating a tropical flower or wearing a big bow. Polka dots are optional. Perhaps someone will find one with all three elements. Call us if you do. ($350-450 each.) *Authors' Collection*.

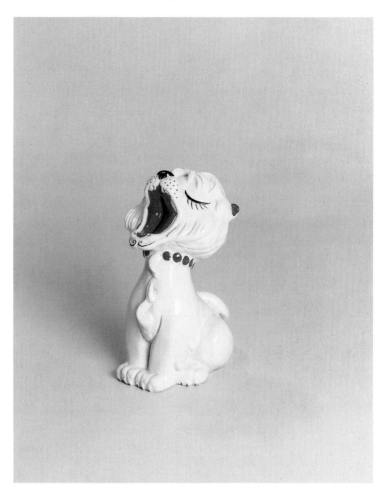

No zoo would be complete without the King of the Jungle. So Kay created this 8" *Lion Bank* (#5921). He's real hard to find, as are most of her works from 1954 on ($400-500). *Authors' Collection.*

This is Kay's charming Penguin Family. Left to right we have *Pete* (#466, $275-350) 7½", *Polly* (#467, $175-250) 4¾", and *Pee Wee* (#468, $125-150) 3¼". The glaze colors used on this series seemed to vary widely, so it's not easy to assemble a matched set. *Authors' Collection.*

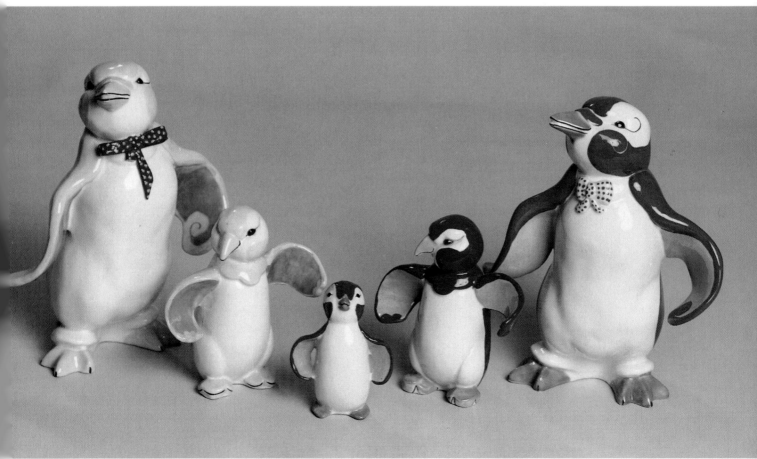

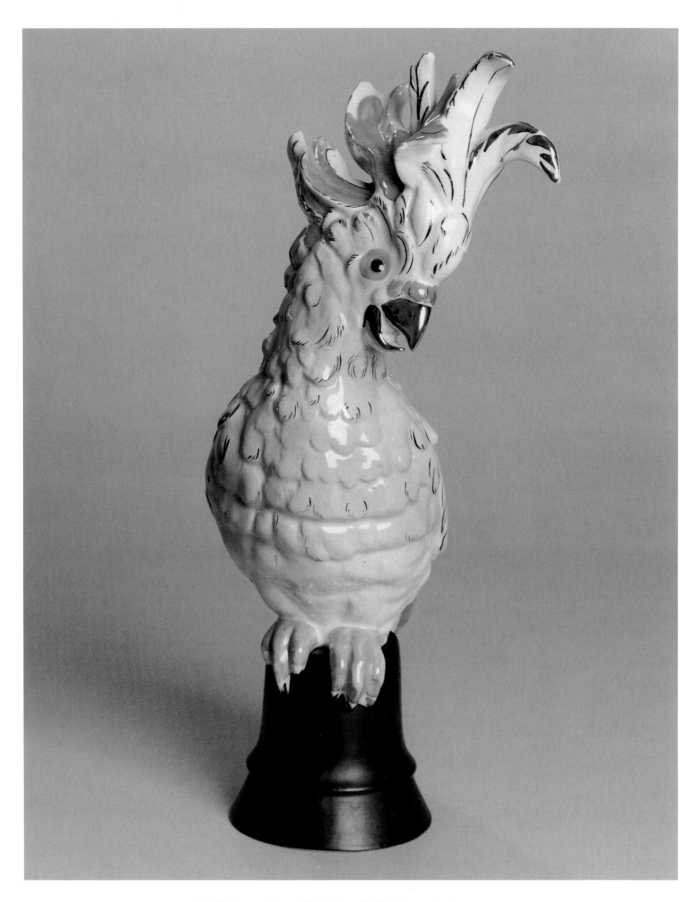

This fabulous *Cockatoo* (#5401) is 15" tall and is no doubt Kay's most ambitious and *exotic* bird. This one has a repaired feather at the top, but judging from the number of flaring ceramic feather spikes, it's amazing more damage didn't occur. Color it rare ($600-750). *Authors' Collection.*

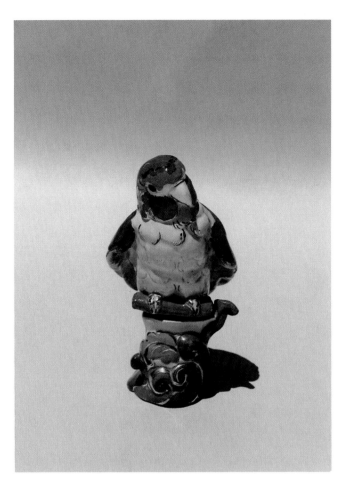

In 1951, Kay introduced *Parakeet On A Perch* (#5164), 5¾", to her buying public. What's interesting is that it had been created six years earlier and then apparently withheld for a later appearance. Our rationale here is that the multi-colored example on the left is initialed "K.F. '45." *Courtesy Finch Estate.* The brown, gold, and burgundy one on the right is decorated like the roosters and chicks in the previous chapter. ($175-225 each.) *Kaye & David Porter Collection.*

In 1954, she re-designed him to look like this fellow (#5403), adding a matte glaze perch and a lustre glaze to the body. The size is slightly smaller, 5½" ($125-175). *Authors' Collection.*

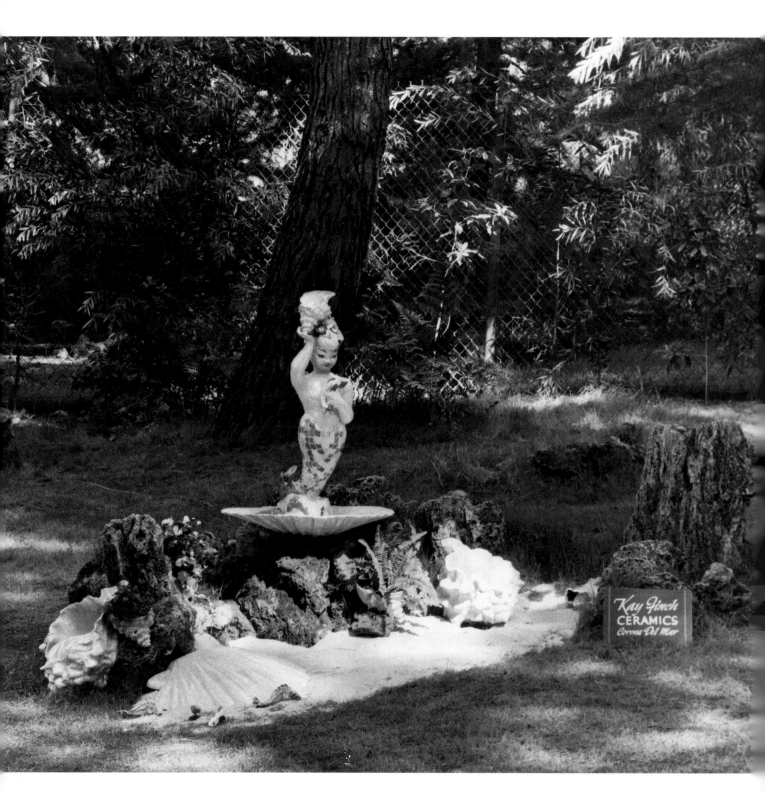

Here's a decorated *Merbaby Fountain* in a promotional photograph.
Circa 1950. *Courtesy Finch Estate.*

Her Undersea World

This is not just another fish story. Kay's denizens of the deep, although limited in scope, are long on desirability. The *Mermaid* and *Seababies* are a tour de force in clay and slip. The two fish that are also used as part of the *Merbaby/Water Baby Fountain* are hand formed and modeled, making each one an original, one-of-a-kind sculpture. Definitely 'see-worthy,' to coin a phrase.

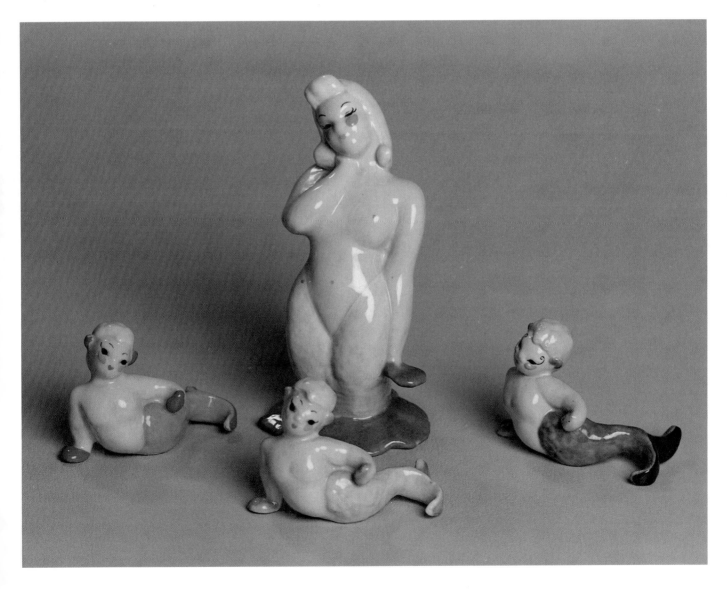

We are pleased to present Kay's Siren of the Sea: *The Mermaid* (#161, $450-550). And her *Seababies* (#162, $225-250 each). We were fortunate enough to acquire these back in 1990, and haven't seen any since. So they were *truly a reel catch!* She stands 6½" tall, while the babies are 2½" x 3½." *Authors' Collection.*

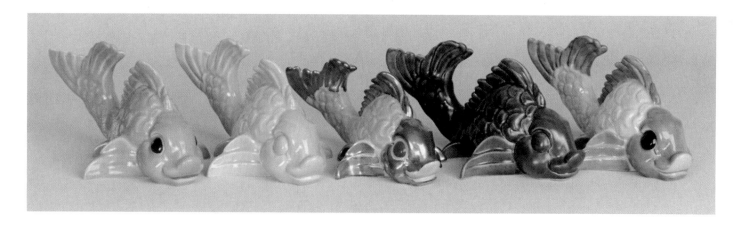

This *fintastic* group of water navigators is simply named *Fish* (#5008). They are 7" long and were obviously made in a myriad of glazes. The copper and aqua fella in the middle is slightly smaller (like the one on the left in the picture below.) Our first reaction was "repro." But the piece came from Kay's estate, and is signed by her, so she must have re-styled the mold. ($150-200 each.) *Kaye & David Porter Collection.*

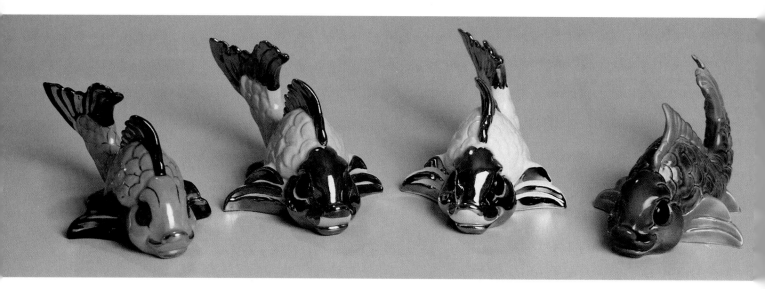

Here are four more *Fish* examples with unusual glazes, the two in the middle accented with a platinum finish (5008L). *Authors' Collection.*

These baby fish are called *Guppies* (#173). They measure just 2½" long and come in some unique glaze and color treatments ($100-125). *Authors' Collection.*

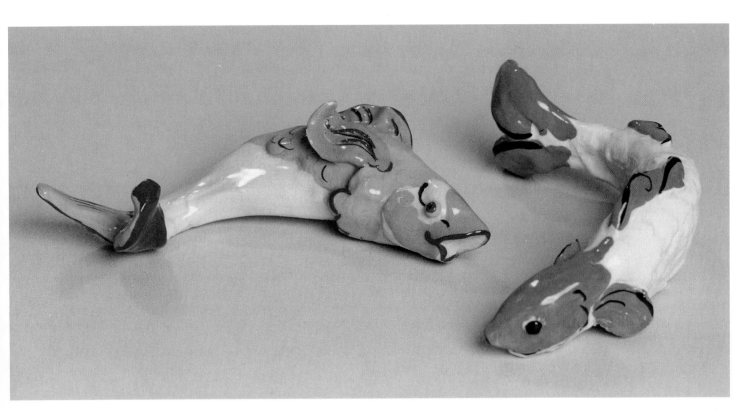

These fish are believed, by Frances Finch Webb, to be Grunion. They are 7" long, have no reference in the catalog or price list, but one is held in the right hand of the Merbaby (or Water Baby) Shell Fountain Set (#4618). We acquired these with Elizabeth Schlappi's collection, so we know they were purchased at Kay's studio. They are not molded; they're heavy, solid sculptures, and may be extremely rare (Unique). *Authors' Collection.*

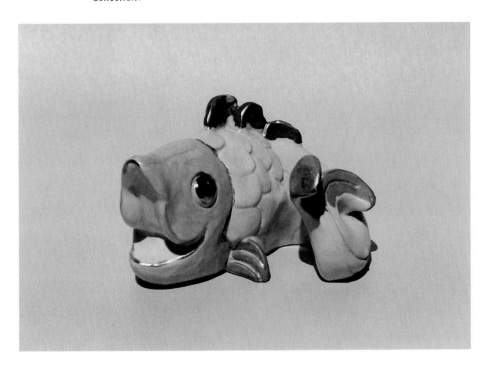

This cute denizen of the deep is appropriately named *Big Mouth Fish* (#6013). He's 3" tall and 4½" long to the curve in his tail. The finish is matte, like most of Kay's sixties productions ($275-350). *Authors' Collection.*

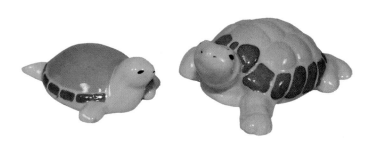

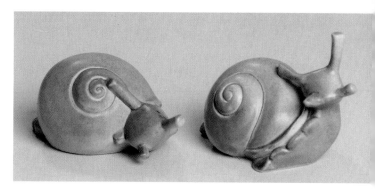

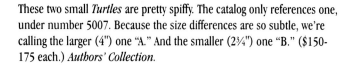

These two small *Turtles* are pretty spiffy. The catalog only references one, under number 5007. Because the size differences are so subtle, we're calling the larger (4") one "A." And the smaller (2¾") one "B." ($150-175 each.) *Authors' Collection.*

The glaze on these *Snails* is from the late fifties (#5476). Both are 6" long. The one on the left is 2½" tall; the other, 6" to the top of his antennae. ($175-200 pair.) *Authors' Collection.*

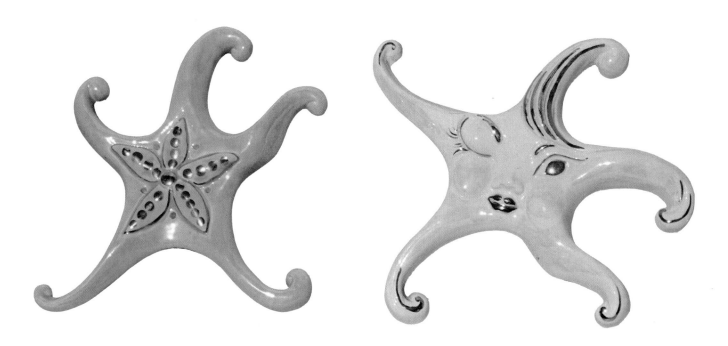

Kay's sometimes 'off-the-wall' design style translated into some 'on-the-wall' ideas for the bath. Here we have a pair of 9" *Starfish Plaques* (#5790), with two different interior design treatments. ($200-250 each.) *Courtesy Finch Estate.*

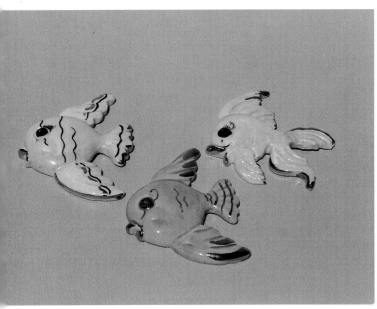

These little guys are called *Baby Fish*, and they're only 2¼" x 3". They'll hook you at first glance. ($50-60 each.) *Courtesy Finch Estate.*

Concluding our cruise through Kay's undersea imagination are two pieces. First, her largest *Seahorse Wall Plaque* (#5788), which is a majestic 16" long ($200-250). *Authors' Collection.* And finally, her 6" *Fish Vase* (#5712, $60-75), which was also available with lid (#5713, not pictured). *Kaye & David Porter Collection.*

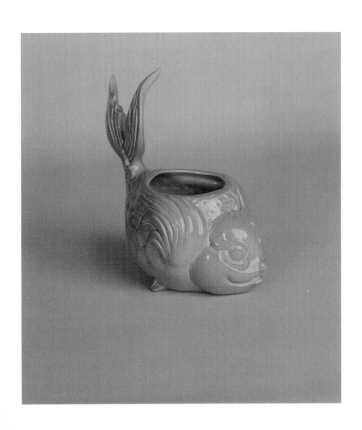

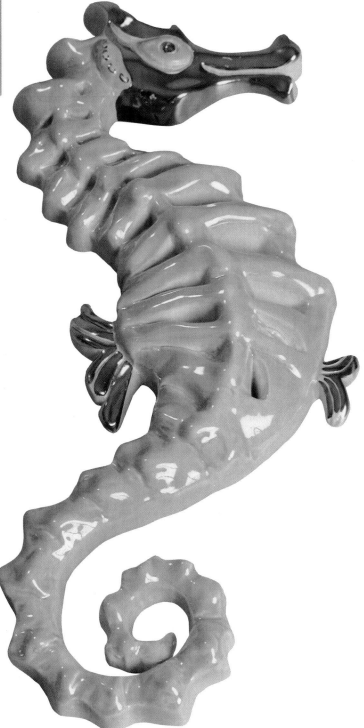

The Rest of Her World

Her People Collection

It has been said that Art imitates Life. One look at Kay's work and you'll see why. Her people evolved from experiencing life here, as well as in Europe and Asia, returning home to translate those experiences into ceramic artifacts imbued with that unmistakable Kay Finch personality.

The *Chinese Princesses*, clearly her finest works, were limited to an edition of twelve. They were designed to complement only the finest homes. Due to the restrictive price ($795), and the spectacular size (nearly forty inches tall), it is uncertain whether all twelve were actually produced.

This *Crown Princess* was once part of Kay's personal collection. She is an adventure into ceramics excellence that few gifted artisans would even dream of, much less attempt. Every minute detail is hand modelled and hand decorated. *Every one.* Jewelry. Fingernails. Crown. The trim on her gown. The flowers and jewels in her hair. Thirty-six inches tall, she is nothing short of breathtaking. Kay even made the decorative ceramic *hand mirror* as an accent piece to accompany her. It is seven and one-half inches long.

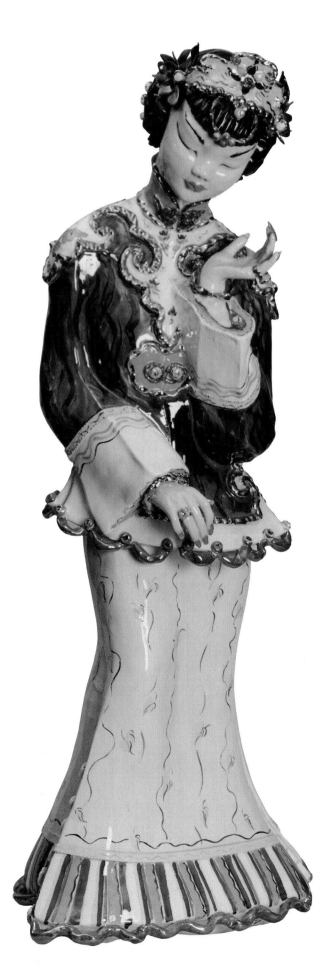

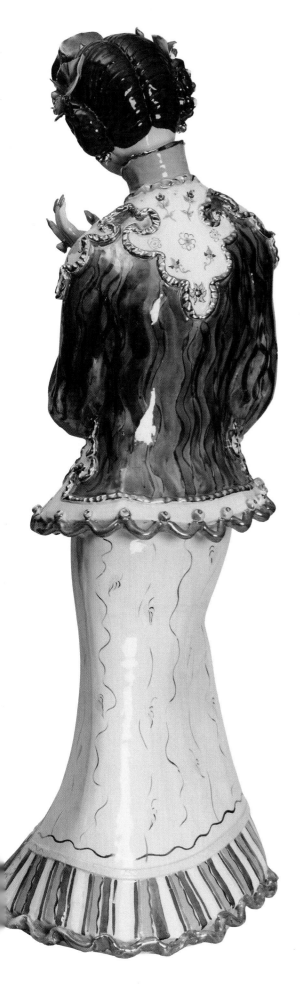

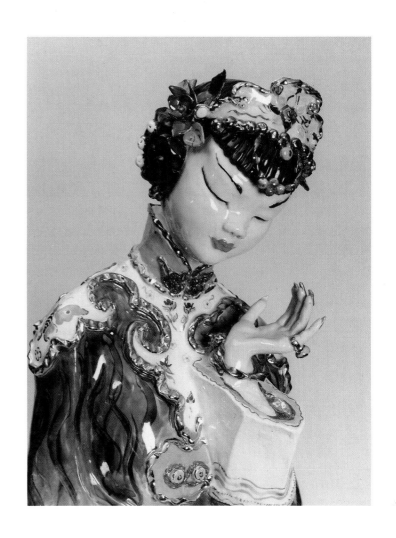

These close-ups will help you get a better idea of just how complex this ceramic masterpiece really is. *Authors' Collection.*

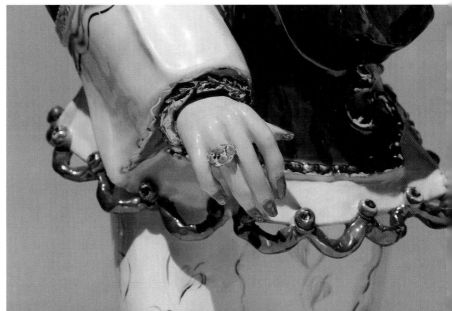

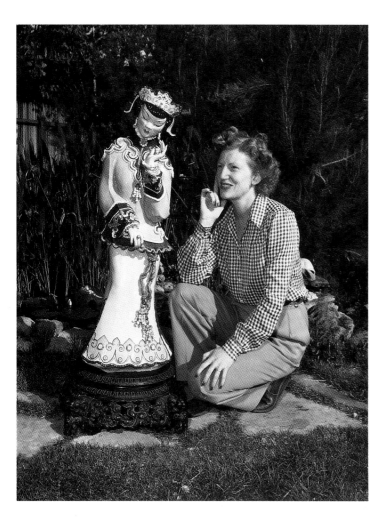

Kay, in 1943, poses next to a *Crown Princess*, mimicking her creation. This will give you a better idea of the size of this piece. *Courtesy Finch Estate*.

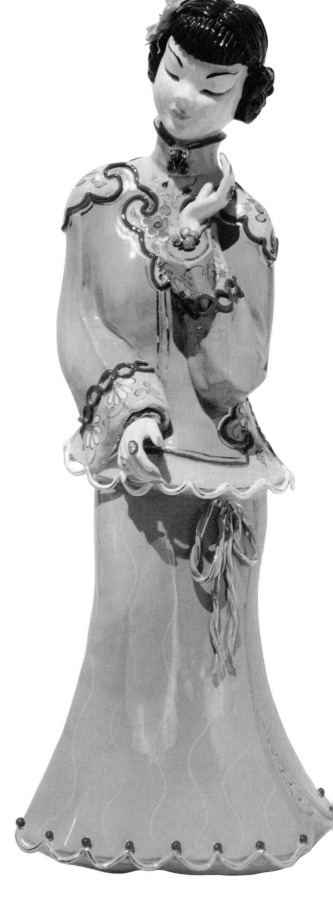

You're looking at a second *Princess*, named Camellia or Pong-Jee, sans crown, who stands 38" tall, 2" taller than the Crown Princess. Her detail is not quite as elaborate, but she's a beauty in her own right ($5000-6000). *Courtesy Finch Estate*.

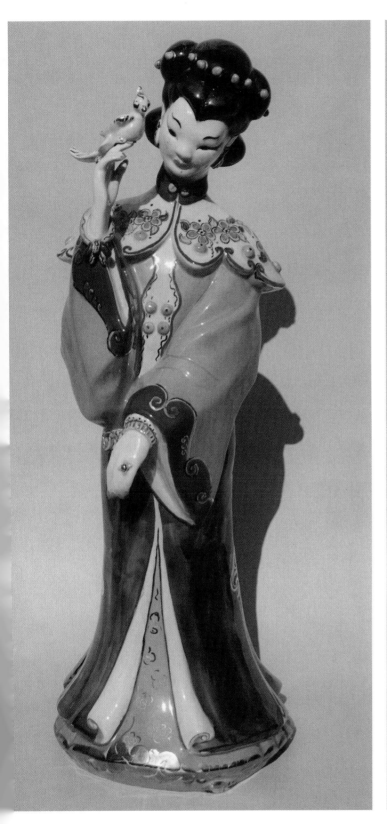
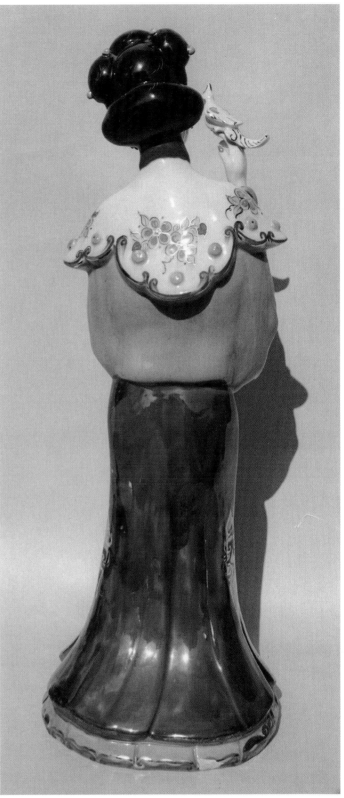

This beautiful lady is called *Chinese Princess* (#477) in the Studio Catalog. She is 23" tall, exceptionally well done, and was available in three finishes ranging from decorative pastels to pink pearl/gold/green, to metallic green. A mahogany stand was also available ($1250-1500). Dorothy Lombard Collection.

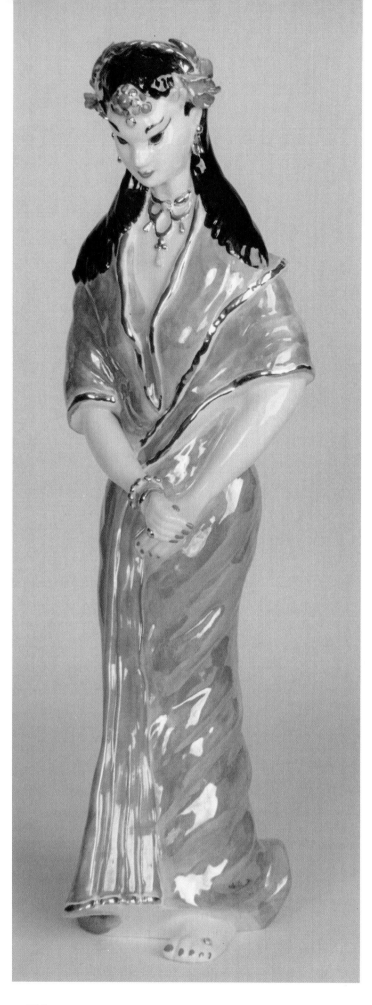

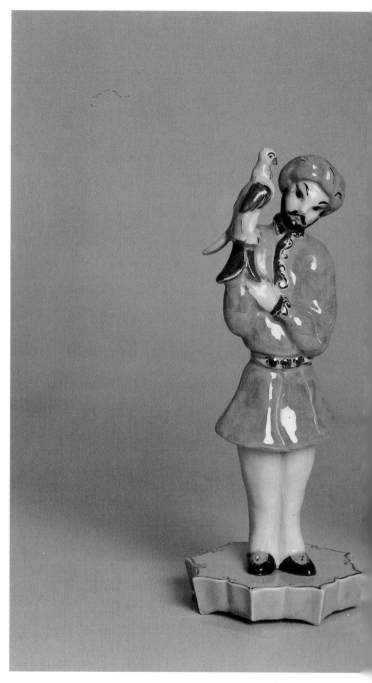

To reiterate, Kay had few peers when it came to concept, glazes, and details. This is her *Persian Harem Girl* (#5161). She is 16" tall, has a companion named *Persian Hunter* (#5160, not pictured) and is exquisitely done. We chose not to buy them several years ago, and berate ourselves today for that decision. ($800-1000 each.) *Kaye & David Porter Collection*.

THIS is the *Sultan*, 10" x 8". Frances Finch Webb does not remember that her mother ever made him. There are no catalog references to substantiate his existence. He *looks* like a Kay creation. He *feels* like a Kay creation. And when you read the inscription on the bottom…"Kay Finch to Jack (Chipman). Come see me again sometime. August 16, '83"…you know he *is* a Kay creation (Unique). *Authors' Collection.*

We *did* however have the good sense to purchase this pair: *Persian Hunter* (#5162) and *Persian Dancer* (#5163). They are beautifully done in the same glaze techniques as their taller cousins, and stand 9½" tall. ($400-500 pair.) *Authors' Collection.*

The *Persian Dancer* was also done in a matte black glaze as a table centerpiece with matching flower bowl ($175-200). *Authors' Collection.*

As they say…"Best Wishes to the Bride…Congratulations to the Groom." This happy couple (#204) was united by Kay in the early 1940s. Perhaps they even appeared on a California wedding cake before becoming a permanent part of the line. He's 6½", she's 6". ($500-600 pair.) *Authors' Collection.*

Meet the American Indian Family. *Indian Brave* (#205), 6¾"; *Papoose* (#207), 3½"; and *Indian Squaw* (#206), 6½". You'll never have reservations about owning this trio. They're absolutely delightful. ($400-500 set.) *Authors' Collection.*

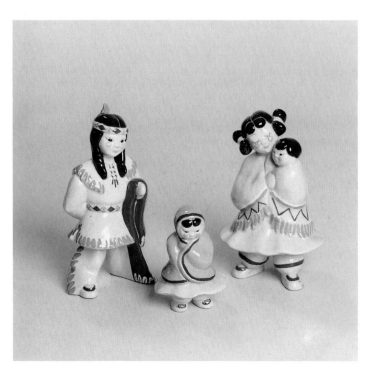

St. Francis (#5456) was made not only as a stand-alone figurine, but also, with the addition of a fount, bowl, and pump, as a fountain. The figurine alone stands a stately 24" tall ($900-1000). *Courtesy Finch Estate.*

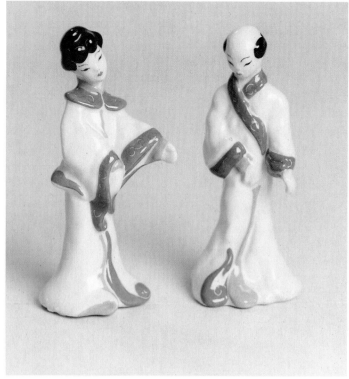

In this photo, the *Chinese Boy* (#4629, $100-125) is watching three 1½" inch tall *Tiny Marching Ducks* (#4631, $75-100 each). When the Chinese Boy and Girl were first introduced, a free pair of ducks was given with the purchase of the pair. Later, they were sold individually. Perhaps they're hard to locate today, because they are unmarked. *Authors' Collection.*

This is the *Chinese Boy* (#4629, $100-125), 6¾", and *Chinese Girl* (#4630, $100-125), 6¾", posed atop Kay's 14" *Sampan* (#5763, $60-70). *Authors' Collection.*

This interesting 5" pair, *Oriental Sage* (#4854) and *Oriental Maiden* (#4855), could be ordered in hand-decorated pastels (as shown), in pink pearl, or in solid glaze with gold. ($150-200 pair.) *Authors' Collection.*

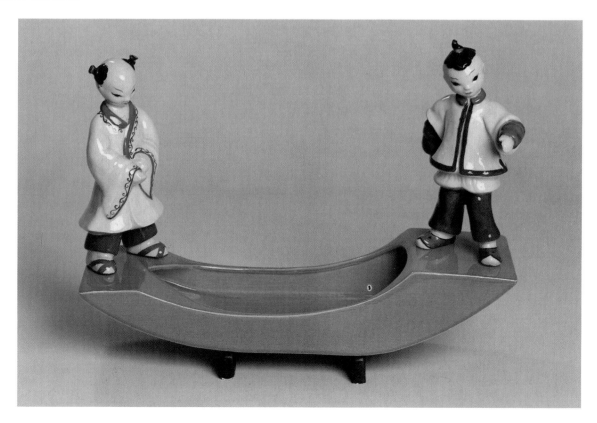

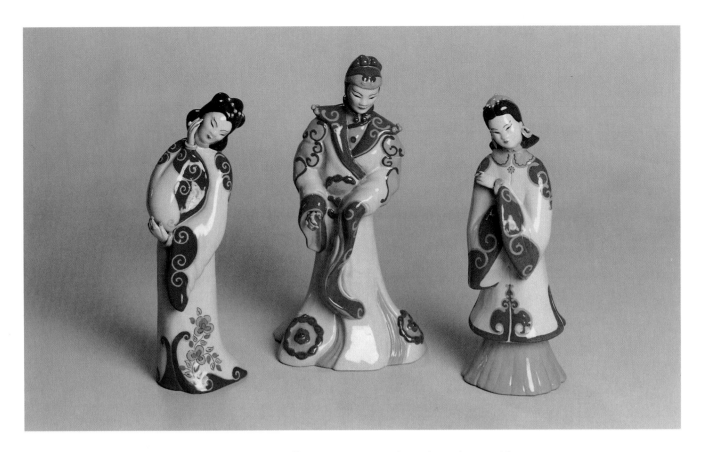

A Mandarin and two different Court Ladies make up this striking trio. The *Court Prince* (#451) is 11", the *Court Lady* (#401) on the left is 10", as is the *Court Lady* (#400) on the right. ($175-200 each.) *Authors' Collection.*

Kay must have been experimenting with this #400 *Court Lady*. She's the same size, but her face and hands are unglazed bisque. *Authors' Collection.*

This is Kay's *South Sea Girl* vase (#4912). She measures 8¾" tall ($175-200). *Authors' Collection.*

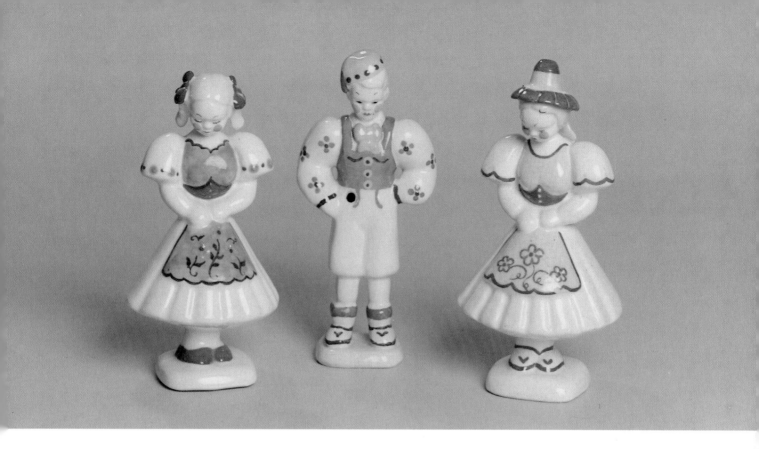

'Creative Freedom' must have been the battle cry among Kay's decorating staff while they were producing her 6¾" tall *Peasant Boy* (#113) and *Peasant Girl* (#117). Each piece becomes an original work of art. Other than some fixed molded detail, there are really no two pieces alike. In the above photo, there is an opening in the boy's hand that could hold a fresh or artificial flower. ($150-200 pair.) *Authors' Collection.*

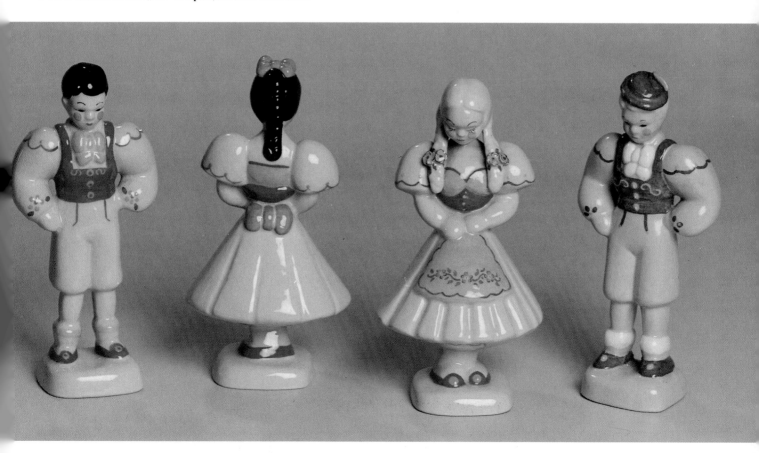

Here they are again. The only thing that remains constant in these two groupings is the gender. *Kaye & David Porter Collection*.

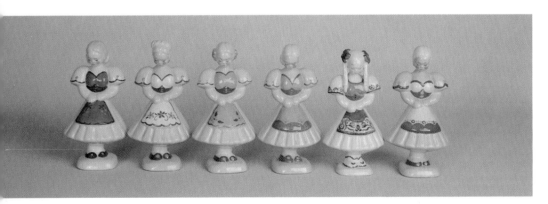

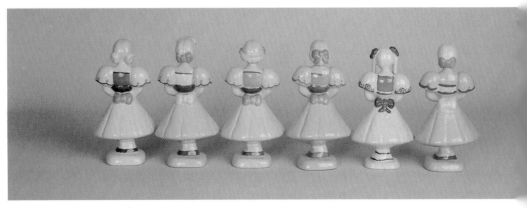

In this chorus line of *Peasant Girls*, you have the opportunity to view the decorators' creativity from two points of view. *Kaye & David Porter Collection*

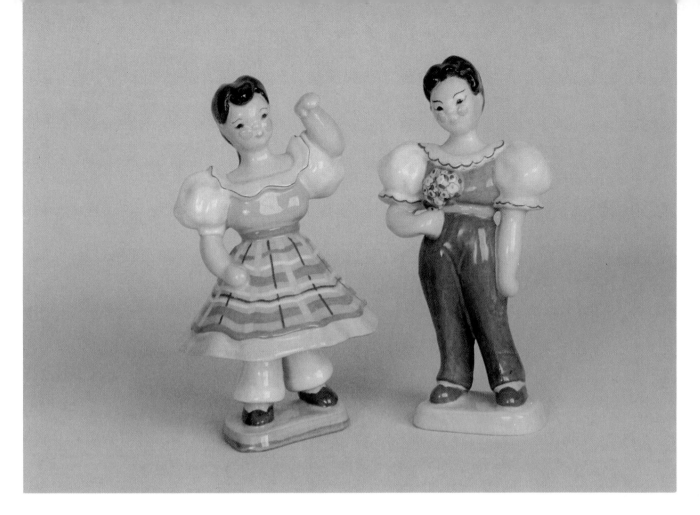

We've searched and searched but we can't find a number or description for this Scandinavian-looking Couple. They are 7½" tall and decorated in traditional Kay Finch glazes. If you find them somewhere in an ad or catalog page, we'd love to hear from you. ($350-450 pair.) *Kaye & David Porter Collection.*

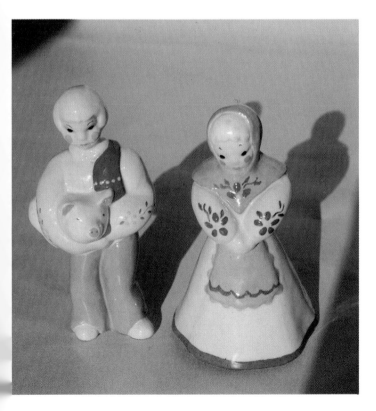

Here are Kay's *Scandie Girl* (#126) and *Scandie Boy* (#127). They are both 5¼" tall. ($200-250 pair.) *Authors' Collection.*

Here she is again made as a pair of candle holders. The height is the same, so part of the head had to be removed while the clay was damp, and then the candle supports added. ($275-325 pair.) *Authors' Collection.*

Kay's Godey Ladies and Gentlemen were produced with as much variety and flexibility as the Peasant Children. There are two different pairs that differ only slightly in overall design. The addition of capes, hats, flowers, and fans all contribute to changing the end result. This pair, which stand 9½" tall, is called *Godey Man and Lady* (#122). They sold for $22.50 a pair fifty years ago. ($250-300 pair.) *Authors' Collection.*

This photo will give you an idea of the degree of change that can occur with the addition (or deletion) of certain design elements. *Authors' Collection.*

Note the elaborate hats and hand painted dress trim on this pair. *Authors' Collection.*

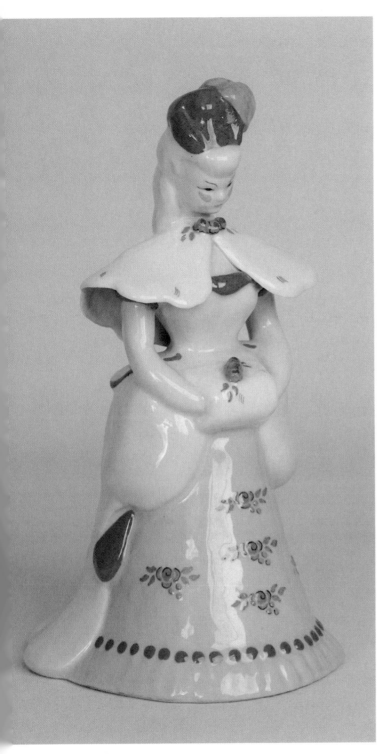

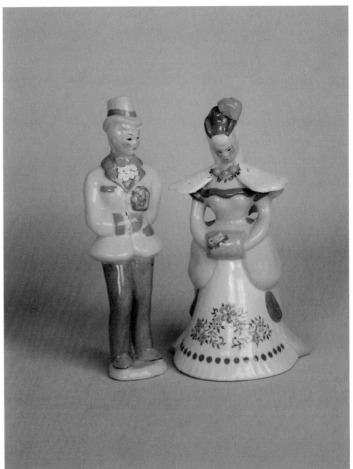

The changes in these three examples are evident, but not major, consisting mostly of heavy slip floral appointments. The cape on the lady was optional, costing an additional $2.50. *Kaye & David Porter Collection.*

This is the other *Godey Man and Lady* (#160). They are 7½" tall and, while attractive, do not get all of the extra "add-ons" accorded their taller companions. These sold for $12.50 the pair—still a respectable sum for the middle half of the twentieth century. ($150-200 pair.) *Kaye & David Porter Collection.*

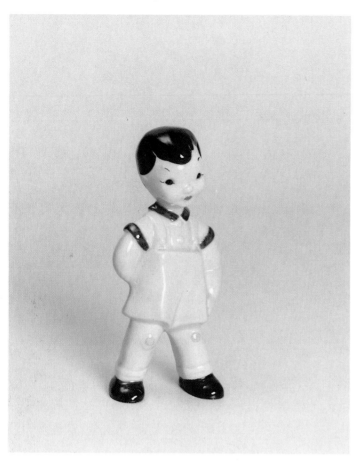

This is Kay's version of *Casey Jones, Jr.* (#5013, $150-200). He stands 5½" tall and is part of a three-piece set that includes a small train and a playmate called *Goody Girl* (not pictured). His knobby knees are testimony to the clever touches that permeate Kay's work. *Courtesy Ron & Juvelyn Nickel.*

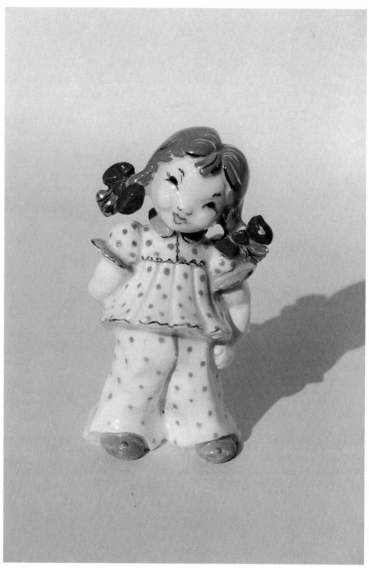

Meet the *Pajama Girl* (#5002). She is also 5½" tall and a real sweetie ($175-225). *Dorothy Lombard Collection.*

"Yes, sir, that's Kay's Baby...No, sir, don't mean maybe." This *Sitting Baby* (#5026, $125-150), also 5½", was a busy little toddler. He also appeared extensively on planters in Kay's 'Baby's First from California' line, but with fewer colors. *Authors' Collection.*

Her Indoor and Outdoor Collection

Some people just don't know when to quit...thank goodness! Not content with designing figurines and planters, Kay applied her expertise to the creation of some rather spectacular outdoor garden fountains. Then for good measure, she created one that would function *inside* the home.

What next? Wonderful banks in the shapes of houses and barns. A unique gable-styled clock trimmed with a miniature dove. Functional vases, bowls, and ashtrays. Topped off with a superb pair of pearlized, almost Romanesque, mask-like wall vases that would easily be the highlight of any wall pocket collection.

For a limited time Kay's son, George, even had the opportunity to apply his creative talents, designing bowls and decanters. The *Moon Bottle*, available with or without stopper, was one of his most celebrated accomplishments.

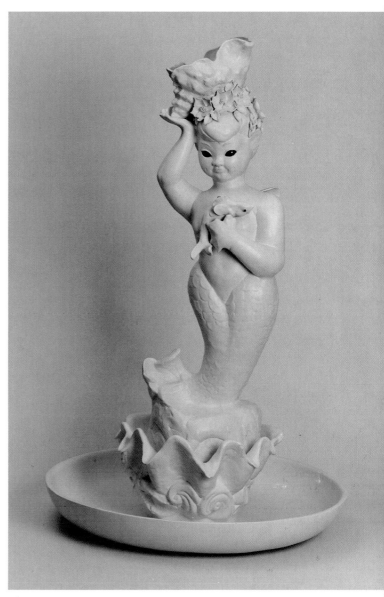

Here she is...the *Merbaby Fountain* (#4618), in a shell pink glaze. Including the fount and bowl, she stands an impressive 37" tall. We have the original pump as well, but have yet to hook it up ($1500-2000). *Authors' Collection.*

These 'fountains' (#5388) are only 6" tall. Kay called them *Bird Bath with Bird*. ($125-150 each.) *Authors' Collection.*

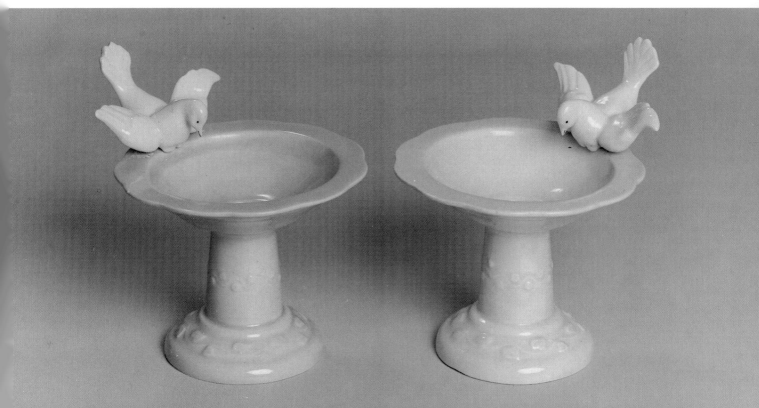

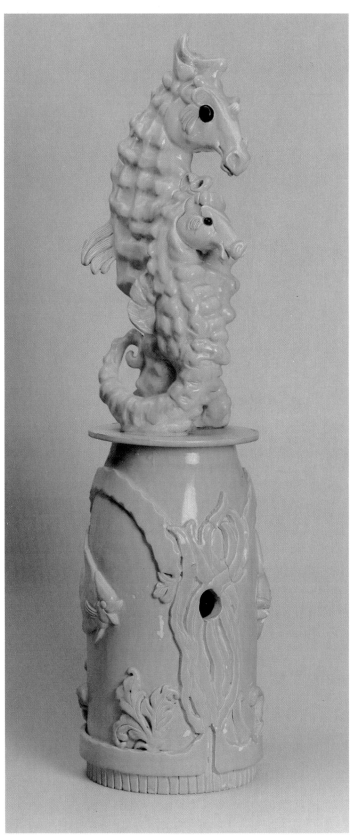

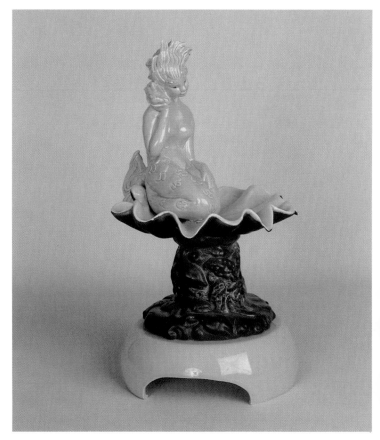

This is the *Sea Nymph Table Fountain* (#6064), with fount and display stand, in a lovely Celadon Green and Midnight Black glaze ($500-600). *Kaye & David Porter Collection.*

Here she is again in a matte Imperial Purple glaze (without stand) measuring 14" tall. If you hold your ear up close to her, you can almost hear the sea ($500-600). *Author's Collection.*

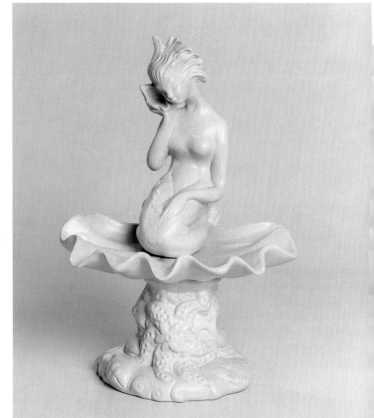

You're looking at the *Seahorse Fountain* (#6063), in a Celadon Green glaze. This phenomenal sculpture resided outdoors for many years at Kay's home in Corona del Mar, attached to this customized aquatic ceramic base. There are a few minor glaze problems in the base from years of exposure to the elements, be we love it just the same. Its total height is 42" ($1000-1500). *Authors' Collection.*

This cute little ceramic frying pan, entitled *Small Skillet* (#5111), is made to hang on the kitchen wall. Pretty classy. 8½" long ($60-75). *Authors' Collection.*

These canisters would do any kitchen proud. On the left, Kay's *Large Canister* (#5109), 9½", on the right her *Medium Canister* (#5108), 7½". ($150-200 each.) *Authors' Collection.*

We purchased this platinum-glazed centerpiece (14" x 5" x 5") with the pair of platinum doves pictured earlier. Our assumption is that all three pieces were used for table decoration ($75-100). *Authors' Collection.*

Kay designed this piece as a *Rooster Cocktail Plate* (#5409), 7½" x 9½". Note the openings designed for canapés. This is also a pretty snazzy rooster. We'd love to find one done in natural and pastel glazes ($200-250). *Authors' Collection.*

This outstanding 7" x 7" mantle clock was made specifically for collector Elizabeth Schlappi. Kay went to her home in 1979 to visit and view her collection, and Kay personally signed the majority of these pieces. The inscription on the base of this clock reads: "Nov. 4th, 1979 (11:54 AM). I have enjoyed my visit here very much and will never forget this day. Kay Finch." (Unique). *Authors' Collection.*

George Finch, Kay's son, also 'got his hands wet' at the studio. His classic *Moon Bottles* are still prized decorator pieces today. These are the two largest in a set of five. The tallest (#5502) is 17", the lavender glaze bottle (#5503) is 13" tall. ($200-250 each.) *Kaye & David Porter Collection.*

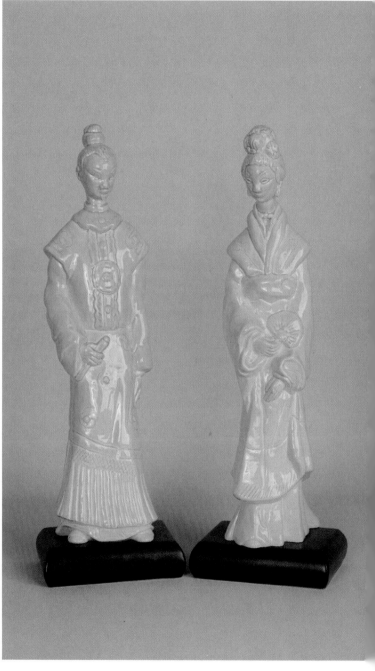

These are Kay's *Ancestor Figurines* (#5710 and 5711), which stand 18" tall. They were also available as wall planters which were 26" tall. ($200-250 pair.) *Kaye & David Porter Collection.*

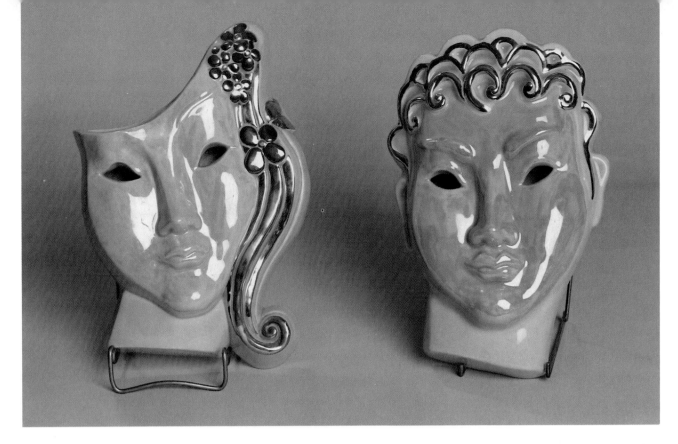

This pair of wall vases, done in pink pearl, gold, and silver are absolutely fabulous. She is 11" tall (#5502), and he (#5501) is 10" tall. They were named, simply, *Girl Wall Pocket* and *Boy Wall Pocket*. ($350-450 each.) *Authors' Collection.*

This is the *Girl Wall Pocket* done in a glossy gold glaze. Spectacular. ($200-250 each.) *Joan Letterly Collection.*

This trinket box and napkin ring were made as table favors for her daughter Frances' engagement party, and are dated Sept 12, 1944. (Unique.) *Courtesy Finch Estate.*

125

Kay created a unique series of banks in the following shapes: three houses, a church, and a barn. In this photo (left to right) are: 1) The prototype for her *Victorian House Bank* (#4612). It stands 5½" tall and is signed "Flower Street House, Kay Finch 1944." It was patterned after Kay's residence in Santa Ana. 2) Her *Russian Barn Bank* (#4627), 4", most likely was conceived from sketches made on her world tour, and; 3) *English Village Bank* (#4611), 5½". It, like the Russian Barn Bank, and the bank in the next photo, must have been constant reminder of Kay and Braden's overseas adventures. ($350-450 each.) *Authors' Collection.*

This recently acquired *Swiss Chalet Bank* (#4628), at 6", leaves us one shy of the complete set. Perhaps someone will find the 6¾" *Church Bank* and let us know. ($350-450 each.) *Authors' Collection.*

Her Nursery Collection

Kay's lovable, huggable figurines were the ideal way to brighten baby's room. So she created a series of planters and decorative designs to fill that need. They were offered in solid glazes or hand-decorated styles, but different colors of slip were used for the hand-decorated versions to separate them from their regular-line 'cousins.'

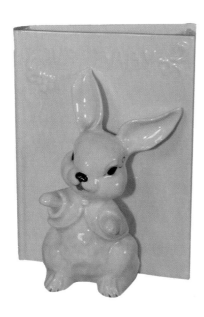

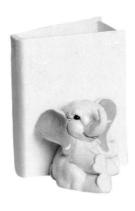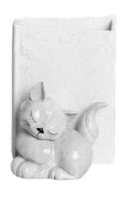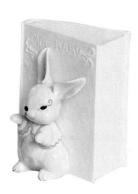

Planters for baby's room must have been the 'cat's meow' back in the fifties. We counted at least two dozen varieties in Kay's 1955 catalog alone. Her charming critters and happy babies were virtually unequaled in the gift marketplace. These three examples are from the *Animal Books* series, and stand 6½" tall. The one on the right is number B5145. The second photo shows it in a solid yellow glaze. ($100-125 each.) *Authors' Collection.*

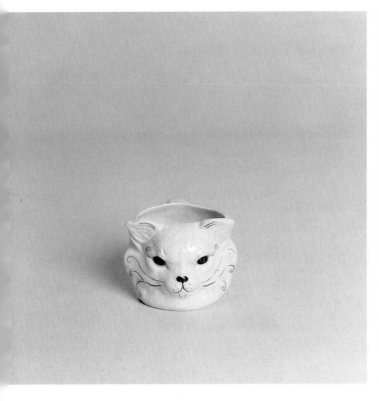

Kay also made two delightful drinking cups with the 'bowl' in the shape of a dog or a cat. This is the *Kitten Face Toby Cup* (#B5122, $200-250), 3". *Authors' Collection.*

In this picture we see an example of the *Animal Blocks* series. On the left is *Lamb on Block* (#5118), 4" tall. The one on the right is the *Elephant Vase* (#B5155), 6" tall. ($100-125 each.) *Authors' Collection.*

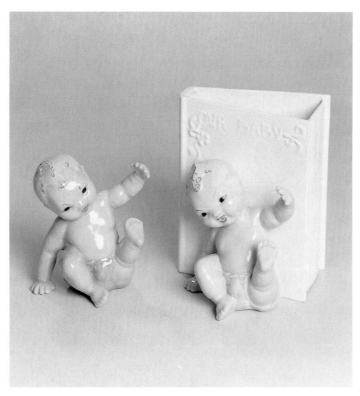

This one is called, obviously, *Baby Book* (#B5143). It is also 6½" tall. We photographed it with the Baby figurine alongside, so you could see the difference in the finishing process ($100-125). *Authors' Collection.*

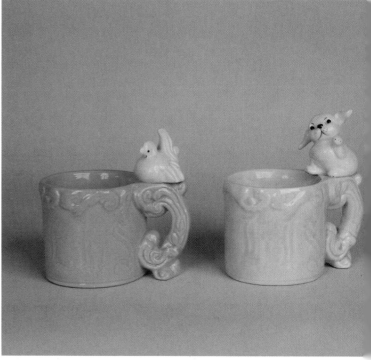

Kay designed both a Kitten and Puppy Globe Stand as part of her Baby Novelty line. The *Puppy* (#B5541D, $125-150), 6", looks like he's reaching into the bowl. (We couldn't resist putting a *Guppy* with the puppy. Most people filled the globe with flowers.) *Authors' Collection.*

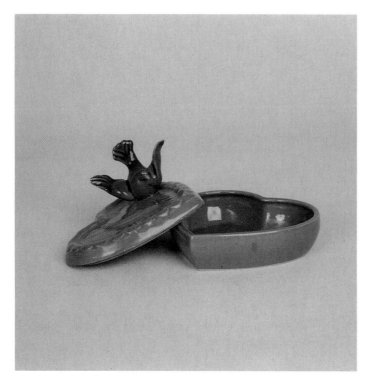

Here's the *Heart Box* (#B5051), 2½", that was utilized for an engagement party favor in the previous section. It has also been referred to as a 'trinket box.' Maybe baby's safety pins were kept here ($75-100). *Kaye & David Porter Collection.*

These are Kay's *"His" and "Hers" Kissing Mugs* (#B5415), 3½". The concept is that the animal on top kisses the child's cheek when he or she drinks from the cup. (It works if you're right handed.) The mugs are embossed with "HIS" on the blue and "HERS" on the pink. We'll bet the kids loved it! ($125-150 each.) *Kaye & David Porter Collection.*

128

Her Holiday Collection

Deck the halls with Kay Finch Pottery...Fa la la la la...La la la la. It certainly was possible. Nativity scenes, Santa figurines, mugs, covered jars, and luncheon sets; angels by the score; ceramic trees and bells; holly-trimmed punch bowls. The list goes on.

There were special turkey ensembles designed for the Thanksgiving table. Kay even remembered Easter with several home-enhancing options.

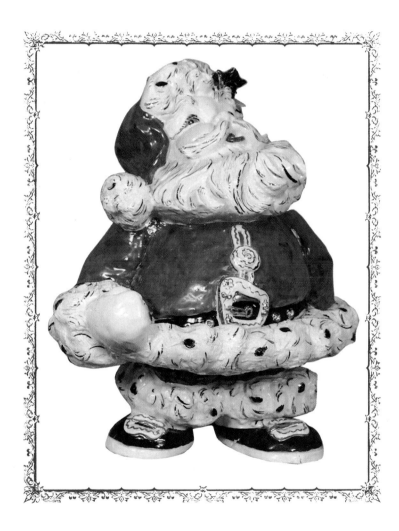

Introducing the one item that's on every Kay Finch collector's Christmas Wish List—ours included. Her magnificent 18" x 18" *Santa Claus* (#6050). In 1960, he sold for $125, so there can't be many of them out there ($1000-1250). *Joan Letterly Collection.*

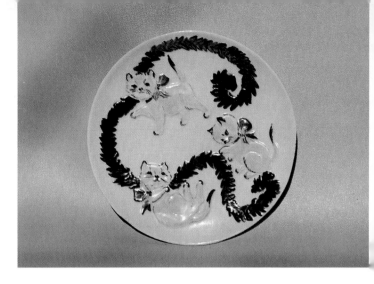

Kay did a series of twelve Christmas plates. This is her thirteenth, which was scheduled for 1962. According to her daughter, Frances, this plate never went into mass production (Unique). *Courtesy Finch Estate.*

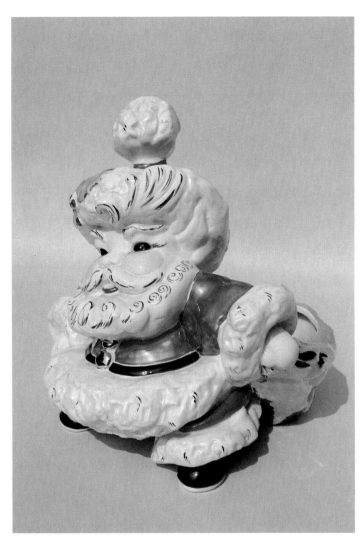

This is Kay's 10" x 10" *Santa Sack Holder* (#5975). If you, like the song says, "Just go nuts at Christmas…" then you, like us, would love to have him featured in your holiday decor. We keep writing the other *real* Santa for one, but he hasn't come through yet ($250-300). *Sharlene Beckwith Collection.*

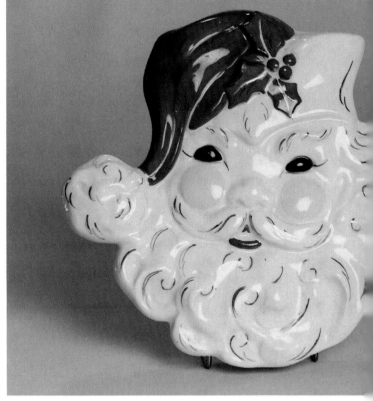

If you happened to stop in for a cup of holiday cheer, we'd serve you in Kay's famous 4" *Santa Claus Toby Jug* (#4950, $125-150), served from her *Holiday Wreath Punch Bowl* (#4951, $100-125), 5¾" tall by 10" wide. *Authors' Collection.*

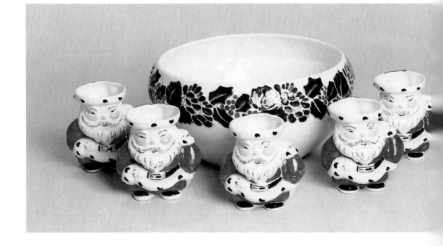

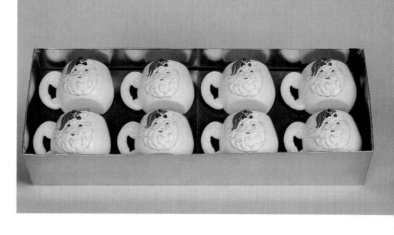

Continuing with our Christmas tour, this is a set of eight Santa mugs from Kay's *Christmas TV Set* (#5951), 2½". They're out during the holidays if you visit the right home in Arizona. ($75-100 each.) *Kaye & David Porter Collection.*

Several years ago, we were fortunate enough to acquire this pair of 9½" *Santa Wall Pockets* (#5373) from Kay's estate. They are magnificent, and greet visitors to our home each and every Christmas season. ($350-450 each.) *Authors' Collection.*

Here's what the above mugs look like when they're resting on the matching plate. And right next door is a wonderful *Santa Canister*, 10½", that we can't find listed anywhere ($150-175). The *Santa Toby Jug* adjacent to it is there for purpose of scale. *Kaye & David Porter Collection.*

Here we have the *Santa Toby Jug* with a hat lid (5½"). Possibly the lid was used to keep Hot Toddy's warm. Or it could double as a candy container ($200-250). He's standing next to a festive 2½" *Christmas Bell* (#6056, $125-150), which is next to Kay's *First Annual Christmas Plate*, 6½", made in 1950 ($125-150). *Authors' Collection.*

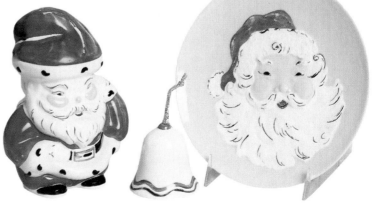

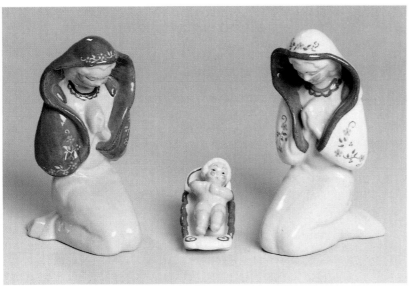

For the Nativity Set, Kay produced several figurines. Here is the *Kneeling Madonna* (#4900), 6", with two different glaze treatments ($125-150). The *Infant In Cradle* (#4900A) comes either attached to the cradle or as separate pieces. He is 4" long ($125-150). *Authors' Collection.*

This is *St. Joseph* (#6054), 10" tall and part of the set ($250-300). *Authors' Collection.*

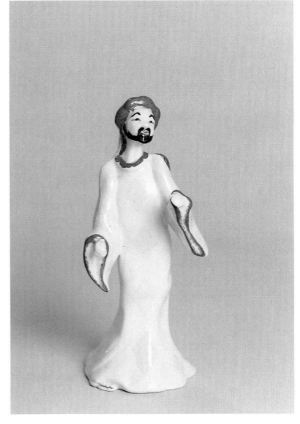

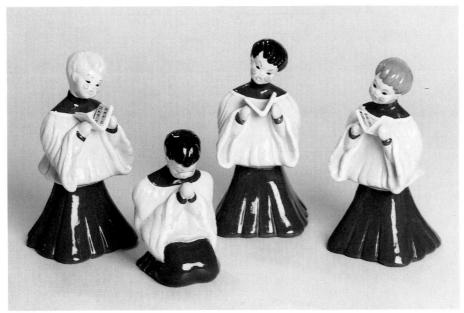

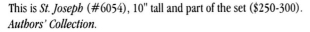

Kay's *Choir Boys* were extremely well done, and quite popular. Note the hand painted detail in the hymnal. The *Choir Boy Standing* (#210, $125-150) is 7½" tall, the *Choir Boy Kneeling* (#211, $85-100) is 5½". *Authors' Collection.*

These *Cherub Heads* (#212) look like smaller versions of the Choir Kids. They're 2¼" tall, come in a variety of colors, and are very desirable. ($75-85 each.) *Authors' Collection.*

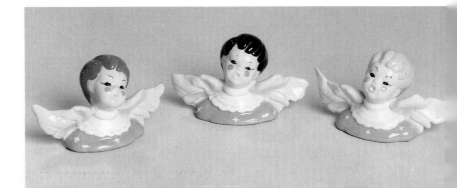

132

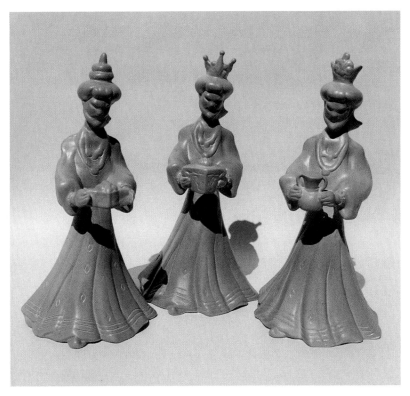

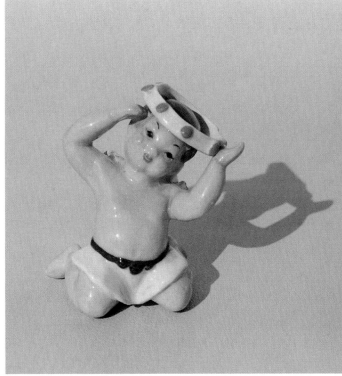

The *Three Wise Men* (#5590, 5591, 5592), 10", were produced with hand-decorated colors like Joseph. But this set was produced in a solid color Sand glaze, more typical of her late fifties or early sixties finishes. ($300-350 set.) *Jim & Jolene Andrus Collection.*

This cute little guy is called *Littlest Angel* (#4803). He is only 2½" tall and quite rare ($150-175). *Dorothy Lombard Collection.*

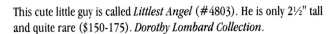

One of our earliest purchases was this beautiful pair of Angel Candle Holders, which stand 8½" tall. They're marked "1940" on the bottom and are finished in an ivory crackle glaze. We suspect very limited production ($250-300). *Authors' Collection.*

Kay's large *Madonna and Child* (#4858, $600-700) is 16½" tall. We have yet to see her. This image came from an archival photo in her daughter's possession. *Courtesy Finch Estate.*

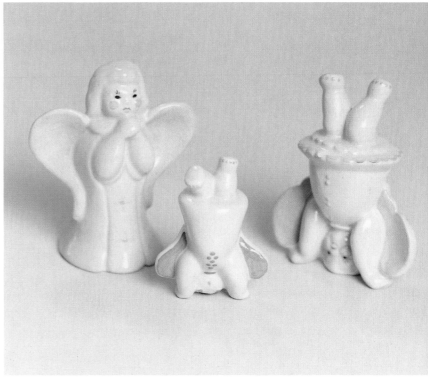

This *Singing Angel* (#4802, $175-200), 4½", is rather unique. And definitely hard to find. *Authors' Collection.*
Center Right: This is a miniature Nativity Set (#4952) which also doubles as a wall display. It's 5½" tall, so the angels and baby are true miniatures. ($100-150.) *Don R. Smith Collection.*

Nobody did angels like Kay did angels. She bent over backwards to be creative, and this grouping proves it. On the left is her 4" *Wide Wing Angel* (#140A, $125-150); on the right is her fabulous *Upside-Down Angel* (#140B, $175-200), also 4"; and in the middle, her *Little Upside-Down Angel* (#140C, $125-150), 2¾". *Authors' Collection.*

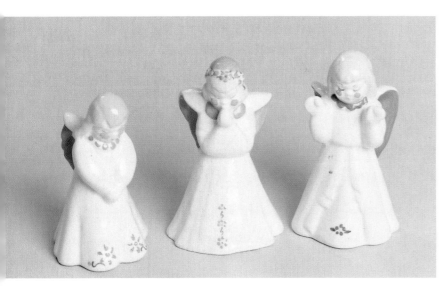

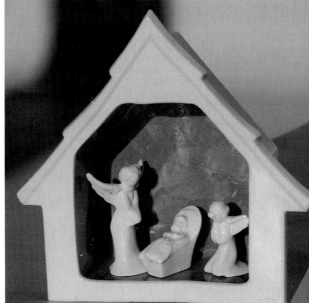

This trio of *Angels* represents some of Kay's earliest work. The Angel on the left (#114B) is 3¾" tall. The Angel in the middle (#114A) is 4¼", as is the Angel on the right (#114C). This group is done in a white glaze. ($75-85 each.) *Authors' Collection.*

Pink was the primary background color for this group of #114 *Angels*. Their letter codes are (left to right) C, A, C, B, C. The decorators had creative freedom here as well. *Authors' Collection.*

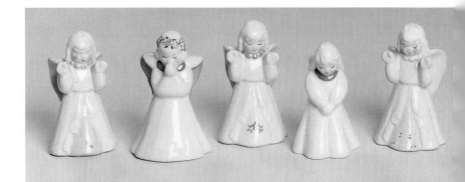

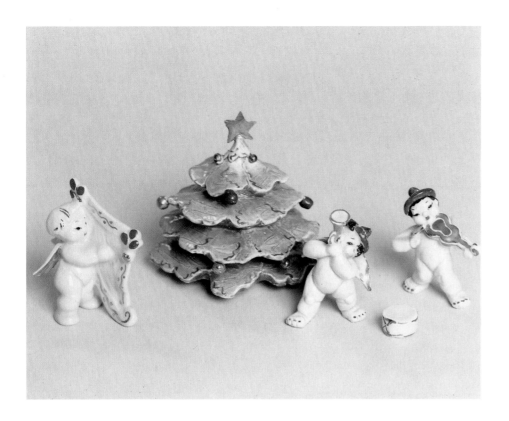

The final pictorials in this collection are Kay's little *Band of Angels*. This ensemble came from Kay's estate, and are the prototypes for the production pieces. The only missing band member was discovered later at Dorothy Lombard's home. They are, as follows: *Angel Child With Harp* (#5151); *Angel Child With Trumpet* (#5154); *Angel Child With Fiddle* (#5152); the tiny drum that goes with #5153 (below). They are grouped around a *Christmas Tree With Star* (#5150), 4", which was a gift from Kay to Braden and is hand-signed "Pop." Each of the band members is approximately 2¾" tall. They are, in a word, glorious. ($150-175 each.) *Authors' Collection*.

This is a backside view (no pun intended) of the *Angel Child With Trumpet* (#5154). *Authors' Collection*.

This is *Angel Child With (out) Drum* (#5153, $150-175). *Dorothy Lombard Collection*.

These little angels are also early pieces and not easy to find. The standing 3¾" cherub is called *Boy Angel* (#4910, $100-125) and his kneeling 2½" companion is named *Girl Angel* (#4909, $100-125). *Authors' Collection*.

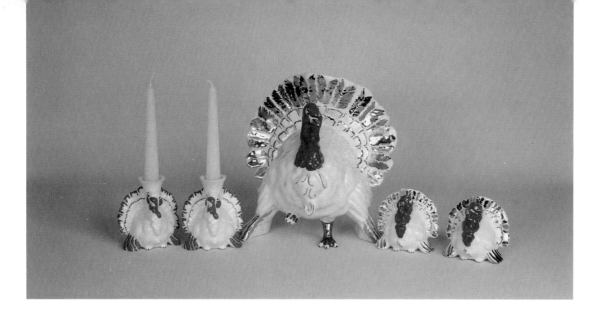

Nothing says lovin' like something from the 'ovens' of Kay Finch.
Thanksgiving dinners take on an extra glow with this ensemble. Left to
right, we have her 3¾" *Turkey Candlesticks* (#5795, $200-250 pair),
10" *Turkey Centerpiece* (#5795, with an opening for flowers in the tail,
$400-450), and the 3" *Turkey Salt & Pepper Shakers* (#5362, $200-250
pair). Bon Appetit! *Kaye & David Porter Collection.*

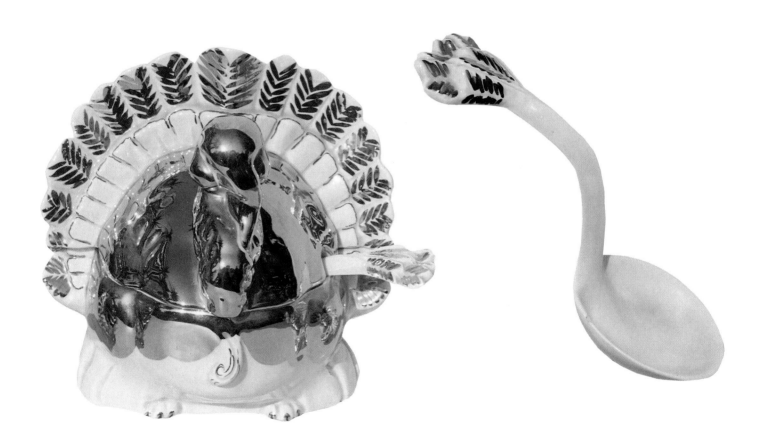

This 9" *Turkey Tureen* (#5361) in platinum and grey would look great
with bone china and silver service. The matching *Ladle* with feather
handle adds an extra touch of elegance ($400-450). *Dorothy Lombard
Collection.*

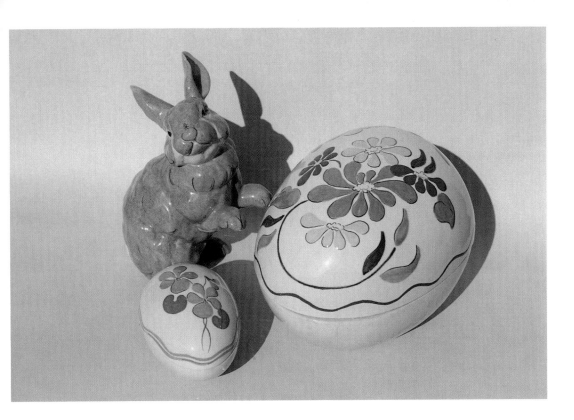

Easter didn't escape Kay's attentive eyes. Here are Kay's covered Easter Eggs, called *Egg Boxes*, pictured in two sizes (with a *Listening Bunny* for scale and effect), 9" x 8" ($150-175) and 3¾" x 5" ($100-125). *Dorothy Lombard Collection.*

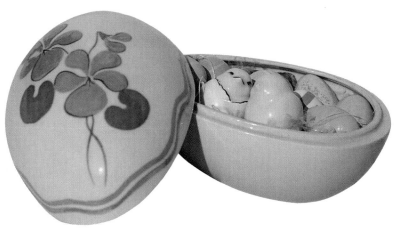

This photo shows the *Large Egg*, ready for Easter delivery. *Dorothy Lombard Collection.*

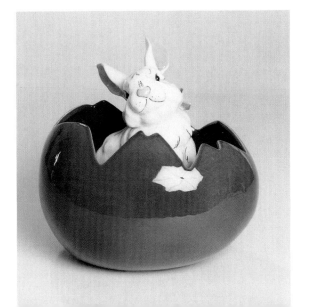

Kay created a series of three broken ceramic eggs ideal for Easter candies or floral arrangements. This one, called *Large Broken Egg* (#5542), is 9" x 5¾" ($100-125). The bunny inside is optional. *Authors' Collection.*

From Pacific Coast Highway
to Pennsylvania Avenue

There is a distillery in Louisville, Kentucky that still produces a liqueur called Southern Comfort. Back in 1948, the president of that company, Francis E. Fowler, invented a drink using his product that carried a special *kick*. So it was appropriately named...*The Missouri Mule*. Coincidentally, another President, Harry S. Truman, no less, was a favorite of Fowlers. And Harry S. Truman hailed from Missouri.

What happened next put Kay and Braden, so to speak, on the road to the White House.

Fowler commissioned Kay Finch Ceramics to design a victory cup to toast Truman's re-election to his second term as President. A series of twelve cups were made in three colors: gold, silver, and rose lustre. Each was emblazoned with the words *Missouri Mule* on one side, and *Southern Comfort* on the other. Hand-lettered underneath the latter on each of the cups was the phrase: *MADE ESPECIALLY FOR PRESIDENT TRUMAN.* They were designed to stand on the opening when empty and on the head when full. The cups met with instant success, as you can readily see from this feature article in the January 17, 1949 issue of the *Santa Ana Register*...

"When Democrats in Washington drink victory toasts these days, chances are that many of them—including the party's top man, President Harry Truman—drink from 'Missouri Mule' cups, designed by the gifted hands of Kay Finch, Corona del Mar ceramist."

"And when they drink, the cunningly contrived cups are a close reminder of their party symbol, for they are designed as the head of a mule, an animal well-known and respected in the President's home state of Missouri."

"President Truman has a dozen of the cups, a present from Francis E. Fowler, Los Angeles, president of a nationally known distilling company who conceived the idea for the cups. Fowler is also the inventor of a drink, 'The Missouri Mule,' which is the name emblazoned on the cup rim."

"Kay Finch designed the cups after Fowler explained his idea. 'It wasn't easy to do,' she said, 'but on the second try I got one that was right.' The first dozen

Here are all three of the famous 4¼" *Missouri Mule Cups* in the original glazes. The rose lustre cup in the middle (Unique) is one of the approved prototypes for the original run of twelve. The other two were part of the second run, which became gifts to other important political figures ($350-400 each). *Authors' Collection.*

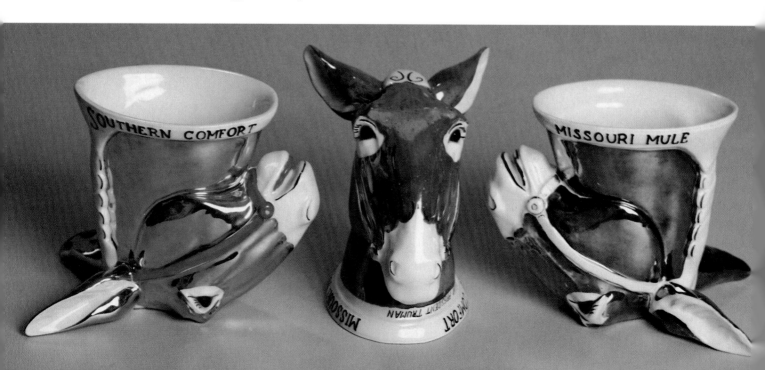

cups went to the President, with the inscription 'Made especially for President Harry Truman.'"

"After other members of the White House staff took a look at the cups, there was an instant clamor for more of the same. So many, in fact, that the Finch concern is working at top speed to keep up with the demand. Fowler intends many of the cups for other capitol figures, including Maj. Gen. Harry L. Vaughn, military aide of the White House."

"A letter from the White House to Fowler expressed the nation's top executive's appreciation for the gift, reading in part: 'Jerry Duggan (American Legion Commander in Missouri) brought me the Missouri Mule cups, which I most highly appreciate. I don't think I ever saw a more beautiful set, and some time or other I am sure they will be a valuable asset to my collection in a museum I am proposing to set up in Independence, Missouri.' The letter was signed by the President."

"That Fowler called on Kay Finch to make the cups is direct tribute to her talent as a ceramics designer. Fowler is an expert on drinking cups, having one of the world's outstanding collections of drinking vessels, some dating back centuries. His collection has been written up many times in national magazines. All of which goes to prove that Corona del Mar isn't very from Washington, D.C., if you go by—Missouri Mule."

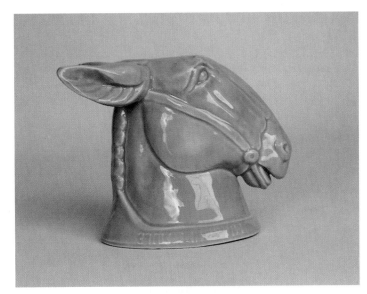

At first blush, this cup looked like someone stole Kay's idea. But there's no mistaking the label inside—which, incidentally, is the first Kay Finch label we've ever seen on any piece ($100-125). *Kaye & David Porter Collection.*

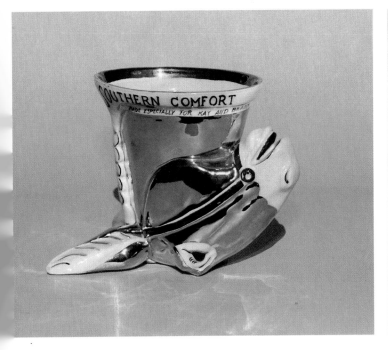

This cup was made by decorators at the studio and presented to Kay and Braden. All of their initials are on the inside. (Unique.) *Courtesy Finch Estate.*

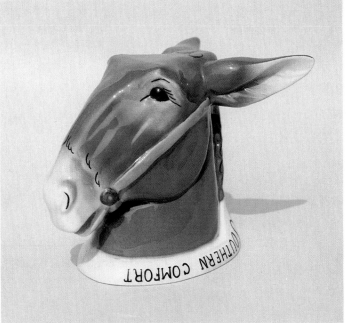

This decorated version may have been part of a third run with a more natural-looking glaze treatment ($200-250). *Sharlene Beckwith Collection.*

Braden and Kay toast the success of their *Missouri Mule Cups* with re-order production samples.

SEA LIONS ON THE ROCK
BELOW ARE IN MEMORY OF
BRADEN FINCH – 1903-1962
FOR HIS YEARS OF DEDICATED
SERVICE TO OUR COMMUNITY
AND TO THE PRESERVATION
OF THIS COAST LINE.

Bronze plaque at Inspiration Point in Corona del Mar at public viewing area.

The End of One Era...
The Beginning of Another

When Braden passed away in January of 1962, the burden of continuing Kay Finch Ceramics without him was too much for Kay to bear. And the business quietly closed its doors.

In 1971 she sculpted a life-size mother and baby seal executed in bronze and dedicated to Braden. They were moved by helicopter out to the rocks just below Inspiration Point in Corona del Mar where they are permanently mounted—a tribute to her husband's memory.

Once Kay had put her affairs in order, she sold some of her molds to Freeman-McFarlin Potteries in El Monte, California. Others went to selected pottery employees, and some were sold to hobbyists. Freeman-McFarlin was well known for their slip-cast earthenware sculptures ranging from (but not limited to) many unusual varieties of wild and domestic animals, to common and exotic birds. Both naturalistic and highly stylized models were included in the line.

The company's product line was available with unusual non-glazed finishes like Woodtone and Gold Leaf, as well as a variety of glossy but more monochromatic glazes; markedly different from Kay's original hand-decorated models.

Maynard Anthony Freeman retained Kay as a free-lance designer for the Freeman-McFarlin organization. Her assignment was to create a new series of dogs, birds, forest folk, waterfowl, and wild beasts. Through 1979, at the age of 76, Kay continued to work wonders with clay. Although her designs were more realistic from a style perspective, each was endowed with that famous Kay Finch personality.

In retrospect, her decision to close the pottery in 1962 probably saved her untold pain and anguish down the road. To effectively compete during the sixties, while maintaining their previously established quality standards, would have been difficult, if not impossible. Foreign imports, particularly those from Japan, had been wreaking havoc with the bottom lines of several established American ceramics companies since the late forties. Many had been forced out of business by now: Roseville, Weller, and Ceramic Arts Studio. Others like Florence Ceramics and Gladding-McBean quit the artware business entirely, concentrating on dinnerware in order to survive. Even mighty Rookwood, established in 1880, tried moving their production from Cincinnati to Starksville, Mississippi in 1960 to take advantage of a cheaper labor force. They faded into oblivion in 1967.

Kay Finch Ceramics had also been affected by 1960, and was forced to make some unwelcome changes in their product mix. In order to offer some competitively priced examples, many of the glossy pieces that had been slip-decorated and hand-painted now became available in matte glazes with little or no accenting.

Some collectors feel that Kay's Freeman-McFarlin pieces don't compare well with her earlier artware. We strongly disagree. If your goal is to build a collection that's as complete as possible, you'll miss some great treasures by shutting out the Freeman-McFarlin sculptures. We wouldn't trade ours for all the tea in China. And we love tea.

Detailed records of the Freeman-McFarlin years were never kept by Kay. (She had discontinued keeping a daily diary in February 1939, coinciding with the establishment of her business and the immense amount of additional work it required.) Some of the details of her Freeman-McFarlin works have been gleaned, however, from notations Kay made over the years in her Daily Reminder books, on note pads, and on appointment calendars. Some fragments collected from those sources follow:

January 1965...	Saturday. Taking model to Maynard.
August 4, 1970...	Maynard picked up Leo II model.
February 23, 1971...	Painted zebra for Maynard.
October 1979...	Puppy model to Scott Chapin, mgr. Freeman-McFarlin. Bring home original.

Her life-size Mother and Baby Sea Lions keep an eternal vigil to the memory of Branden Finch, Kay's friend, partner, and husband.

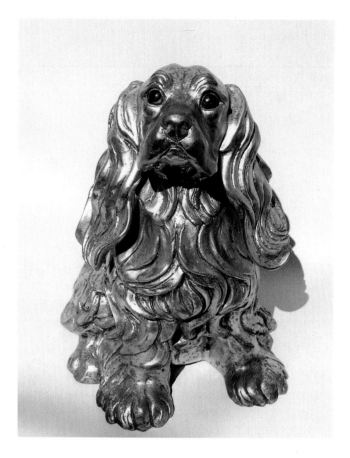

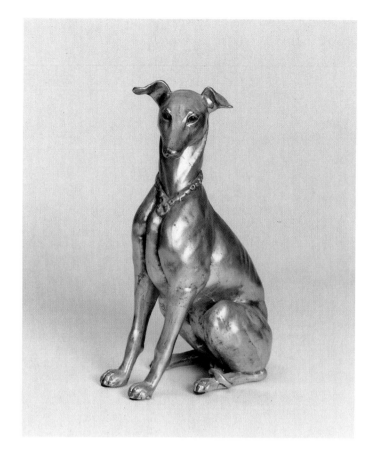

Cocker Spaniel, 12½". Script signature: Kay Finch USA #843 ($450-500). *Courtesy Finch Estate.*

Whippet (#836), 12½". Block signature: Kay Finch CALIF ($500-600). *Authors' Collection.*

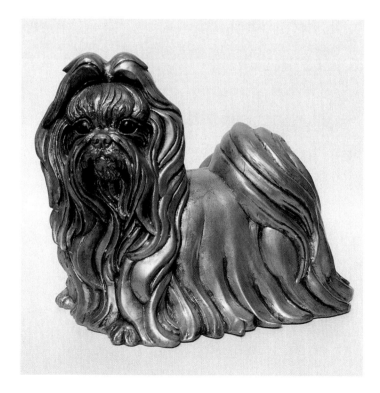

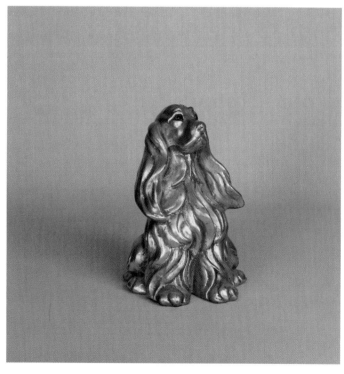

Shih-tzu, 10" x 12". Block signature: Kay Finch USA #837 ($450-500). *Sharlene Beckwith Collection.*

Cocker Spaniel, 8½". Block signature: Kay Finch USA #846 ($200-250). *Kaye & David Porter Collection.*

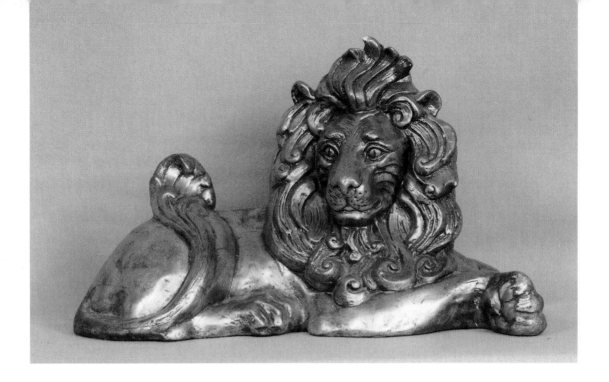

Lion, 13" x 20". Block signature: Kay Finch #811, 1974 ($700-800).
Joan Letterly Collection.

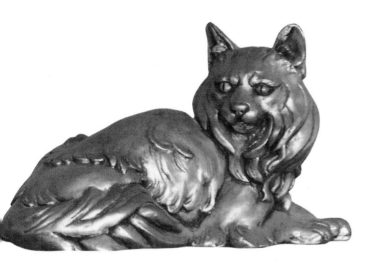

Cat, 7" x 10". Block signature: Kay Finch #833 ($200-250). *Joan Letterly Collection.*

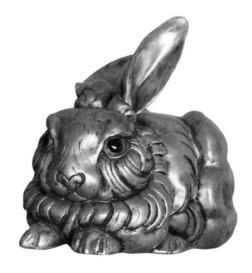

Lying Rabbit, 7" x 9". Block signature: Kay Finch USA #830 ($250-300).
Joan Letterly Collection.

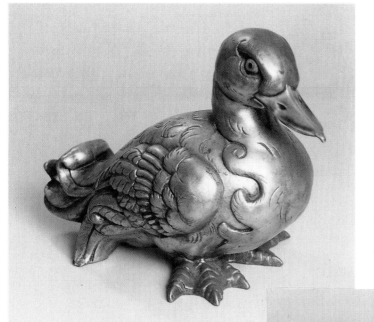

Duck, 10" x 14". (Note glossy, light green beak.) Block signature: Kay Finch USA #818 ($350-400). *Authors' Collection.*

Giraffe, 7½" x 8". Block signature: Kay Finch, CALIF. USA #835 ($250-300); *Mr. & Mrs. Bird*, 3¼" and 4¼", no mark ($75-100 pair); *Standing Bunny*, 7½" ($250-300). Block signature: Kay Finch USA #829 ($250-300). *Authors' Collection.*

SILVER LEAF GLAZE

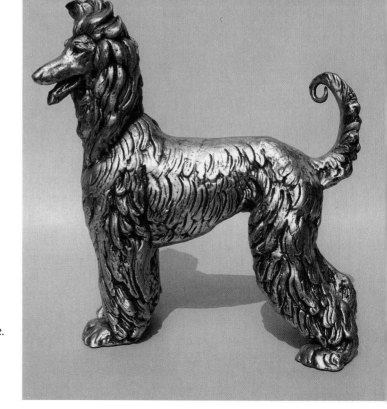

"Rudiki" Afghan Hound, (#834),13". No mark. This is a stunning glaze. We've not seen another piece finished in this manner ($700-800). *Sharlene Beckwith Collection.*

144

FINE ARTS GLAZE

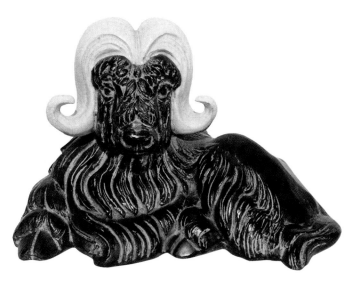

Cape Buffalo (#821), 6½" x 9". According to Frances Finch Webb, this was a gift to her husband, Jack, and not put into production. Unique. *Courtesy Finch Estate.*

Duckling (#827), 9" tall. We love this guy, with his blended finish and glossy accents ($250-300). *Courtesy Finch Estate.*

WOODTONE GLAZE

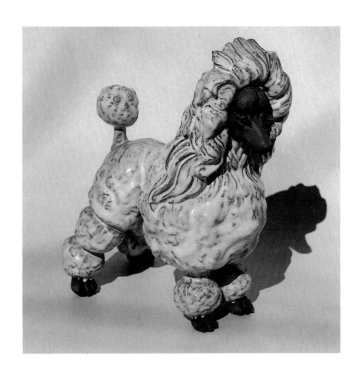

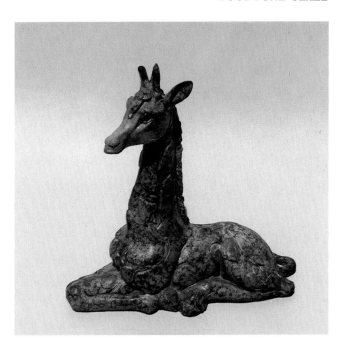

Poodle, 9¼". Produced in 1972 ($650-750). *Courtesy Finch Estate.*

Baby Giraffe (#835), 7½" x 8¼". This is also an extraordinary matte finish ($350-400). *Courtesy Finch Estate.*

PORCELAIN WHITE/FLORENTINE WHITE GLAZES

The name 'Porcelain White' pretty much speaks for itself. The medium Owl *Toot* in this picture is the *only* piece we've encountered with this glaze ($75-100). In the middle (*Mr. & Mrs. Bird*, $75-100 pair) and on the right (*Toot*, $75-100) begin Freeman's 'Florentine White' glaze. Mr. & Mrs. Bird are unmarked, while Toot only says "CALIF. USA." The "Florentine Glaze" is more of a semi-gloss finish. *Authors' Collection.*

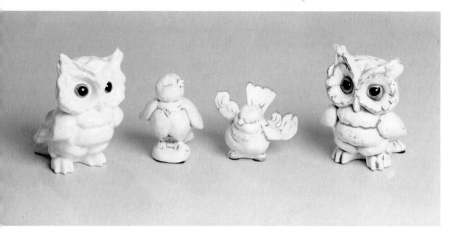

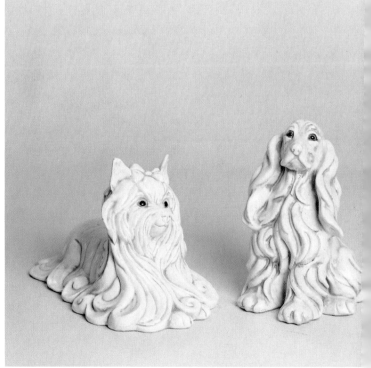

Rabbit, Lying, 7" x 9". Block signature: Kay Finch USA #830. ($350-400.) *Dorothy Lombard Collection.*

Donkey, Standing (#839), 9½" tall ($350-400). *Courtesy Finch Estate.*

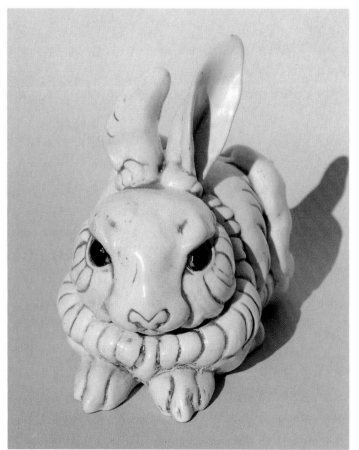

Yorky, Lying (#831), 11" x 7". Block signature: Kay Finch, California USA ($350-400), and *Small Cocker*, 8½", ($200-250). Block signature: Kay Finch USA. *Authors' Collection.*

146

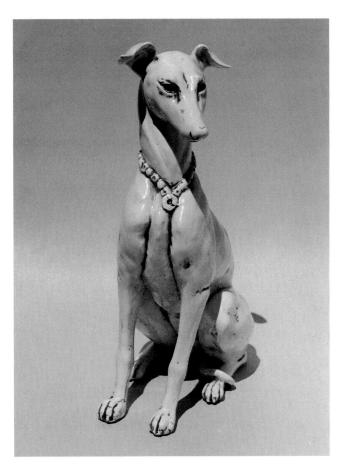

Whippet, Sitting (#836), 12½". Block signature: Kay Finch, California USA ($500-600). *Courtesy Finch Estate.*

Cockatoo, 13", marked only with the number 828 ($200-250). *Authors' Collection.*

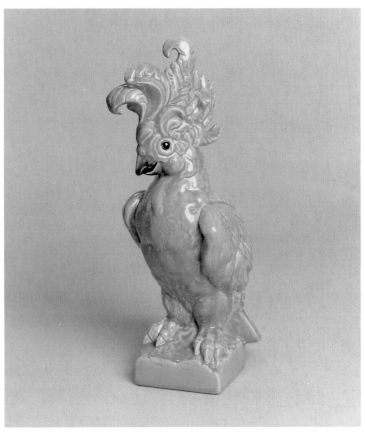

Mr. & Mrs. Bird (Restyled), 4". Marked #825 and #826. ($100-125 pair.) *Courtesy Finch Estate.*

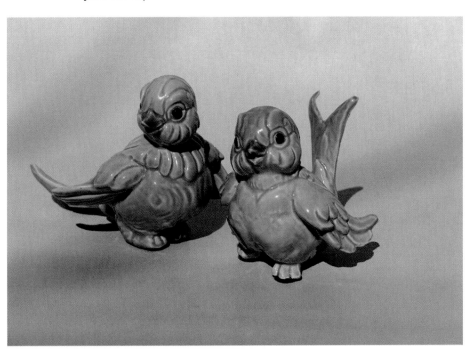

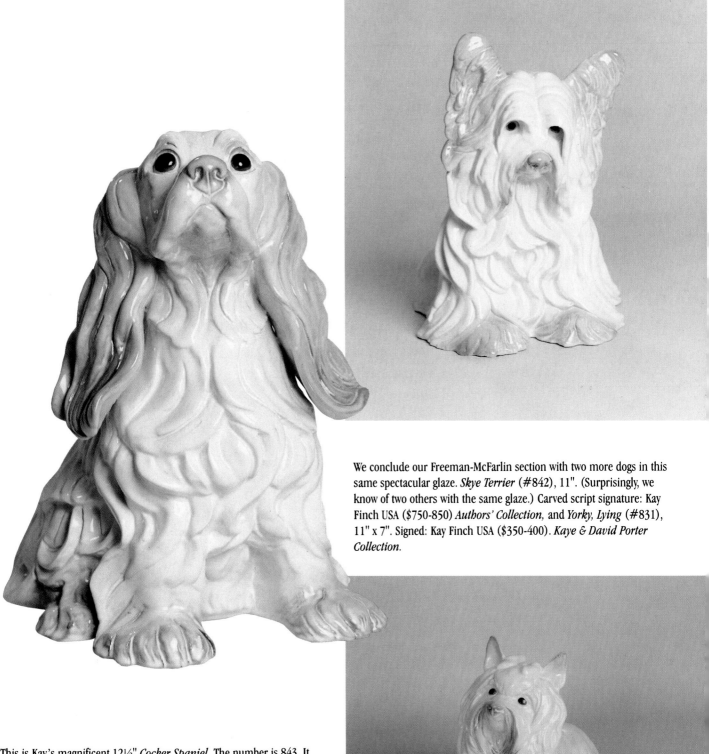

We conclude our Freeman-McFarlin section with two more dogs in this same spectacular glaze. *Skye Terrier* (#842), 11". (Surprisingly, we know of two others with the same glaze.) Carved script signature: Kay Finch USA ($750-850) *Authors' Collection,* and *Yorky, Lying* (#831), 11" x 7". Signed: Kay Finch USA ($350-400). *Kaye & David Porter Collection.*

This is Kay's magnificent 12½" *Cocker Spaniel*. The number is 843. It was a gift from Kay to the publisher of *TM, The Cocker Spaniel Magazine,* in the late sixties. Upon presentation, Kay told her it was a one-of-a-kind piece. Perhaps it was the first one out of the mold. It's extremely heavy and is covered with a glaze that resembles Freeman's Porcelain White. But there are wonderful accents of grey around the ears, nose, and feet. It looks expensive, and may well have been created by Kay working with Freeman-McFarlin chemists to achieve a new, exciting finish. The Kay Finch signature on the bottom looks hand carved. ($900-1000.) *Authors' Collection.*

Her Originals

Kay did many original sculptures. Some were simple. Most were extremely complex. Her earliest works—often capricious, always symbolic—recaptured some special memory, event, or favorite pet.

Simply put, she lived clay…she loved clay. Luckily, for all of us, she took that love and turned it into a career. The following one-of-a-kind examples give us an opportunity to experience those feelings and memories.

Done in 1944, this is "Kay On Smoky" and "Braden On Sig." 7½" each. Braden proposed to Kay while on horseback (note the gold ring on the base), and these sculptures symbolized the event. *Courtesy Finch Estate.*

This is a 7" sculpture of Kay and her younger sister, Mary Virginia, astride a horse named "Bunny." Dated 1944. *Courtesy Finch Estate.*

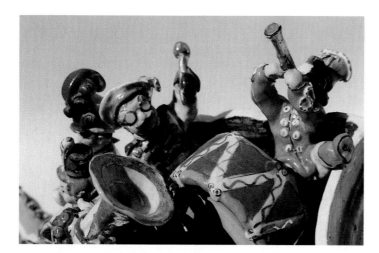

This is Kay's *Band Wagon*, dated "Dec. 5, 1942" (Kay and Braden's Wedding Anniversary). Written on the door is "Est. 1922", the year they were married. It is 23" long, 10" tall. It depicts family members as well as special important employees, fourteen in all. It is, in three words, "To Die For." *Courtesy Finch Estate.*

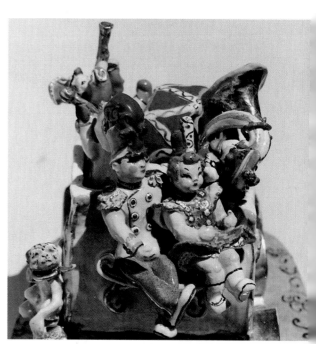

Riding on top in the front seat are Braden and Kay. The little monkey to Braden's left is none other than Frances Finch (Webb). The balance of the photos are to highlight area details. *Courtesy Finch Estate.*

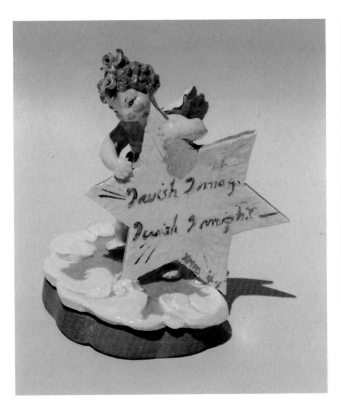

In December 1944, Kay presented this sculpture, "I Wish I May, I Wish I Might," to Braden as a Christmas gift. This has to be seen from two vantage points to be truly appreciated. 5½". *Courtesy Finch Estate.*

In 1943, Kay's first pottery crew (who affectionately called themselves "The Goons") gave her a Dalmatian puppy. This sculpture immortalized that event, 6" tall. *Courtesy Finch Estate.*

This is a 14" terra cotta bust of Kay's daughter, Frances, done in 1942. *Courtesy Finch Estate.*

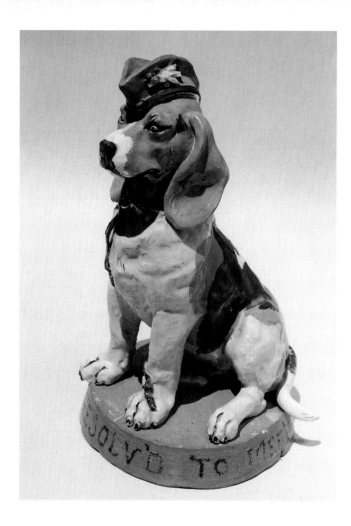

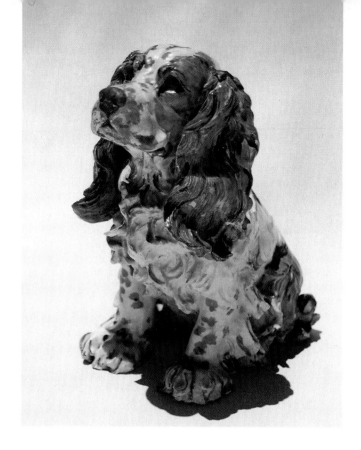

Vicki, the Cocker we saw in the Canine chapter, was created in terra cotta before she became part of the line. Kay decided to glaze the sculpture, and here it is. *Courtesy Finch Estate.*

"Bobbie Burns" is the name of this 9" Beagle, done in 1944. He is patriotically garbed and sits on a pedestal with a quote from poet Robert Burns…"Resolv'd To Meet Some Ither Day." *Courtesy Finch Estate.*

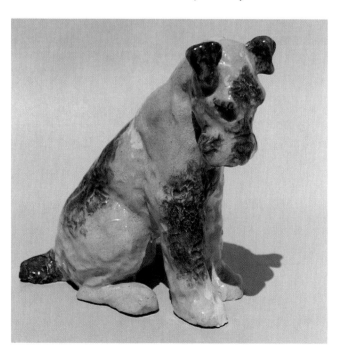

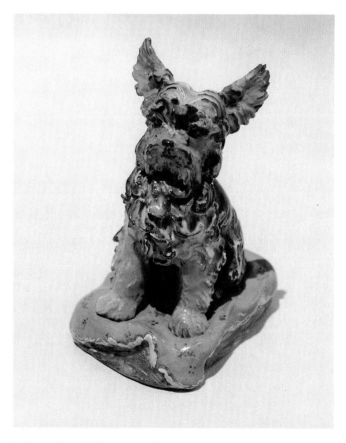

At the tender age of twenty-one, Kay's hands were already shaping her destiny. That's when she created this 6" Airedale, named "Mac." It's dated 1924. *Courtesy Finch Estate.*

In September of 1942, Kay's Yorky pup "Petit Point" reached the ripe old age of five months. So she made sure Petit Point stayed 'petit' forever in this 5½" sculpture. *Courtesy Finch Estate.*

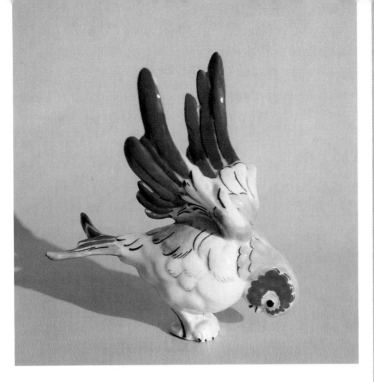

According to Frances Finch Webb, this exotic 6" bird was also a prototype, never reaching the production stage. While it's perfectly balanced, the small perch and wide wingspan make it susceptible to tipping and breakage. *Authors' Collection.*

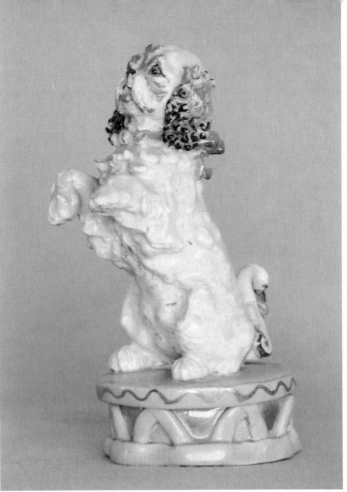

Dated 1942, this 6" Spaniel sculpture was a bequest from Kay's estate to canine aficionado, breeder, and friend, Joan Letterly. *Joan Letterly Collection.*

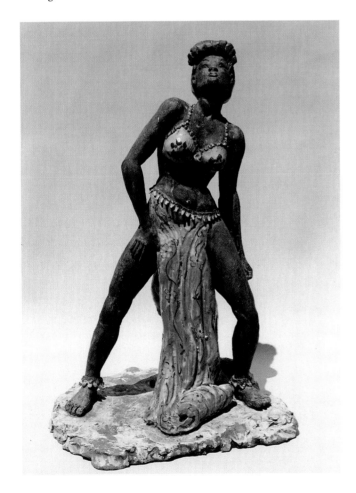

Kay was impressed by a club dancer named Carmen D'Antonio early in 1941, resulting in this 20½" terra cotta sculpture. Very beautiful. Very atypical. *Courtesy Finch Estate.*

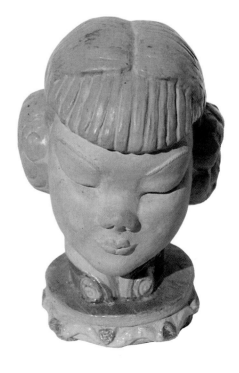

Remember the spectacular Chinese Princesses? This is a terra cotta sculpture for the head. It stands 7½" tall. One was also a permanent fixture on Braden's desk. *Dorothy Lombard Collection.*

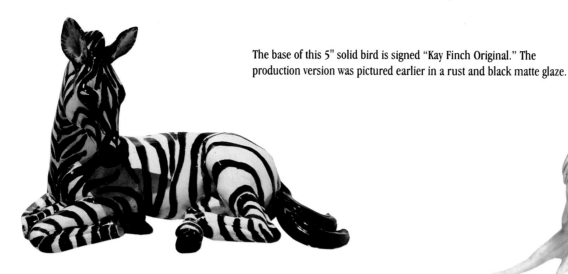

The base of this 5" solid bird is signed "Kay Finch Original." The production version was pictured earlier in a rust and black matte glaze.

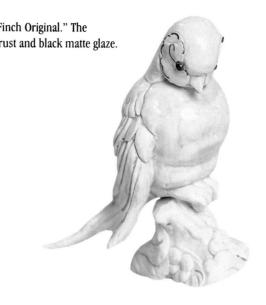

Kay created this prototype 9¼" x 13½" *Zebra* for inclusion in her Freeman-McFarlin line early in 1971. A February 21 diary entry states…"Painted Zebra for Maynard (Freeman)." For some unexplained reason, she waited until 1982 to sign it. It amazes us that the Freeman organization never adopted the design. *Authors' Collection.*

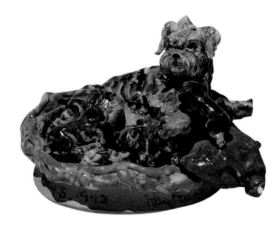

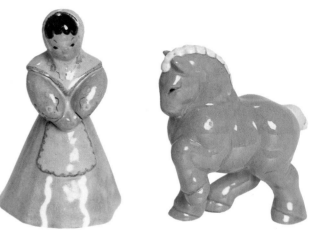

According to Frances Finch Webb, decorated terra cotta examples of her manufactured line were not offered for sale. This 5½" Scandie Girl and her 4" Percheron companion could have been produced prior to the official opening of her studio. *Authors' Collection.*

On May 8, 1942, Kay's Yorkshire "Peggy" presented her with a litter of pups. Once again, she created a sculpture to commemorate the blessed event. 4" x 6". *Courtesy Finch Estate.*

This is Kay's Dalmatian, "Judy," sculpted in 1943. She's the same dog captured in "From The Goons", all grown up. 8½" x 5½". *Courtesy Finch Estate.*

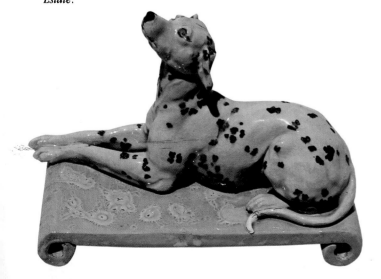

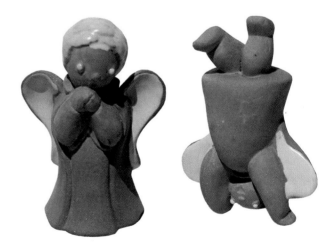

More terra cotta. It's a good bet that these small 2¾" topsy-turvy angels were made prior to the official hanging of the Kay Finch Ceramics shingle. *Courtesy Finch Estate.*

Her Imitators

This section includes some pictorial examples which bring to mind the old adage, "Imitation is the sincerest form of flattery." We feel, at the very least, that Kay would have been extremely offended, had she known how extensively her work had been copied. And these are some of the *better* look-a-likes. We have also seen some poor imitations made from clay, as well as plaster and metal. You should be able to recognize them in plenty of time to avoid giving them more than a cursory glance. But there are some real 'foolers' that will make you look twice.

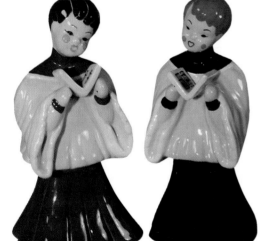

The Choir Boy 'clone' is really interesting. He's the same height, and made to scale from the waist up only. This shot from 'down under' shows the change. Plus, his facial detail is uncharacteristic. *Authors' Collection*.

We bought this 'groovy' pig years ago, thinking we had a great Finch bank. Of course, it isn't. It's another Lefton copy, minus the Japan label, but with the tell-tale black numbers stamped on the bottom. *Authors' Collection*.

On the left we see an *exact scale* copy of *Smiley*, Kay's 6¾" tall by 7¾" long pig figurine (and sometimes, bank). It was made by Lefton (see label and underside of above photo) in Japan, using a transfer technique rather than slip. This copy is 5½" tall and 6¾" long. Even if the label is removed, keep an eye out for the black number underneath. Kay's pieces won't have it. *Jim & Jolene Andrus Collection*.

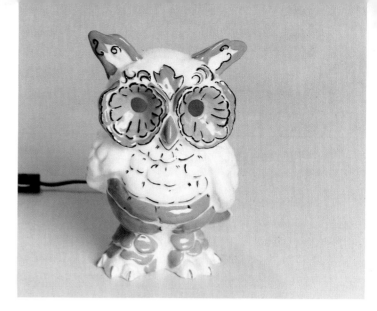

This TV lamp with the 'cut-out' eyes is a 9" rip-off of *Hoot*, Kay's tallest owl. An educated guess would be Capistrano Ceramics.

Someone liked 'Monkeyshines' enough to make a reduced size, 7" version of him into a planter. Once again, look at the weak black accents.

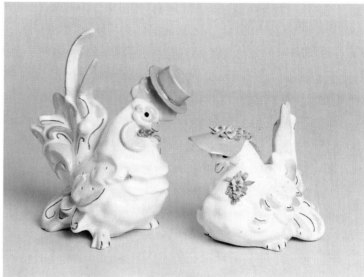

This pair is a super copy of Butch and Biddy made into canapé holders. He is 7¼" and she is 4½". They are exact scale reproductions with flawless decoration and appliqués. Note the difference in the tails from the originals pictured in the Woodland section. We bought them just for the book, so you wouldn't make a mistake. Are we nice, or what!

Here are two more copies from some enterprising plagiarist...Toot (5¼") and Tootsie (3½"). Note how uneven the painting is. Also, the black line detail is heavy and overdone. *Courtesy Dane Cloutier.*

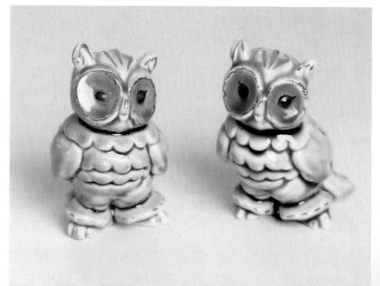

This pair of 3¾" salt and pepper shakers have a black Japan mark on the bottom. Tootsie, they're not.

Her Marks

Better than half of the pieces in our collection are un-marked. But the majority of the unmarked examples fall into three categories:

One: The design of the piece restricts identification. It's either too small or the area available for identification is too small, or...

Two: It had an ink-stamped bisque bottom that washed off or rubbed off, or...

Three: The mark was impressed in the greenware stage but became camouflaged when the slip (glaze) was applied. It pays to look twice because sometimes the ghost of a mark will still be visible.

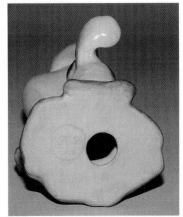

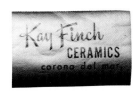

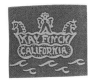

Here are two Studio labels that we have yet to see on a piece other than the solid-glaze, green Missouri Mule Cup. The original logo with its wave-borne crown-carrying seahorses and an angel, is well-annotated here. *Courtesy Finch Estate.*

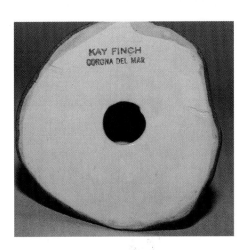

For the record, there are three types of signatures:

A) *Black Ink Stamp—Overglaze.* Shown here are four variations on bisque bottoms. Washing will reduce or remove them, so be careful. The "K.F. Calif" in a circle is rare (and almost gone). The other three are more frequently found.

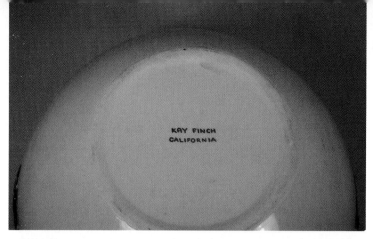
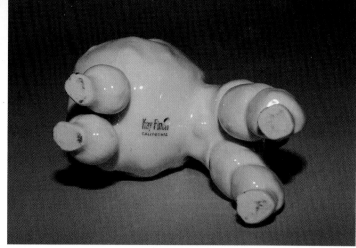

B) *Ink Stamps—Underglaze*. Various colors were used. The red one *looks* hand lettered.

This photo shows the underside of Kay's Freeman-McFarlin Yorky #831. Without the sticker (or the knowledge you now have) it would be easy to mis-identify the piece as a Kay Finch Studio product.

C) *Hand Incised—Overglaze* and *Underglaze*. This early-on technique leaves the best indicia, but it's very labor-intensive. When business began to boom, Kay switched to "A" and "B" in order to keep pace with demand.

159

Back cover of a 1950s advertising flyer. It gives you an idea of the scope of the facilities. *Courtesy Finch Estate.*

A group of twenty-three #477 *Chinese Princesses* in Ruth Sloan's show room, Los Angeles. *Courtesy Finch Estate.*

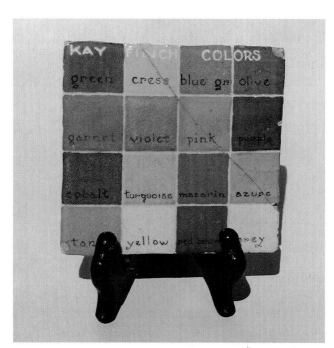

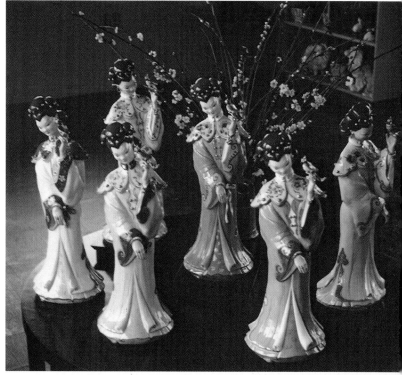

This is a palette used by the decorators and as a color chart when buyers at the studio placed their orders. *Courtesy Finch Estate.*

Hand-made tile from Kay's Corona del Mar patio. Note seahorses, fish, and shells. *Courtesy Roberta Tripoli.*

Her Scrapbook

This section was reserved for historical material: archival photos, ads, brochures, black and white studio shots, drawings, etc. A potpourri of images and artifacts from Kay's earliest days until the closing of her studio in 1962. Nearly all of the elements contained herein actually came from scrapbooks that Kay kept.

Once again, we are indebted to Frances Finch Webb for her courtesy, patience, diligence, and direction during our "Studio Tour" at her home in Mountain View, California, in June of 1995. Our eternal regret is that we never had the opportunity to meet Kay to share her experiences first-hand.

#903 PIG BLUE		
Talc	5 lb---9 oz.	
Tenn	4 lb---15 oz.	
E.P.K.	1 lb---3 3/4 oz.	
#63 Frit	1 lb.	
R.D. UG #221	1 lb---4 oz.	
Cobalt Oxide	2 oz.	
1½ Oz Sod. Sil		
½ gal Media		

Kay used index cards for all of her glaze formulae. This is a sample of one used for *Smiley, Grumpy, Winkie,* and *Sassy.*

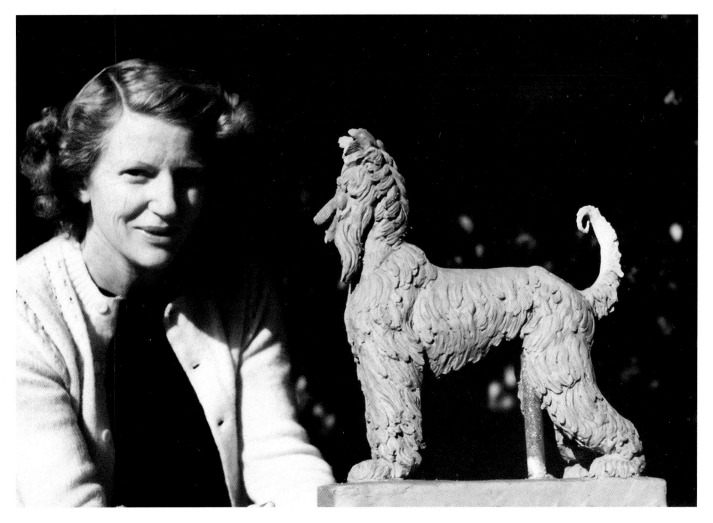

Kay with clay model of *Rudiki. Courtesy Finch Estate.*

Kay and production manager with large *Donkey* clay model. *Courtesy Finch Estate.*

The Decorating Department, circa 1940. Note Production Manager Al Schultz with *Grandpa Pig* in tow. *Courtesy Finch Estate.*

This is Kay's first model from life at the Memphis School of Fine Arts, about 1924. *Courtesy Finch Estate.*

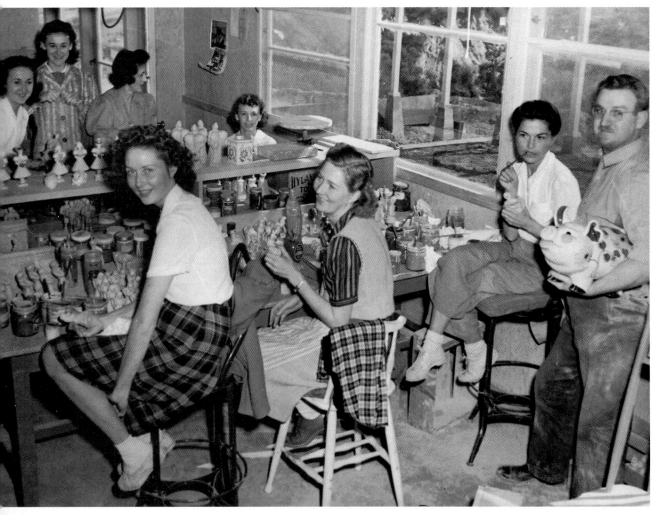

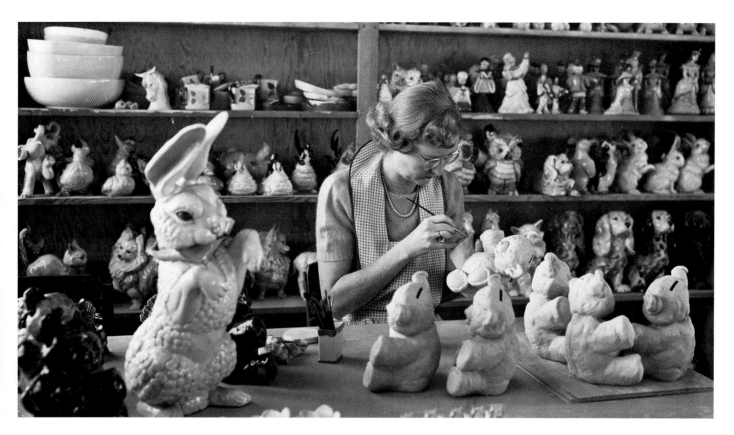

Mary Lou Dierker, one of Kay's best decorators, is painting a *Teddy Bear Bank* (circa 1950.) Look at all the super pieces around her, including the *Church Bank* and the *Dancing Angel!* If only we could place an order... *Courtesy Finch Estate*.

This is Ruth Sloan's Los Angeles showroom in the early forties, with Kay's work featured in the entrance. *Courtesy Finch Estate*.

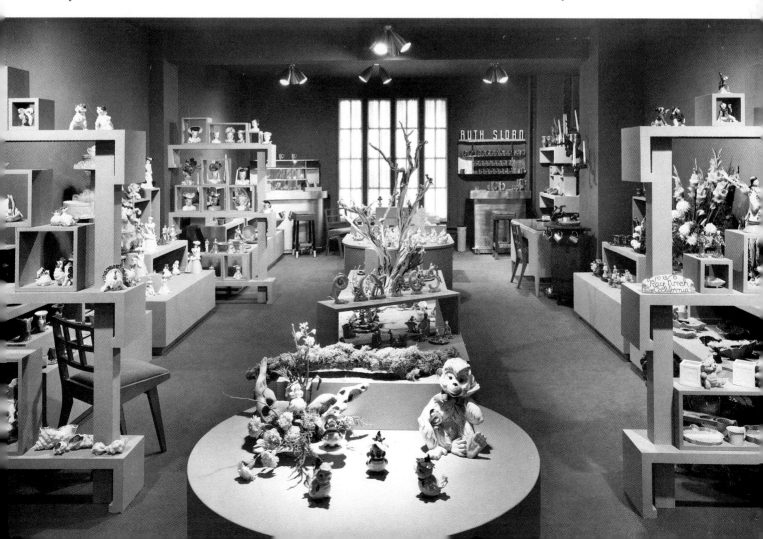

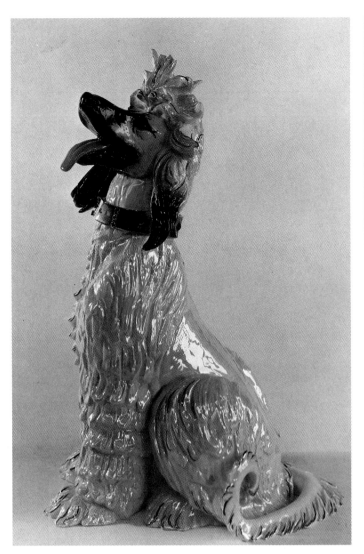

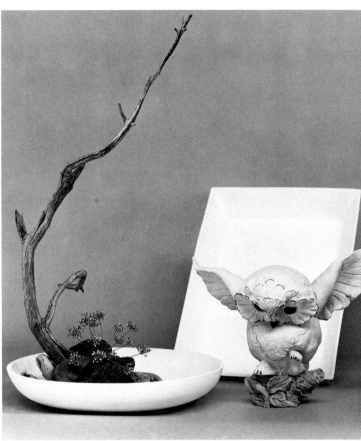

We know someone who has two of these. How unfair. *Courtesy Finch Estate*.

Heeeere's *Johnnie*, Kay's famous Afghan Hound and winner of 18 Best of Show awards. He's 18" tall. And rare. Circa 1954. *Courtesy Finch Estate*.

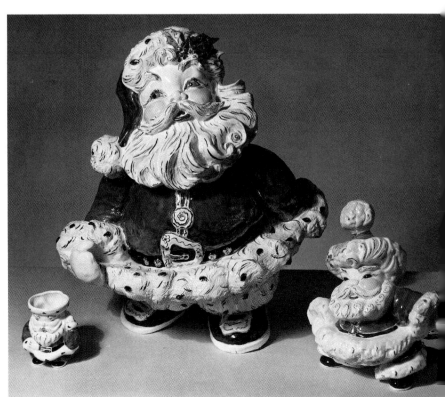

Anyone's Christmas would be a lot merrier if they had these three to display (ours included). *Courtesy Finch Estate*.

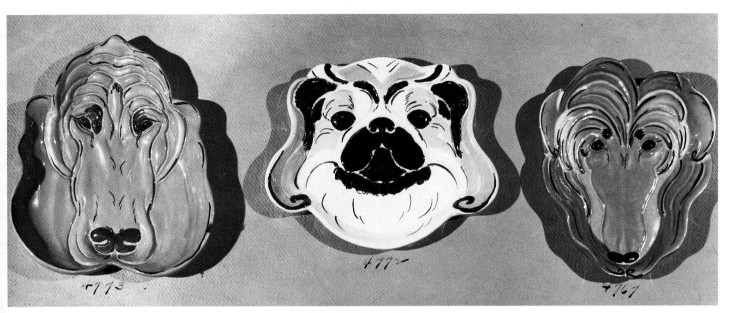

These ashtrays had to be a hit among dog lovers. *Courtesy Finch Estate.*

Another early 1940s photo of Kay and "The Goons." *Courtesy Finch Estate.*

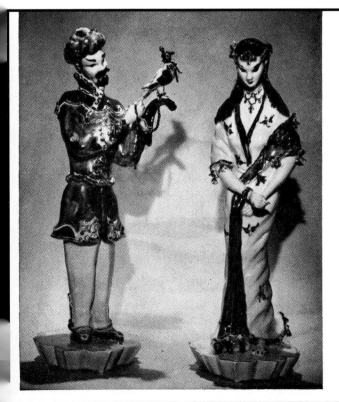

An excellent example of a 1940s ad in *Giftware* and *Gift and Art Buyer. Courtesy Finch Estate.*

165

Three more examples of 1940s ads in *Giftwares* and *Gift And Art Buyer*. *Courtesy Finch Estate.*

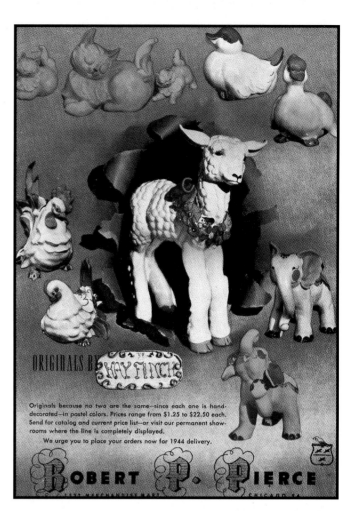

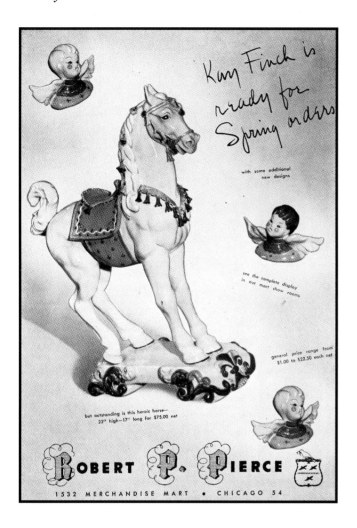

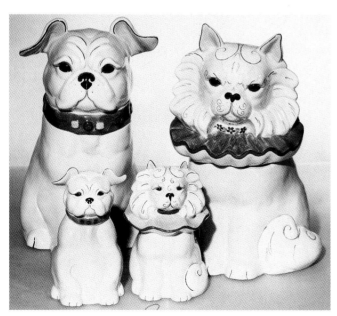

The Canine/Feline Kitchen Companions. Where is that *Cookie Pup*, anyway? *Courtesy Finch Estate.*

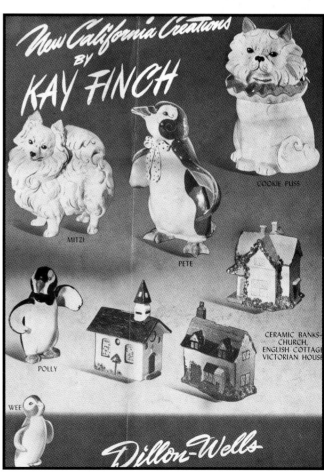

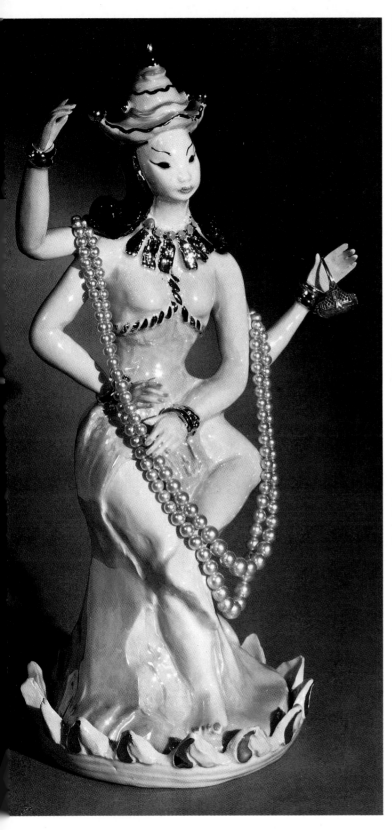

The elusive #4965 *Ring Bearer Goddess. Courtesy Finch Estate.*

TaeJon guards Kay and Braden's 'entertainment center.' His likeness appears on glassware, steins, tumblers, and a wall-mounted photo. Circa 1955. *Courtesy Finch Estate.*

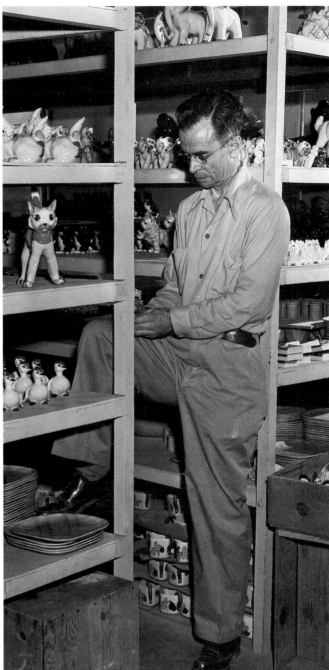

Another stock room photo, circa 1949. *Courtesy Finch Estate.*

Kay Finch By The Numbers

This numerical listing was derived from a combination of sources including Kay's studio logs, the "Kay Finch Ceramics Guide" published by Frances Finch Webb, and a variety of company catalogs and listings. While every effort has been made to provide the most factual listing possible, it is virtually impossible to be completely accurate.

Records were not exact and a variety of inconsistencies exist. For example, in the original Kay Finch Master Price List, number 127 is designated as "Peasant tots." In reality, all catalogs were produced with the number 127 being assigned to the *Scandie Boy*. Somewhere in the process what is known as the *Peasant Boy* was assigned the number 113. It would seem in looking at the pieces that the Scandie and Peasant pieces have transposed numbers!

Pieces made prior to 1946 were assigned only three digits. Beginning in 1946 the first two digits of a number represent the year of initial production. In some instances one number served for two or three like items (such as the angels), with those being designated as "a/b" or "a/b/c." The "B" designation indicates babyware items. Banks were also designated with the "B" following the number (e.g. #164-B, *Smiley* Pig Bank).

Glaze options were also indicated with an alpha code. Items with an "L" were available in Lustre finishes, and it would appear that only items available in a choice of finishes have this designation, while those available *only* in Lustre did not have the alpha indicator, although this is not consistent. It is assumed that "P" stands for pearlized, usually referring to the Pink Pearl glaze.

Items with a "T" designation were part of the Topper Flower Bowl Series. Figural pieces such as squirrels, birds, and the Sage and Maiden were used to accent these bowls and would sometimes have this designation.

There are gaps in the numbering sequence, and it is the opinion of Frances Finch Webb that some items scheduled for production were never actually produced.

And finally, there are pieces that we have not been able to find reference to in any catalog or archival photo that are, without a doubt, Kay Finch works.

This short list of three-digit numbers falls out of order, having been produced no earlier than 1949.

100B	Bootee Planter
102	Flare Bowl with Stand, 26"
103	Half-Egg Bowl with Stand, large
104	Square Bowl with Stand, 24"
104B	Bassinet Planter, large
106B	Bear with Block Planter
107B	Potty Planter
108B	Stork Planter, large
109B	Baby with Block Planter
110B	Stork Planter, small
111B	Bassinet Planter, small
200T	Calla Vase
201T	Acanthus Vase
202T	Fan Vase
203T	Ribbon Flower & Candle Holder
204T	Temple Bowl
506T	Two-piece Pansy Ring
509T	Three-piece Candy Cane Flower Holder
510T	Two-piece Christmas Tree Vase

FINCH BY THE NUMBERS MASTER LIST

1939-1945

100	Baby Chick
108a/b	Squirrels
113	Peasant Boy
114a/b/c	Angels
117	Peasant Girl
120	Rabbit, ear up/ear down
122	Godey Man & Lady, 9½"
122C	Godey Man & Lady with Cape & Hat, 9"
126	Scandie Girl
127	Scandie Boy
129	Chanticleer, 10¼"
130a/b/c	Work Horses
131	Tiny Pig, 1¾" (available as salt & pepper)
136	Kneeling Lamb
140a	Wide-wing Angel
140b	Upside-down Angel
152	Baby Cottontail Rabbit
154	Pekinese
155	"Ambrosia" Persian Cat, 11"
156	Miniature Pekinese
157	Tiny Persian Cat
158	"Puddin" Yorky, 11"
159	Coach Dog, 17"

160	Godey Man & Lady, 7½"
161	Mermaid
162	Seababy
163	"Grandpa" Pig, 10"x16"
164	"Smiley" Pig
164-B	"Smiley" Pig Bank
165	"Grumpy" Pig
165-B	"Grumpy" Pig Bank
166	"Sassy" Pig
166-B	"Sassy" Pig Bank
167	Life-size Lamb, 20"
168	Prancing Lamb
170	Yorky Pup, ears up
171	Yorky Pup, ears down
173	Baby Fish (Guppy)
176	"Biddy" Hen
177	"Butch" Rooster
178a/b	"Peep" & "Jeep" Ducks
179	"Jezebel" Cat
180	"Hannibal" Angry Cat
181	"Mehitable" Playful Cat
182	"Muff" Kitten
183	"Puff" Kitten
185	"Winkie" Pig
185-B	"Winkie" Pig Bank
187	"Hoot" Owl
188	"Toot" Owl
189	"Tootsie" Owl
190	"Violet" Elephant, 17"
191	"Peanuts" Elephant
192	"Popcorn" Elephant
201	Bride
204	Groom
205	Indian Brave
206	Indian Squaw
207	Indian Papoose
210	Choir Boy, standing
211	Choir Boy, kneeling
212	Cherub Boy Head
213	Stallion, 21"
400	Chinese Court Lady, hand on shoulder
401	Chinese Court Lady, hand to face
451	Chinese Court Prince
452	Listening Bunny
453	"Mr. Bird"
454	"Mrs. Bird"
455	"Vicki" Cocker, 11¾"
461	Shell Match Holder
462	Shell Ashtray
463	Shell Vase Wall Pocket
464	Camel
465	"Mitzi" Pomeranian
466	"Pete" Penguin
467	"Polly" Penguin
468	"Pee Wee" Penguin
471	Papa Duck, 7¼"
472	Mama Duck, 4¼"
473	"Carrots" Rabbit
474	"Amour" Mare
475	Western Prospector's Burro
476	Afghan Head, 12"
477	Oriental Princess Holding Bird, 23"
479	Cache Pot, 4"
504	Cache Pot, 4"
505	Cache Pot, 3"
506	Baby Cup, "For A Good Girl" or "For A Good Boy"
508	Cigarette & Match Holder
510	Shell

1946

4610	Church Bank, 6¼"
4611	English Village Bank, 5½"
4612	Victorian House Bank, 5½"
4614	"Puss" Cookie Jar, 11¾"
4615	"Pup" Cookie Jar, 12¾"
4616	"Puss" Shaker
4617	"Pup" Shaker
4618	Water Baby Fountain, 31"
4619	Conch Shell, 12"
4620	Cockle Shell, 23"
4621	Shell wallpocket, 14"
4622	"Harriet" (with hat and/or purse) or "Harvey" (with bow) Rabbit, 21"
4623	"Cuddles" Rabbit
4626	Elephant with Floral Decoration in Ears, 5"
4627	Russian Barn Bank, 4"
4628	Swiss Chalet Bank, 6"
4629	Chinese Boy, 7½"
4630	Chinese Girl, 7½"
4631	Little Marching Duck (Companion piece to Chinese Boy & Girl)
4632	Powder Box, 2"
4633	Power Box, 3"
4634	California Country Plate, 10½", "Briar Rose" or "Blue Daisy"
4635	California Country Cup
4636	California Country Saucer
4637	California Country Creamer
4638	California Country Sugar Bowl
4653	Oblong Tapered Bowl
4657	Square Flange Bowl
4658	Long Oval Bowl
4659	Oval Flare Bowl
4660	Long Low Bowl

1947

4729	Flower Ashtray
4730	Ivy Leaf Dish
4766	Cigarette Holder
4767	Afghan Head Ashtray/Wall Plaque
4768	Long-eared Donkey
4769	Long-eared Donkey with Basket
4771	Wall Match Safe
4772	King Charles Spaniel Head Ashtray/Wall Plaque
4773	Bloodhound Head Ashtray/Wall Plaque
4774	Skunk
4775	Skunk
4776	Donkey, 28"
4776X	Saddle for Donkey, birch & metal composition
4778	Cocker Head Ashtray/Wall Plaque
4779	Yorky Head Ashtray/Wall Plaque

1948

4801	Dancing Angel
4802	Singing Angel
4803	Littlest Angel
4804	"Mumbo", Baby Elephant, sitting
4805	"Jumbo", Baby Elephant, standing
4806	"Caress" Colt
4807	Rice Cup
4811	Buffet Plate & Cup
4830	Afghan
4831	"Dog Show" Scotty (black) or "Dog Show" Sealyham (white with black trim)
4832	"Dog Show" Airedale
4833	"Dog Show" Westie

4834-5-6	"Hear No Evil, See No Evil, Do No Evil" Kittens
4841	"Socko" Circus Monkey
4842	"Jocko" Circus Monkey
4843	"Mrs. Banty Jr. " Hen
4844	"Mr. Banty Jr." Rooster
4847	"Tubby" Playful Bear, sitting
4848	"Cubby" Playful Bear, standing
4850	Collie Head Ashtray
4851	"Dog Show" Yorkshire
4853	Turkey, 5"
4854	Chinese Maiden
4855	Chinese Sage
4856B	Kitten Face Cup & Plate
4858	Standing Madonna Holding Baby Jesus, 16½"

1949

4900	Kneeling Madonna
4900A	Infant in Cradle
4903	"Happy" Monkey, 11"
4905a/b	"Mr. & Mrs. Dickey Bird"
4905S	"Mrs. & Mrs. Dickey Bird" on skis
4906	"Baby" Teddy Bear
4906B	Teddy Bear Baby Vase
4907	"Mamma" Teddy Bear
4908	"Papa"Teddy Bear
4909	Girl Angel
4910	Boy Angel
4911	Afghan Angel, standing/head turned
4912	South Sea Girl Vase
4913	South Sea Mother & Babe
4930	Pagoda Sweetmeat Box
4930P	Cigarette Box with Pagoda Lid
4931	Pagoda Sweetmeat Box
4932	Octagon Ashtray
4950	Santa Claus Toby Jug
4951	Holly Wreath Bowl
4952	Creche with Two Angels and Infant
4955	Dog Ashtray/Plaque, various breeds and Persian cat, 4¾"
4956	Swan Flower Bowl, large
4957	Swan Covered Dish
4958	Swan Astray
4959	Fan
4960	Fan Ashtray
4961	Fan Box with Lid
4962	"Monkeyshines" Monkey
4963	Afghan Angel, lying
4964	Afghan Angel, standing/head cocked
4965	Goddess Ring Holder
4975	Holly Sprig Cup

1950

5000	Cherub Prayer Plaque
5001	Doggie with Silver Bell
5002	Pajama Girl
5003	"Dog Show" Cocker
5004 L	Sleepy Winking Bear, small flower hat
5004 L	Sleepy Eyes Open Bear, large flower hat
5005	Bunny with Jacket
5005L	Bunny with Lustre Flower Hat
5006	"Ducky-Wucky"
5006L	"Ducky-Wucky"
5007	Turtle
5008	Fish
5008L/P	Fish, lustre or pearl decor
5009	Frog
5012	"Whirly-Girly"
5013	"Casey Jones Jr."

5014	"Goody Girl"
5015	Casey's Engine #9
5016	"Dog Show" Afghan - "Jubilee"
5019	Hippo
5020	Pheasant, long-tail
5021	Boy's Head Wall Pocket
5022	Girl's Head Wall Pocket
5023	Temple Bowl
5024	"Dog Show" Poodle
5025	"Dog Show" Boxer
5026	Baby, sitting
5051	Heart Box
5051B	Heart Box With Attached Bird, lustre
5052	Vase
5053	Annual Christmas Plate, Santa head
5054	Santa Plate, 1950, large
5055	"Porky" Pig
5056	Vase
5057	Bowl
5072	High-ball
5073T	Candle Tree
5080	Cocker Pin or Tie Slide
5081	Afghan Pin or Tie Slide
5082	"Rudiki" Afghan, 13"

1951

5100S	Canister Set
5101 L	Dove, head cocked
5102 L	Dove, head up
5103	Siamese Cat, 10"
5104	Siamese Cat, crouching
5106	Cocktail Plate
5107	Cocktail Cup
5108	Canister, medium
5109	Canister, large
5110	Salt Shaker
5111	Skillet, small
5112	Skillet, large
5113B	Teddy Bear on Book Planter
5114	Shell Low Bowl, 12"
5114 L	Shell Low Bowl, 12"
5116	Incline Vase, square
5117	Incline Vase, rectangular
5118B	Lamb on Block Planter
5120B	Lamb on Book Planter
5120	Lamb
5121B	Dog Face Toby Cup
5122B	Kitten Face Toby Cup
5143B	Baby on Book Planter
5144B	Rabbit on Block Planter
5145B	Rabbit on Book Planter
5150	Christmas Tree with Star
5151	Musician Angel Child with Harp
5152	Musician Angel Child with Fiddle
5153	Musician Angel Child with Drum
5154	Musician Angel Child with Trumpet
5155B	Sitting Elephant on Cylinder Vase
5156B	Sitting Monkey on Block Vase
5160	Persian Hunter, 16½"
5161	Persian Harem Girl, 16½"
5162	Persian Hunter, 10½"
5163	Persian Dancer, 9½"
5164	Parakeet on Perch
5165	"Baby Ambrosia" Kitten, 5½"
5170T	TV Lamp Vase & Base
5171	TV Lamp Vase Only
5172	Persian Star Vase
5173	Persian Round Plate Bowl
5174	Flat-top Flower Holder

5175	Melon Trophy Box
5176	Chalice Vase
5177	Annual Christmas Plate, Tree Ornament
5178B	Sitting Elephant on Square Planter
5179	Siamese Cat Sitting
5180	Siamese Cat

1952

5201	Cocker, 8"
5203	Playful Poodle, standing, 10"
5204	Playful Poodle, crouching, 7"
5208	Balboa Hurricane
5210	Hurricane Planter & Shade
5211	Balboa Round Bowl, 11"
5212	Four-Piece Ashtray Set
5214	Cache Pot
5216	Ashtray
5220CH	One-block Candle holder
5220	One-block Planter
5221	Three-block Planter
5223	Hors d'oeuvre Dish
5227	Two-block Planter
5228	Four-block Planter
5229	Four-block Square Planter
5230	Two-block High Planter
5231	Three-block High Planter
5250	Large Individual Salad
5251	Medium Bowl
5254	Oblong Bowl
5260	Cocker, 4"
5261	"Beggar" Poodle, 12"
5262	"Beggar" Poodle, 8"
5270	Duck Tureen
5280	Free-form Planter
5281	Geranium Table Planter
5282	Philodendron Planter
52XX	Annual Christmas Plate, Snow Crystals

1953

5300	Pheasant, 10"
5301	Doggy (Also available as bank)
5302	"Jezzy" Cat, 4¾"
5303	Baby Bunny
5304	Sitting Elephant
5310	Oval Bowl
5311	Round Footed Bowl
5312	Round Bowl
5313	Rectangular Bowl
5320	"Pup" Dachshund, 8"
5322	Leaf Bowl
5331	Dog Ashtray/Plaque, various breeds, 5¾"
5332	Dog Ashtray/ Plaque, various breeds, 7¾"
5333	Dog Cigarette Box with Cover, various breeds
5334	Dog Cigarette Box and Ashtray Set
5340	Cache Pot
5341	Cache Pot
5350	Demure Kitten
5351	Mama Bear, 2"
5352	Papa Bear, 2¾"
5354	Rooster
5355	Hen, 1½"
5356	Chick, ½"
5360	Turkey Center Piece
5361	Turkey Tureen with Ladle
5362	Turkey Salt & Pepper
5363	Circus Clown
5364	Circus Elephant, 3½"

5365	Circus Elephant Baby, 2¼"
5366	Goldilocks, 3"
5367	"Junior" Pup, 2"
5368	Baby Bear, 1½"
5377	Candy Cane
5372	Christmas Wreath
5373	Santa Face Wall Pocket
5374	Christmas Stocking, large
5375	Christmas Stocking, small
5376	Christmas Tree
5380	Salad Bowl, large
5381	Salad Plate
5385	Candle Holder
5386	Coaster
5387	Santa Boot
5388	Bird Bath with Bird, 6"
53XX	Annual Christmas Plate, Holy Angel

1954

5400	Oriental Woman, 29"
5401	Cockatoo, 15"
5403	Parakeet on Perch, lustre
5404	Dip Dish
5405	Shell Dish
5406	Cockle Shell
5407	Baby Squirrel
5408	"Piggy Wiggy" Pig
5409	Rooster Cocktail Plate
5412	Artichoke Plate
5413	Candle Holder Lights
5414	Hibiscus Platter
5415	Kissing Mugs
5417	Scroll Console Bowl
5418	Scroll Console Bowl
5419	"Perky" Poodle, 16"
5450	Platter
5451	Punch Bowl
5452	Cup
5455	Bird Bath
5456	St. Francis, 25"
5457	St. Francis, 12"
5458	Stein with Dog Handle, large
5459	Stein with Dog Handle, medium
5460	Planter
5461	Star Candle Holder
5462	Canapé Tray
5463	Cone on Stand
5464	Globe on Stand
5465	Vase, 13½"
5466	Vase, 10½"
5467	Tapered Cylinder Vase
5468	Bowl Planter
5469	Bowl Planter
5470	Acanthus Planter
5471	Sycamore Planter
5472	Calla Planter
5473	Rubber Tree Planter
5474	Grape Planter
5475	Reindeer
5476	Snail
5479	Sleigh
5490	"Johnny" "Best in Show" Afghan, 18"
54XX	Annual Christmas Plate, Lambs & Tree

1955

5501	Minaret Bottle, 27"
5502	Moon Vase, 17" (Also sold with stopper)

5503	Moon Vase, 13" (Also sold with stopper)
5504	Large Mosque Vase
5505	Small Mosque Vase
5506	Large Circle Bowl
5507	Small Circle Bowl
5520	Salad Bowl
5521	Relish Dish
5522	Salad Server
5525	Afghan Plaque, 27" long
5530	Flying Owl
5540	Sand Bucket
5531	Miniature St. Francis
5541	Rose Bowl with Dog or Kitten
5542	Egg Shell, large
5543	Egg Shell, small
5544	Egg Bank
5546	Egg with Rabbit
5548	Leaf, large
5549	Bowl
5551	Lazy Susan
5552	Cake Stand
5553	Afghan, sitting, 5"
5554	Afghan, romping, 6¾"
5555	Afghan, playing
5556	Baby in Tub
5557	Afghan, lying
5558	Cigarette Box
5559	Modern Ashtray
5560	Colossal Bottle, 36"
5561	Mighty Moon Vase
5562	Candle Tower, 25"
5563	Candle Tower, 18"
5564	Candle Tower, 13"
5565	Candle Tower, 8"
5570	Urn
5571	Tall Flower Vase
5572	Dwarf Tree Planter
5573	Low Bowl
5574	Low Bowl
5577	Garden Lantern, 11"
5578	Garden Lantern, 22"
5580	Santa Plate, 10½"
5590	Wise Man, 10"
5591	Wise Man, 10"
5592	Wise Man, 10"
5594	Madonna, 6"
55XX	Annual Christmas Plate, Three Wisemen

1956

5601	"Mrs. Foo", 22"
5602	"Mr. Foo", 22
5603	"Foo" Dog
5610	Roll-rim Vase, 17"
5611	Roll-rim Vase, 11"
5620	Butterfly Wall Piece, 14"
5621	Butterfly Wall Piece, 14"
5622	Colossal Butterfly Wall Piece, 28"
5623	Colossal Butterfly Wall Piece, 28"
5635	Smoke Set, tear-drop
5636	Smoke Set, crescent
5637	Smoke Set, domino
5638	Smoke Set, head
5640	Smoke Set, helmet
5643	Baby Colossal Butterfly Wall Piece
5644	Baby Mosque Vase
5645	Moon Vase, 5½"
5646	Moon Vase, 4"
5666	Usabata Vase
5670	Starfish Wall Piece

5671	Shell Wall Pocket
5672	Seahorse Wall Piece, 16"
5673	Seahorse Wall Piece, small
5674	Sea Wolf Wall Piece
5680	Santa Plate, 16"
56XX	Annual Christmas Plate, Mr. & Mrs. Snowman

1957

5701	Handle Bottle, 28"
5702	Handle Bottle, 22"
5703	Handle Bottle, 14"
5706	Ashtray, rectangular, large
5708	Ashtray, rectangular, small
5709	Cigarette Box with Lid
5710	Ancestor Figure, woman, 16"
5711	Ancestor Figure, man, 16"
5712	Fish Vase
5713	Fish Vase with Lid
5720a	Ginger Jar without Lid
5720	Butterfly, 14"
5721	Butterfly, 14"
5722	Narcissus Bowl
5723	Ginger Jar with Lid
5724	Astray
5725	Ashtray
5730	Garden Seat (Or as Jardiniere), 15"
5740	Planter
5741	Planter
5742	Planter
5750	Ashtray, circle
5752	Ashtray, domino (new)
5753	Ashtray, teardrop (new)
5754	Astray, helmet
5755	Astray, crescent
5757	Afghan, wind blown
5761	Pillow Vase, 9"
5762	Pillow Vase, 7"
5763	Sampan Bowl, 14"
5764	Circle on Foot
5765	Candelabra
5766	Salt & Pepper
5767	Oil & Vinegar
5768	Compote
5770	Court Figure Wall Planter, woman, 15"
5771	Court Figure Wall Planter, man, 15"
5772	Wall Princess, 25"
5773	Wall Planter, 13"
5774	Ancestor Wall Planter, woman, 26"
5775	Ancestor Wall Planter, man, 26"
5780	Bamboo Flower Holder, 14"
5781	Light of Asia Flower Holder
5782	Bamboo Candle Holders
5783	Branch Vine Flower Holder
5784	Dogwood Flower Holder, 6"
5785	Jumpup Flower Holder
5786	Gaybird Wall Piece
5787	Swallow Wall Piece
5788	Sea Horse Wall Piece, 16"
5789	Sea Pony Wall Piece
5790	Starfish Wall Piece, 9"
5790X	Christmas Compote with Santa Head
5791	Fish "Goldy" Wall Piece, 6"
5791X	Christmas Punch Bowl, Bells & Bow
5792	Fish "Queeny" Wall Piece, 6"
5792X	Annual Christmas Plate, Jingle Bells
5793	Sea Fern Wall Piece, 9"
5793X	Christmas Cup, Bell & Bow
5794	Seaweed Wall Piece, 10"
5794X	Christmas Candle Holders

5795a/b	Fish Lures Wall Pieces
5795	Turkey Candle Holders
5795X	Santa Claus, 10"
5797	Turkey Centerpiece
5798	Turkey Platter, 21"
5799	Turkey Relish Dish
5799A	Cranberry Bowl
5799B	Turkey Compote
5799C	Turkey Plate, 10½"

1958

5801	St. Francis Wall Planter, 18"
5802	St. Francis Wall Plaque, 27"
5803	Wall Bowl
5810	Ming Vase, circular, 11½"
5811	Ming Vase, circular, 5½"
5812	Ming Vase, rectangle, 11"
5813	Ming Vase, rectangle, 5½"
5814	Melon Vase, 10"
5815	Ming Vase 8½"
5830	"Dog Show" Bulldog
5831	"Dog Show" Dachshund
5832	"Dog Show" Pomeranian
5833	"Dog Show" Maltese
5834	Ming Ashtray, 9"
5850	Jardiniere, 17"
5851	Base for Jardiniere
5852	Jardiniere, 12½"
5853	Base for Jardiniere
5854	Jardiniere, 9"
5855	Base for Jardiniere
5856	Flask with Stopper, 22"
5857	Flask with Stopper, 13½"
5858	Flask with Stopper, 29"
5859	Diamond Flask with Stopper, 30"
5860	Stopper
5861	Stopper
5862	Stopper
5863	Stopper
5870	Modern House Bank
5871	English House Bank
5872	Victorian House Bank
5873	Swiss House Bank
58XX	Annual Christmas Plate, Madonna & Baby

1959

5901	Eagle Plaque, large
5902	Eagle Plaque, medium
5903	U.S. Shield
5904	Eagle Plaque, small
5905	Eagle on Base
5915	Axe Head Bottle with Stopper, 18"
5916	Arch Bottle with Stopper, 18"
5920	Whippet, 23"
5921	Lion Bank, 7"
5922	Cat Lying on Back, 7"
5923	Cat Standing, tail up, 7"
5924	Mink, 7"
5925	Long-eared Cat, 5"
5926	Long-eared Dog, 6"
5929	Tree Bird
5930	Lava Bowl, 18"
5931	Lava Bowl, small
5940	Caddie
5941	Globe
5942	Trifoil
5943	Pillow

5945	Quatrefoil
5946	Cylinder
5947	Ming Reflecting Pool
5950	Santa Cup
5951	Two-piece Santa TV Set
5952	Punch Bowl with Santa
5960	Button Soap
5961	Canister with Top, large
5962	Canister with Top, small
5963	Tumbler
5964	Waste Basket
5965	Tissue Holder
5966	Moon Lotion Bottle with Top, 7"
5967	Moon Lotion Bottle with Top, 10"
5968	Potty Planter
5969	Ashtray, 5½"
5970	Del Mar Candle Holders, large
5971	Del Mar Candle Holders, small
5975	Santa Sack Holder, 10"
5980	Petal Bowl, large
5981	Petal Bowl, small
5983	Petal Candle Holder
5984	Quail Mama
5985	Quail Baby
5986	Vase, round, footed
5998	Tripod Stand, small
5999	Tripod Stand, large
59XX	Annual Christmas Plate, Cherub Heads

1960

6001	"Mattababy" Fountain, 22"
6002	Shell Fountain
6003	Shell Fountain Adapter
6004	Pump #1
6005	Lotus Fountain
6006	Sea Horse
6010	Broken Egg, medium
6011	Egg Box, medium
6012	Bowl, round
6013	Fish
6020	Canister, small
6021	Tumbler Toothbrush Holder
6030	Book Planter or Book with Baby Planter
6031	Block Planter or Block with Bunny Planter
6032	Buggy Planter or Buggy with Dog Planter
6033	Bucket Planter
6034	Tub Planter or Baby with Tub Planter
6035	Double Bootee Planter
6036	Crib Planter, large
6037	Bear Planter, large
6038	Bear Planter, small
6040	Decorator Lantern
6041	Handle Bottle, small
6042	Ashtray, round
6043	Ashtray, round
6044	Ashtray, round
6045	Ashtray, round
6046	Ashtray, rectangular
6050	Santa Claus, Lustre, 18"
6051	Candlestick
6054	St. Joseph
6055	Christmas Bell, large
6056	Christmas Bell, small
6061	Shell Basin, 24"
6062	Fountain Basin, 18"
6063	Sea Horse
6064	Sea Nymph Kneeling
6065	Shell

6066	Shell
6067	Dolphin, small
6070	Chimney, large
6071	Chimney, medium
6072	Chimney, small
6080	Usabata Vase
6081	Trifoil Vase
6085	Ashtray, Oriental, circle, large
6086	Ashtray, Oriental, square, large
6087	Ashtray, Oriental, circle, small
6088	Ashtray, Oriental, square, small
6089	Ashtray, Oriental, rectangle, small
60XX	Annual Christmas Plate, Poinsettias

1961

6102	Shell Ashtray, large
6103	Shell Ashtray, medium
6104	Shell Ashtray, small
6140	Zodiac Ashtray, square
6141	Zodiac Ashtray, round
6142	Zodiac Ashtray, free-form
61XX	Annual Christmas Plate, Santa in Sleigh

1962

| 6211 | Bull, 6½" |
| 62XX | Annual Christmas Plate, Kittens & Garland |

KAY FINCH/FREEMAN-McFARLIN PRODUCTION NUMBERS

Kay's creations were assigned numbers from 801 to 849 by Freeman-McFarlin. In the listing below we have listed only those numbers where the piece has been documented either by Frances Finch Webb or that we have seen in various collections. It should be noted that many numbers were used for more than one piece. For example, number 838 was assigned to the Standing Donkey and to a Bird.

803	Dove	832	Yorky, standing
804	Dove	833	Cat, lying
806	Bird	834	Afghan Hound
811	Lion, 19 1/2"x12"	835	Baby Giraffe
815	Owl, 8 1/2"	836	Whippet, sitting
816	Owl, 6"	837	Shih-tzu
818	Duck, large	838	Donkey sitting/Bird, big
821	Cape Buffalo	839	Donkey, standing/Quail
823	Mr. Bird, 4"x5"	840	Quail
824	Mrs. Bird, 3 1/2"x3 1/4"	841	Quail Baby
825	Bird, 4"/Owl Plaque	842	Skye Terrier
826	Bird, 4", tail up/Owl Plaque	843	Cocker Spaniel, 12 1/2"x 11 1/4"
827	Duck	845	Kite Bird
828	Cockatoo	846	Cocker, small/Wall Swallow
829	Rabbit	847	Wall Dove, flying
830	Rabbit	848	Wall Dove, sitting
831	Yorky, lying		

A Word About Prices

We doubt that any individual is the world-renowned expert on this subject. But as both collectors and dealers, we've given it our best shot. A few dealers have told us some wild stories about what certain pieces have sold for—well beyond what we perceive their value to be. We've also been privy to some asking prices that are unthinkable for pieces that haven't sold.

This is a growing market. We will continue to learn more as the market continues to grow. There are many factors that will cause prices to go up—or down—from our assigned values. Glaze, color, condition, rarity, restored versus repaired, and...the passage of time. Our prices reflect a near-mint status. Because Kay's glazes are so fragile, the larger or more complex the design, the more likely it is to have a nick here or a glaze flake there, especially on her slip-decorated wares, or pieces with add-on filigree like flowers, tassels, branches, leaves, etc. A common piece with problems will affect the price much more so than a rare piece with the same problems. As always, it's a supply versus demand challenge. Right now, it seems for the vast majority of her works, demand is outstripping supply.

We have used the 'Unique' designation for rare or one-of-a-kind pieces rather than specific prices, since we cannot presume to assign a value for these items.

Bibliography

Chipman, Jack. *Collector's Encyclopedia of California Pottery.* Paducah, KY: Collector Books, 1992.

Kay Finch Ceramics. Various catalogs, brochures, promotional literature; various years. Corona del Mar, California.

Schneider, Mike. "Kay Finch Ceramics' animals don't stray far," *Antique Week*, Knightstown, IN, July 12, 1993.

Webb, Frances Finch. *A Collectors Catalog of Kay Finch Pottery.* Mountain View, CA: Privately printed, 1992.

Index